PRIMARY
REDEMPTION

MESS TO MASTERPIECE

REDEEMING CULTURE THROUGH
CREATIVE EXPRESSIONS OF

FAITH HOPE LOVE

TIMOTHY J. KOSTA

Cover Art & Interior Illustrations by Timothy J. Kosta

Cover Pottery by Krissy Kosta & Adam Ross

ISBN: 978-1-7379656-1-9 (Paperback)
ISBN: 978-1-7379656-8-8 (Ebook)

You have given a banner to those who fear You, that it may be displayed because of the truth.

—Psalm 60:4

DEDICATION

Soli Deo Gloria

To my Potter and Redeemer—this is your work.
I treasure you above all, and I love you more than any other.
Let this book be for your glory and your name. May it bring
you joy and delight as it leads earthen vessels
to your marvelous light.

TABLE OF CONTENTS

PART 1
Preparation for the Journey

PART 2
Mess to Masterpiece

APPENDIX

PART 1

PREPARATION FOR THE JOURNEY

INTRODUCTION

There I was, standing on stage at my easel with a pencil in one hand and a blank piece of art paper in the other. Bright stage lights illuminated my body as droplets of water burst from my pores like a fresh-squeezed orange. I was surrounded by a colorful assortment of art materials, a talented group of musicians, and a diverse crowd of people. Congregants of my church gathered to worship, pray, and seek God during an exceptional *Week of Prayer* in 2015. During this time, I was permitted by my church leadership to create a spontaneous piece of art—live in person. Everyone who gathered was hungry for a personal encounter with God Himself—and He was about to deliver.

I am an art educator and professional artist, but creating live art on stage in front of masses of people is something I thought I would never do. As a young adult, creating art can be an isolated and personal experience; but as you mature, you begin to see the fruits of sharing your gift with others. As an educator, you discover a lot about the personal life of your students through the art they create. My goal is to continue to help build my students' sincere trust in me. I strive to create an environment of safety where students can share the underlying meaning of their creations. Sharing their ideas is crucial for their creativity and my own. Students have influenced my art through the collaborative process in many instances. When you begin to step out in faith and cultivate your gift amongst others, you begin to reap the benefit of learning new skills, inspiration, and the construction of new ideas. There is something powerful and rejuvenating when creative people surround you. I believe creating art in a community is very important, but I didn't always

see it this way. When I create, I usually choose to do so alone in a secret place, a place where I can attentively hear God's voice. This is one instance where creating alone is very important and necessary. Jesus spent a lot of time alone in prayer to receive the inspiration, creativity, and directions needed to bring redemptive healing to the masses. His creativity didn't remain isolated for long. It went from the secret place, which made its way into the community through miraculous expression. I always viewed creating art as a personal act, either developed in my classroom or home studio. I never imagined creating pieces of art where hundreds of people would be watching and staring at my every move. But I was destined for this very moment. I was being called out of my boat of safety to walk by faith on the water. I could hear the voice of the Creator calling me deep within my soul, and I was ready to respond to His call with a resounding, *Yes*. I hadn't received the vision of what I was to create on the platform until this point. I began to feel surges of anxious thoughts as I stared at the blank sheet of paper. I continued to pray, worship, trust, and listen for His still small voice, as I continued to believe that He would reveal the answer to my prayer.

The foundation of my creative processes usually begins with words and pictures. Keywords highlighted by the Holy Spirit will emerge, which leads to a thread of pictures. Soon after, a vision comes forth, along with the words expressing the meaning. Sometimes this will be revealed before I even step foot in front of a canvas. Other times, I have absolutely no foreknowledge of the direction to take. At this moment, I have to trust Him completely, regardless of whether there are one or hundreds of people present. I call it an "underwear moment"—a moment where you feel the most exposed, vulnerable, and insecure. This very moment requires the greatest amount of faith to thrust

you forward into a divine opportunity. As I waited patiently, God revealed the inspired images. Why was I so nervous or surprised? He had always come through in the past, and this time was no different. His timing is always perfect. Taking the time to listen actively, even in a place of commotion or groups of people, requires great faith and trust in the leading of the Holy Spirit. We must wait on the Spirit. When we yield our hearts and ears to the Spirit, we will find ourselves in a prime location to receive a direct download from the Creator to His creation.

The Message Revealed

The vision He had given me was of a potter sitting at his wheel while working on one of his prized clay pieces. Every night, for five consecutive evenings during the *Week of Prayer,* He had me create a new artwork depicting a broken clay vessel. Each picture depicted the vessel going through redemption, transformation, and sanctification. It is an amazing love story between the potter and his treasured clay. Before I knew it, God publicly created a framework for a visual art series right before my very own eyes entitled, *Crafted by the Potter.*

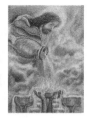

After obediently creating these five images, He revealed that there were additional images to be made within the art series two years later. It dawned on me that a beautiful, life-changing love story was about to be born. It led to creating the children's

book series entitled, *The Adventures of Clay* and the book you are now reading. I owe it all to the Potter, the Creator Himself. It all came to pass by hearing and responding to the Potter's call, even though there were moments of questions and bouts of insecurity. I chose the path of faith and obedience even though the full outcome was unknown to me at the time. The choices we make today, whether small or large, are packed with redemptive power; they not only affect the present but future generations as well. These choices have positive and negative consequences that can drastically change our lives, destiny, and culture.

I love what Edith Schaffer says about art and creation: "God has communicated in His written Word, the Bible, and it remains fresh and gives deeper understanding as we read and reread, but as He has told us that His creation communicates His glory to us, His revelation also never comes to an end. We are to search for more understanding and appreciation of who our Redeemer is, who our Eternal God is, as we walk through woods with a friend or children, as we ski over fresh powder snow mountains, or as we walk along a sandy beach or sit on a rock and examine a beautiful insect or a wildflower. Just as in an art museum, we are to enjoy the work of an artist and be glad that Rembrandt painted as he did or that Mary Cassatt's paintings of mothers and children delight us as they do, we are to also search for an understanding of the artist. Just so, God's creation is to be enjoyed, but we are to be sensitive to the reality of what we are finding out about Him, the way we are getting to know Him." [26]

One of my favorite prophetic images in the Bible comes from Jeremiah 18:1-10 (NIV). This vision revealed to the prophet is the basis for this art series's foundational words and images. It all started with God giving Jeremiah a vision and a choice to make:

"This is the word that came to Jeremiah from the Lord: 'Go down to the potter's house, and there I will give you my message.' So I went down to the potter's house, and I saw him working at the wheel. But the pot he was shaping from the clay was marred in his hands; so the potter formed it into another pot, shaping it as it seemed best to him. Then the word of the Lord came to me. He said, 'Can I not do with you, Israel, as this potter does?' declares the Lord. 'Like clay in the hand of the potter, so are you in my hand, Israel. If at any time I announce that a nation or kingdom is to be uprooted, torn down, and destroyed, and if that nation I warned repents of its evil, then I will relent and not inflict on it the disaster I had planned. And if at another time I announce that a nation or kingdom is to be built up and planted, and if it does evil in my sight and does not obey me, then I will reconsider the good I had intended to do for it.'"

Notice that Jeremiah has an immediate choice to make. God told him to "Go down to the potter's house, and there I will give you my message" (v. 1). God says, choose to obey my command and go to the potter's house, and *there* I will give you my message. This verse shows us that God had placed conditions on the revelation of the message. It all starts with a heart of obedience, saying, *Yes, Lord.* Jeremiah could've chosen not to go down to the potter's house and continued to seek God for the vision at his current location, but he would have never received the message or provision from God if he had done so. By putting his measure of faith into obedient action, hope began to arise from within as he made the wise decision to journey down the road to the Potter's house. Jeremiah's faith produced hope deep within him. It was the hope that he would receive the inspired message God desired to reveal to the people of Israel. Faith

and hope gave birth to the greatest of all expressions—love. 1 Corinthians 13:13 says, "These three remain, faith, hope, and love, but the greatest of these is love." After hearing the message from God, as revealed to Jeremiah, the people of Israel had to make a choice as well. They had to choose to operate in faith, hope, and love. They could either repent of their sins and receive mercy or do evil and have God's blessing removed from their lives. I can relate to this vision. If I refused to answer the call to create live works of art during the *Week of Prayer,* moved by either fear or insecurity, I would've missed out on God's plan and purpose for the creativity He placed deep within me. What a blessing that we can serve a Creator who operates in the opposite ways we do; He operates by faith, hope, and love. Here is one foreshadowing of many in the Old Testament revealing the Creator's heart to redeem culture.

Two of my other favorite stories in the Bible that reveal God's inspired message involve Jesus's devotion to prayer. The first is when Christ teaches us how to pray, "Our Father who art in heaven hallowed be your name" (Matt. 6:9-13). The second is when Jesus is found praying for us. He is about to endure the pain and suffering from his arrest, trial, scourging, and crucifixion. The apostle John recounts the words of a special prayer found in chapter 17. Christ prayed for those who would believe in Him "that they might all be one, just as you, Father, are in me, and I in you" (v. 21). He then continues repeating the word, *one,* to emphasize His point, "That they may be one even as we are one, I in them and you in me, that they may become perfected into one" (v. 22-23). The definition of *one* in Hebrew means "unity." It can also mean "whole or complete." The Potter is a creator who desires a relationship with His creation. I see a dynamic parallel between these two scriptures. He desires to see His vessels completely one, whole,

unified and sanctified as a good artist should. He never wants to leave His masterpiece fractured or fragmented into hundreds of disjointed pieces, although brokenness is often necessary for reconstruction. He never wants to be separated from his workmanship; rather, He constantly seeks to shape, mold, and renovate us into the vessels we are meant to be. He envisioned unity between us, the Father, the Son, and the Holy Spirit from the beginning. After all, we are ultimately in the palms of his hands. But it comes down to a personal decision—a choice of what we will permit His sculpting hands to do or not do deep down in our hearts. The Potter has also made an eternal choice. No expense was considered too great, no road too hard, no restrictions or persecutor's threats were too intimidating. Nothing can stop Him from pursuing the perfect fellowship and oneness He desires to have with us—His clay.

Join me as I take you on a literary and visually exciting adventure, as you encounter a beautiful love story between the Potter and His clay. You will be captivated by the amazing acts of faith, hope, and love the Creator expresses for you—His treasured vessel—as He transforms you from mess to masterpiece.

God made you; uniquely designed, strategically gifted, exceptionally durable, crafted with quality, empowered to heal, and unconditionally loved. Your God-given creativity—whether big or small—has the power to redeem the present culture as you sow the good seed with faith, hope, and love. In doing so, the creative potential you possess will reap a harvest of extraordinary proportion.

—Timothy Kosta

THE POWER OF PROPHETIC ART & CREATIVITY

Art is the visual language that reaches the far ends of the earth. It is a significant force that shapes past, present, and future cultures. Art is one of the most potent, influential forces in all creation. But let's face it. Art and creativity are messy. If we take a moment to view our lives as a piece of pottery, the potter works tirelessly to shape, mold, and renovate each broken vessel out of sincere love for the clay. Just as red, yellow, and blue collaborate in a harmonious unity that gives birth to the vast spectrum of colors, artistic and creative expression is a primary element within humanity.

Whether you realize it or not, you're an artist in your own way in the pursuit of beauty; you have a unique language, creative gifts, talents, and abilities. From the beginning, you were **Empowered** to create, **Chosen** to redeem, and **Destined** to worship. *The question is, What are you creating* (building), *and who or what are you redeeming* (saving) *and worshiping* (glorifying)? Your simple everyday creativity, regardless of your method of expression, is like a seed. After the seed is planted, watered, and nurtured—planted by faith, watered with hope, and nurtured with love, it will produce a harvest that captivates the viewer's senses and heart instantly—it is transformational. Creative individuals carry the heavy cross of the demands of beauty. They walk the extra mile through mud, dirt, and rocky turmoil to deliver a message of hope to the hopeless and redemption to the lost. Art is love, and love is an art. Art indeed gets messy because of its great purpose—foundations that are deeply rooted in faith,

hope, and love. These foundational elements are essential in redeeming oneself and the culture at large. Yes, art is primary. Art and creativity are supernatural, culture-shaping forces used for good or evil. You can redeem a culture when you have empowered creativity flowing through a chosen vessel, or assist in disintegrating a culture through a prideful and selfish spirit.

I believe art is life-giving because it gives birth to a message that can become a reality in the viewers' lives. Just as we may have the privilege of being a parent to one or more children, we know that their lives shape and affect our own. Art is a conduit that brings forth life. You may not consider yourself an artist, but you are. You engage in creative endeavors every day, whether you realize it. You choose what to wear, sculpt your hair, sing a song, play an instrument, make a meal, landscape the garden, decorate your home, and create something deep inside someone when you speak into their lives. Yes, you are an artist and make a SIGNIFICANT impact on the world around you every day! Yes, the God of all creation wants to communicate through your creative talents to you and others collaboratively. At first, a visual image of what you are creating will capture the attention of the viewers' eyes. Soon after, they will quickly find that the message sinks into the depths of their heart before manifesting through their actions. We see this every day as visual images in our daily lives bombard us. Art constantly speaks and is alive. But *what is* the content of the message communicated to the hearts and minds of the viewer? Is it a message of truth that can build us up? Or is it a lie that will ultimately tear us down? Throughout history, artists have given life to the cultures of every nation through the message it communicates. If we did not have art, we would not have a culture, a history, or diversity. From the beginning of time, the Creator wanted His Kingdom poured out over all

the world's cultures. Humankind is the evidence of this grand plan, as we all bear His image. When we collaborate with Him, we are qualified to be change agents in our present culture.

Look up the meaning of the word *prophecy*. You will find it defined as "revealing by divine inspiration, to reveal the will or message of God, to illuminate or bring truthful revelation to a situation."[36] Paul taught that prophecy is one of the major spiritual gifts we should all "earnestly desire" (1 Cor. 14:1). He shares how it brings strength, encouragement, and comfort to us personally and those around us. Revelation 19:10 says, "The testimony of Jesus is the Spirit of prophecy." Not only do prophecy and the prophetic gifts manifest in times of personal and community worship, but through the vehicle of the visual and fine arts. Jesus Christ is the Spirit of prophecy. If He is not the One we are setting our sights upon, listening to, and having communion with, we are setting ourselves up for receiving a false picture with a false message.

Prophetic art assists in leading people into a deeper, more intimate relationship with the Creator while encountering His presence and Glory through the visual arts. Prophetic art is made with any art media such as painting, drawing, sculpting, mixed media, photography, graphic arts, and many more. It communicates the Father's heart through Jesus Christ; it reveals His thoughts, prophecies, promises, strategies, plans, and divine timing. It is manifested through the elements and principles of design by leading people into a personal encounter with the heart of God. Creating prophetically differs from other types of creating. Through the Holy Spirit, it allows the breath of God (His Word) to guide the artist in every step of the creation process. It begins with unfolding the original idea, design, or sketch to the actual unveiling of the vision with the media of choice.[20]

Kingdom Expression: A Top-Down Effect

The goal of prophetic art is to know and understand the Father's heart, while effectively communicating the relevant and urgent *Rhema* word, the "now" word of God, to others. It is a visual depiction of utmost urgency regarding what is happening in your life, the lives of others, or the world at large at this very moment. It can serve as a warning, a strategy for healing, or a solution to a current situation on God's heart. A piece of art can often cut to the heart regardless of one's language, emotional barriers, social status, or one's intellect. I like to call this a *Kingdom Expression*. The visual art represented serves only as a vehicle to transport and deliver a message from the Kingdom of Heaven to earth. We are called to be Kingdom-minded, as all good things come from above. I visualize this as a top-down approach. I visualize this as a tree, upside down with its roots deeply connected in the Kingdom of God with its fruit-bearing branches reaching to nourish the earth. This tree represents the Son of God—the Hope of Glory—along with you and me. We are the vessels made in His image that He has chosen to work through. It is Christ in us that is the hope of glory. He is the one who bridges the gap between heaven and earth and, at the same time, desires to partner with our creative gifts and talents. Don't you see, He has chosen you and me to bridge the gap! We represent the upside-down tree. We may look unusual and uncommon to the world, but God's ways are not ours. He chooses uncommon people and uncommon methods to bring about uncommon results. He produces miraculous fruitfulness in and through His chosen vessels to bless the world. Being Kingdom-minded provides an opportunity where people can be encouraged, comforted, and lifted to an awareness of God's tangible presence. 1 Corinthians 14:3 says, "But everyone who prophesies speaks to men for their

strengthening, encouragement, and comfort." Art and creativity should serve as a selfless act of love towards the Creator and to their fellow humanity—it is an act of beautiful worship unto God. The ingredients of faith, hope, and love, coupled with our persistent asking, seeking, and knocking, allow us to see God's glory and power manifested on the earth. We will see physical and spiritual healings, deliverances, transformations, words of knowledge, salvations, and baptisms in the Holy Spirit out of His abundant grace and mercy. The Creator himself desires to fill us—His vessels—with fresh, Kingdom anointing to redeem a lost, dying, and thirsty world.

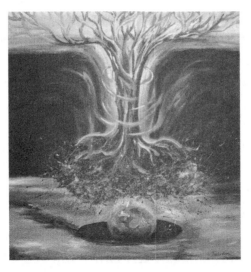

Uncommon to the World, 2015, Timothy Kosta

We Have Been Given a Banner

One of the first passages you encountered as you began reading this book comes from Psalms 60:4, "You have given a banner to those who fear You, that it may be displayed because of the truth." A banner can be anything elevated or lifted. It can

be your hands, a flag, a signal, a symbol, or a visual picture. It is a symbol that produces a sense of faith, hope, and love within the viewer. The word itself can be used as a military term, where a standard is assigned to an army or a flag on a ship. I know when women are about to give birth, the nurse can have the mother set her focus on a visual picture during delivery. This "banner" assists the woman by taking her focus off the present pain and redirecting it to the anticipated love for her newborn child. Regardless, we must realize that God has put something specific in our hands that is powerful in worship and spiritual warfare against the enemy. How can you be a recipient of this banner, you might ask? It is a gift given "to them who fear the Lord" (v. 4). The fear of the Lord is holy, with deep respect and reverence for God himself. God has committed such a standard to His people that we might go forth as soldiers in His army. When we are wholeheartedly devoted to God, we are enlisted in His service and ultimately fight His battles.

As a creative individual, God may have entrusted you with the banner of painting, drawing, sculpting, singing, or dancing, to name a few. It has been given to be lifted high, to raise a standard against the enemy in your life and others. Our whole life is worship unto God, and we have been given the weapons necessary to wage war against the enemy. The weapon of "banners" is meant to be displayed because of His truth—the Word of God. Banners may be for the cause of truth or in defense of justice and righteousness. Our creativity is never to be displayed for the vain or prideful parade; never to be utilized in an unrighteous or unjust cause. Just as the banner of an army was not to be waved to and fro for the very purpose of carrying desolation or securing victory, its purpose was that a righteous cause might be vindicated; that the honor of God might be promoted and elevated. It is never about us or our works of art for the approval of human flattery or selfish gain.

Our work is meant for the advancement of His Kingdom. It is meant to help set the captives free from bondage, encourage the hopeless, and restore sight to the blind.

There are many examples where God empowered individuals to create banners by faith. Two of the earliest, Spirit-filled artists in the Bible are Bezalel and Oholiab. They serve as prime examples of visual artists called into powerful action. These two craftsmen were filled with the Spirit of God to build the *Ark of the Covenant*, which became a banner for the Israelites (Ex. 31) and a catalyst for the *Shekinah Glory* to be physically manifested. God also instructed Moses to sculpt a bronze snake upon a pole in the wilderness so that everyone who looked upon the banner was saved and healed from the deadly bite of fiery serpents (Num. 21). On the other hand, Jacob sculpted a monument made from stacked stones. This served as a banner reminding Jacob and the people of how vividly God spoke to them (Gen. 28). Lastly, Jesus was painted red with his own blood as He was nailed to a cross. Without realizing the spiritual significance, the Roman soldiers raised the cross up like a banner of deliverance and eternal freedom, symbolizing the new covenant for all humanity (Jn. 19).

Bringing the Banner to Tanzania, Africa: A Personal Testimony

One Sunday morning, at the age of 9, I sat in church with my parents listening to a guest missionary speak about his experiences in Africa. I was so enthralled by his message that my creative mind began to run wild, envisioning myself in that very place. Towards the end of the message, my mother leaned over and whispered, "*One day, God may call you to go to Africa. Do not be afraid. I know you are young, but God will prepare you*

for the moment when He calls you. At first, I was scared. But at the same time, I knew that it was not my mother speaking those words; it was God Himself revealing a future event. I took the revealed Word given to my mother and kept it close to my heart. As I got older, God continually placed the nation of Africa on my mind, particularly Tanzania. Growing up, I was never given the opportunity to go on a mission trip to Africa. After 26 years of waiting patiently, the prophetic word that was spoken over my life finally came to fruition.

Two years prior, I had created the visual art series, *Crafted by the Potter.* I had five beautiful images that I knew were powerful and meant to be used by the Creator Himself. One of the images resembled an African landscape, specifically Mt. Kilimanjaro, in Tanzania. I even sold a print of this artwork to a woman who specifically said to me, *I love this artwork because it reminds me of Africa.* Can you believe that! God continued to show me visions that confirmed He was working something together for good. I shared this with my wife Krissy, who said, *If God has meant it to be, there will be an opportunity that will arise.* Days later, God spoke to my heart, saying, *Timothy, you obediently stepped out in faith by allowing me to use you to create these visuals in worship. Now, I want you to take this visual message to my creation in Tanzania. Now is the time. This is the place I want you to go to, and I will be with you.* Sure enough, the following Sunday, the mission's pastor announced there would be a men's trip to Tanzania over the summer. As Krissy and I reminisce about that Sunday, she always reminds me that even as she heard the formal announcement from the pulpit, she felt in her heart that I was going to Africa. After all these years, I knew this was the moment God had been preparing.

From that point on until I left for the trip, everywhere I went, God brought to my attention pictures of African wildlife on the back of Jeep Wranglers, in magazines I viewed, and

even personal artwork created by my students in school. They didn't even know about the trip! It was one confirmation after another. With that, I started to get prepared. I spent a lot of time in prayer and fasting. I made postcards and prints of each image from the art series. I also had a substantial portion translated into Swahili. I even made big posters of each of the images. I knew I would share the gospel with people through these visuals. Months later, I had a gallery showing of the art series at my church and was permitted to sell the originals and prints. All the artworks were sold, and the overabundance of funds was used to fund the trip to Tanzania. Even extra funds were available to bless the lead missionary and ministry we served under while in Tanzania. Originally, 5-7 men were slated for the trip, but the number began to dwindle little by little. It was down to me and my friend Greg. Due to the lack of individuals, the mission board contemplated canceling the trip. In the end, God had chosen just the two of us to travel to Tanzania to accomplish the work He had already planned. God had chosen us for a special assignment.

God was sending a banner of visual art with a message of love, straight from the Potter to his beloved vessels. While in Tanzania, God created multiple opportunities for me to share Gods' love through the art series. Every day we hiked or drove through "the bush," with rolled-up posters and postcards in my backpack, ready to reach various villages with the gospel. I was sharing the visual message in public schools, churches, and villages that were primarily Muslim and Christian. I shared the story of God's love just like Jesus did when He walked on the earth. Led by the Holy Spirit, He went out of His way to share captivating stories and parables to reach the lost. As my words, along with the Holy Scriptures describing the artworks were being translated into the Swahili language, multitudes were captivated by the visual art presented. After hearing the

story of God's great love, crowds of children came running to receive the miniature version of the story created on postcards, while others wanted to hear more about Jesus. It was truly an amazing sight to see! Children and adults were introduced to the greatest treasure known to humanity. Greg and I traveled to various mud hut churches sharing the good news while working hard every morning to help clear large areas of the jungle. We also helped lay the foundations for a local village youth center, church building, and missionary housing. One afternoon, I had the privilege of going out into one of the larger villages along the coast to share the gospel through live painting. I brought my folding easel, paints, brushes, and a canvas. My translator and I set up shop under a portico where fishermen would come to rest and relax after a long night of fishing. This is where I was given the inspiration to paint a picture of Jesus calling the disciples to follow Him. In doing so, He said He would make them "fishers of men" (Matt. 4:19). Men gathered around to watch each step of the painting, while others began to ask questions. The art paved the way for many great conversations about God's love and the process of salvation. Some tried to debate their Islamic faith, while others saw the love of Jesus in a new light that day. After finishing the painting, one man came running after me and shared how much that painting inspired his faith, increased his hope, and desired this love. He desperately wanted the painting, and I gave it to him as a reminder of the good work that had begun deep in his heart that day.

You see, God put a banner of His love in my hands through visual art to wave it in front of the eyes of the Tanzanian people. He placed visual seeds in my hands to cast into the new fields being cultivated. Dry and broken clay fragments were being watered down and molded into a new vessel. I may never know how impactful this trip was in this physical realm, but I know that it had a lasting effect in the spiritual realm where

my heavenly treasure is stored. This trip changed my life and the lives of others. I know that it is only the beginning of all God wants to do! Every day as we enter the arena of life, we battle against good and evil; light versus the dark; building up and tearing down; creating and defacing. If we choose to create with the art tools of faith, hope, and love, the Spirit of the Lord God will move in and through us. As the prophet Isaiah said, "The Spirit of the Lord GoD is upon me because the LORD has anointed and commissioned me to bring good news to the humble and afflicted; He has sent me to bind up [the wounds of] the brokenhearted, to proclaim release [from confinement and condemnation] to the [physical and spiritual] captives and freedom to prisoners..." (Is. 61:1-2 AMP).

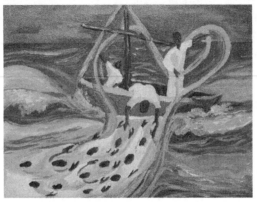

Art & War: Fighting for Freedom through Creativity

I, too, have had personal encounters where I have partnered with God, as He has used the creativity He has placed within me to be a "freedom fighter," not only in the battles in my own life but in the life of others. During an evening worship service at my church, I was painting a picture based on Moses, the great Exodus, and the pillar of fire that God placed in the way of Pharaoh. The theme was all about deliverance. At the end of the service, a woman had come up to the altar wanting prayer but was physically acting strange. Sure enough, she was demon-possessed. She began making strange noises; her eyes were rolling into the back of her head, her body became contorted, etc. This was the first time I had encountered a demon-possessed individual. An altar worker and church leader prayed over her but called on leadership for assistance. I was one of them. I began praying with the leadership for her deliverance, but the spirit within her was very resistant. I remember standing in front of her praying while gazing at the imagery of the painting I had just created during the two-hour service. At that moment, the Holy Spirit spoke to my heart and spirit, saying, *Take the painting I gave you, wave it as a banner in front of her eyes, and see the salvation of the Lord.* I had never done anything like that before, and of course, my first response was, *Really, Lord?* He said to me, *Go on the stage and pick up the painting. Bring it down to the altar and wave it in prayer and warfare before her eyes.* God is so gracious to us even when we question Him at times, not in unbelief, but with a sincere spirit trying to comprehend the situation. In obedience, coupled with faith, hope, and love, I took that painting and waved it in front of her eyes. Others from the leadership team continued to lay their hands upon her praying for deliverance in the name of Jesus Christ. Sure enough, God brought illumination by calling

out the spirit of witchcraft, and as a result, it immediately left her! There was a great "Exodus" and deliverance that set this woman free from bondage. This miraculous event was only made possible through the power of the Holy Spirit, yet His will was to complete the work through the vehicle of art. He used mere paints, brushes, a canvas, and a willing vessel to be the vehicle in bringing this deliverance to pass. A year later, I saw this woman again, and she thanked me for being faithful with the talent God had given me. She thanked me for not giving up the fight for her deliverance as others, and I stormed the gates of hell on her behalf. God imparted freedom through the mighty name of Jesus.

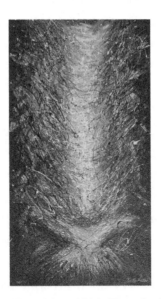

Show Me Your Glory, 2014, Timothy J. Kosta

I have had multiple experiences where God has overshadowed the gift He has given me to do something extraordinary. He can do the same in and through your gifts and talents to redeem the present culture. One time, God placed an image in my mind that I painted in obedience to Him. After creating the

image, God instructed me to give it to a woman diagnosed with cancer. After she received that gift, the power of Jesus Christ moved upon her life, and she recovered! Another time, I found out about someone's relative who attended our church who was imprisoned and falsely accused. I had created a painting that exhibited someone's hands breaking out of physical chains and being set free. I gave it to his wife, who believed in a miracle of deliverance, and sure enough, he was set free months later. These are only a few instances where God's power was used through artistic creation to bring transformation in one's life, both physically and spiritually. These were all miracles from God Himself. There is nothing magical or mystical about the artwork I have created. The power comes from a life surrendered to God—a willing vessel. If Jesus healed a blind man using clay (Jn. 9:1-7), God could work His will through anything! God calls us to use the gifts and talents he placed deep within us to bring meaningful change to our world and society for His glory. Sometimes we need to search deep within to discover, unearth, and polish the treasure He has placed deep within us. It is often not for our pleasure but for the good of those around us. We have been created to love and serve one another. We are called to defend the weak with weapons that are not carnal or of this world. As the apostle Paul says in Ephesians 6:12, "We fight not against flesh and blood, but against the rulers, against the authorities, against the powers of this dark world and against the spiritual forces of evil in the heavenly realms." We must have the heart of King David, who was said to be "a man after God's own heart" (1 Sam. 13-14). Qualities centered on the heart of the Master need to be within our hearts. King David defended the weak and those who were unjustly treated. In the secret place of the Most High he used the banner that God placed in his hands; the banner of creativity in praise, song, and palmistry-worship.

What was true then of the people of God is true now within the church age. God has given us—His church—a banner of creativity that is meant to wage a war of justice, righteousness, and truth. It is meant to be deployed in overcoming His enemies, to carry the weapons of truth against all injustice, falsehood, error, oppression, and wrong. Friends, God's Word is the truth, and this truth sets His creation free. We are to be people set on fire by the truth of His Word. His Word is full of promises that must be activated by faith. Faith is an action word and a weapon. It is an arrow that is meant to be shot from a bow. You can see the results of faith by reading Hebrews 11. Faith moves us from listening to physical action. God had me create the illustrations (banners) you will meditate on in this book. Their purpose is not to give you something nice to look at or mere words to be read. Their purpose is to be put into action through faith. After all, scripture states, "Faith comes by hearing and hearing the word of God" (Rom. 10:17).

As you journey through the following chapters, each illustration was generated from this place of worship and is the framework for the inspired literary message. Through faith—I wave a banner of creativity, illumination, healing, and deliverance over you in spiritual warfare. As you encounter His message of redemption, I pray that every stronghold will be broken in your life and divine healing be poured into every area of your vessel. I pray that every creative gift, talent, and ability deep within you will come alive like never before in the mighty name of Jesus. May you be filled with faith, hope, and love as you journey on the road to the Potter's house, a place where you will discover the greatest treasure of all time.

God doesn't want us to be shy with our gifts,
but bold, loving and sensible.

—2 Timothy 1:7 MSG

THE POWER OF WRITTEN & VISUAL JOURNALING

Years ago, I began to make it a habit to start journaling during my devotional time with God as I read scriptures in the Bible, prayed, and actively listened. I noticed that my journals were quite different from typical journals. I love to write, but as an artist and illustrator, I also love to have free space to draw and visually process my thoughts. I found that drawing and journaling helped me understand what I felt and sensed from God. Writing and drawing freed me spiritually, mentally, emotionally, and creatively. It was so therapeutic that I could better comprehend what the Holy Spirit was speaking to me personally and in the lives of those around me. It is called the art of visual journaling. As an art educator working with all ages, along with students with special needs (emotional, behavioral, and non-behavioral), visual journals are highly therapeutic and assist students in processing various positive or negative life events.

Each journal entry is not a masterpiece drawing but a quick thumbnail sketch with words boldly printed, speech bubbles, and illustrations that help me process life's journey. Ideas for new artworks, writings, projects, lesson plans for my students at school, poetry, and stories come from the drawings I have sketched in my quiet time with God. Revelation and prophetic messages have been personally revealed through writing and drawing. I have been able to navigate through and prevent many storms in my life through this method. I tend to journal about parenting, decisions, personal feelings, problems,

concepts, spiritual truths, prophetic messages from God, and any other topics that arise in my mind and spirit. Some entries have questions for God, struggles, and unanswered prayers. Everything I write or draw in the journal does not make sense either. This is not a journal for everyone to see, but a journal of the relationship between God and me. It is good to have a secret place where you and God can meet in the quietness of His presence. The key to hearing His voice is a surrendered heart and spiritual posture of active listening.

This book contains a section at the end of each chapter called *Visual Journal & Creative Space*. This is a perfect place for you to contemplate ideas you read within each chapter, thoughts, prayers, revelations, questions, and create visual sketches/artworks. You do not have to be good at drawing or consider yourself an artist. That is not what this section of the book is about. Rather, for this important exercise to be effective, you need to approach it with an open heart and a teachable spirit. Some of you may be feeling intimidated by what I am encouraging you to do. Your initial thought may be to skip over these sections of the book. The visual journal components are pivotal faith steps that will initiate breakthroughs as you obey the promptings of the Holy Spirit. The enemy will do everything to keep you from receiving victory in the current battle you are facing. This is where your faith and obedience will be put to the test. The sections at the end of the chapters are for everyone—artists and non-artists alike. These sections are reserved for writing, simple sketches, drawings, collages, poems, photographs, etc., between you and the Creator. This may be a step of faith for you, but remember, God looks at your heart and obedience. No one else will be looking at these drawings or will try to decipher their meaning. God knows what they mean. Journaling is a treasure. It had helped me in

my own life when things did not make sense, or I was going through difficult trials and testing periods. Because of this, I know it will help you too. Being the visual learner I am, having things written down in front of me helps me stay organized and make sense of the situation. One of my favorite parts about having a journal is that I can revisit what I was going through at the time and how God answered my prayers. I use my journal as a visual banner, waving the words and visuals before my eyes (meditating on God's Word in my heart), mind, and spirit to remind me of God's faithfulness. I also use my journal for prayer requests as I intercede for a loved one, a miracle, a promise, or a much-needed provision.

I pray that the visual journal section will lead you into the habit of creativity, sketching, and writing. Start right here in this book, and if God makes it fruitful in your life, you can move into a larger sketch pad or journal. The key is to start writing or drawing. You can use various materials such as pencils, pen and ink, photography, and collage. You can even apply color using various art materials to further bring your drawings to life. Many times my visual journals become the framework for larger works of art. God is providing you with the opportunity for a deeper collaboration with Him. He desires a meaningful relationship with you. Take advantage of it. God will use this visual tool to bring healing, deliverance, freedom, and liberty in your own life and the lives of others.

Come Up Higher, 2018, Timothy J. Kosta, Visual Journal Entry

PHYSICAL & SPIRITUAL VISION

I recently had cataract surgery on my left eye even though I am only 40 years old. When I graduated from high school, I got into a serious car accident that almost took my life. The trauma from the impact caused me to lose vision in my left eye, and the doctors did not know to what extent or how long I would be without vision. I sat in bed for three weeks with a terrible concussion, fractured bones, and an eye without sight. Thankfully, God restored my sight through much prayer, faith, and time.

As years went by, a cataract began to form in my eye at an early age, causing me to have clouded vision. It finally needed to be taken care of because of the difficulty it was causing me to see clearly. I had grown used to seeing the world in a particular way. My right eye was working ten times harder to compensate for the vision loss in the left eye. After having the surgery, the colors in my world began to change. I felt like I was looking at a 3-D world. Yet, I still had a problem. I saw things wonderfully from a distance as I had never seen before. My vision was so good that I did not even need a contact lens in my left eye. But even though I could see clearly at a distance, I now had difficulty seeing up close. I had to wait patiently for several months for my eye to heal before a second treatment could be performed to allow me to see things clearly in my near vision. I had been living with an increasingly "cloudy" view of the world for a time. For a second time in my life, I can honestly say, "I was once blind, but now I can see!" I prayed by faith that God would heal me; I could "see" it happen through faith's eyes, and He did exactly that over time. I trusted and

believed that God was more than able to heal me through an instantaneous touch from heaven. In the spirit, I know that my prayer was answered immediately without any question in my mind. The time frame for the manifestation of healing to occur physically within my eye was a process that took time and patience. I learned that we must trust God in His creative process. All art takes time and patience. Sometimes art can happen instantaneously, and sometimes it takes longer than expected to bring about the best results possible. So it is with a creative manifestation of healing. This does not negate the fact that God is our healer. Just because the healing process takes place at a slower rate than we would like doesn't mean that God has forgotten you or decided not to heal you. When a leper came and asked Jesus, "If you are willing, you can heal me and make me clean," Jesus responded, "I Am willing" (Matt. 8:2). He chose to heal my eye using a multi-step process through the aid of an Ophthalmologist and a laser. As I went into surgery, I looked up at a laser that flashed a brilliant, heavenly light show that aided in correcting my eyesight. After months of recovery and readjusting to my new vision, the view was like nothing I had recalled seeing before. My eyes were clear and colorful in ways that they had not been previously. I could now see because the old lens in my eye was removed and a new one replaced it! I began to learn that God loves patience and every step taken within the process. Art and creativity are a process as well. It is a process that cannot be rushed because each step—big or small—is crucial for the success of what is to come. Each step builds upon the other, forming richness in color and depth.

Sometimes, we may fail to "see" God and His creations as clearly as possible. Cataracts on the eye are not necessarily the problem. Instead, think of it as a spiritual veil covering your eyes and heart. This represents our eyes of understanding over

time. Even if we are mature Christians, we begin to take God's creation for granted and the truth He can speak through it if we are not careful. As a result, we fail to see His awesome power, creativity, and beauty as they are reflected through the world He created. How does this "cloudy" vision develop, and our perspectives become warped? It could be anything from ignorance, misinformation, lack of curiosity, or failure to appreciate God. A good example is an experience Saul of Tarsus had. After meeting Christ on the road, he was struck with blindness on the road to Damascus (Acts 9:1-19). After three days of blindness, "There fell from his (Saul's) eyes something like scales, and he received his eyes" (v. 18). Saul was given three days to reflect on a lifetime of spiritual blindness to what God was doing in the world. We know from the New Testament that Saul, who became the apostle Paul, saw God and His perfect plan for the first time. We may not need such an eye-opening experience as Paul, but I am saying that there is a lot to learn about God when we open our physical and spiritual eyes to His creation. God "spoke" His creation into existence and continues to speak His truth through it if we take the time to look and listen.

How the Creator Speaks: The Arrow of Faith

The two most familiar ways God has spoken to us about Himself are through the Living Word of God—Jesus Christ— and the inspired scriptures, the Bible. The apostle John tells us that Jesus came into the world as the *logos*—the Living Word of God. Scripture states, "In the beginning was the Word, and the Word was with God, and the Word was God" (Jn. 1:1). The first line of scripture in Genesis reads, "Then God said..." (Gen. 1:1). And the writer of Hebrews begins his powerful letter

by saying that in the past, God "Spoke...by the prophets," but "in these last days," He has "spoken to us by His Son" (Heb. 1:1-2). Jesus spoke the Word of God because He was and is the Word of God. Therefore, our tongue has such creative power. It has the power to construct something wonderful in another's life, or it has the power to destroy and kill. Our words have a creative power to bring life or destruction and death. We must be cautious about what we say regarding ourselves and others. Not only this, but we need to be discerning about the words we receive in our lives from the tongue of others. Promises found in Scripture can be molded into our lives by speaking them by faith. A healthy identity can be constructed based on what we speak and hear but can also be cast down and destroyed by what we say and believe. The words that the Creator speaks bring life into our vessel. When we hold onto His words of truth, our faith grows like a sharp arrow on a trajectory to hit the desired target. [10] As we apply scripture, we learn, "Faith comes by hearing and hearing the word of God" (Rom. 10:17).

Long before the Bible was canonized in the fourth century, the Word of God was used to refer to the words of the prophets, Jesus, and the apostles. These words were written down and compiled into a single book. God spoke His Word in audible and written form for centuries, resulting in the book we call the Bible. It is a record of God's words to mankind and God's love letters to creation. The scriptures were inspired by God and written by men in Aramaic, Hebrew, and Greek. The amazing fact is that the scriptures were recorded by chosen men—inspired by the Holy Spirit—on different continents and countries than one another. They had primitive communicative devices with vast deserts and oceans between, yet the complexity of the scriptures is coherent and speaks

one unifying message. Let's not forget to mention that there are approximately 2,500 prophecies that appear in the Bible, with about 2,000 already completely fulfilled. The remaining continue to be fulfilled now and into the near future. [11]

As mentioned previously, God Speaks through His creation. Have you ever considered that you can "hear" God speaking in the natural world? Psalm 19:1-4 says that we can! David was a shepherd who spent many days and nights under the beautifully lit heaven. David said that the heavens "declare the glory of God" and show "His handiwork." Day and night, God's handiwork "utter speech" and "reveals knowledge." There is nowhere else where His "voice is not heard" (v. 1-3). The New English Translation says, "Heaven's voice echoes through the earth; its words carry to the distant horizon" (v. 4). What a beautiful picture painted in our minds through the Creator's voice. But we must have spiritual eyes to see and perceive it.

The apostle Paul continues to remove any cloudy vision and clarify how God has made Himself known to us: "For since the creation of the world His invisible attributes are clearly seen, being understood by the things that are made, even His eternal power and Godhead, so that they (me and you) are without excuse" (Rom. 1:20, emphasis added). This is a powerful statement! People who encountered Christ were without excuse; people who hear the Word of God are without excuse, and people who open their eyes to the glory of God in creation are without excuse. God is known not only through Christ, Holy Scripture, and by the things made by His creation. God has gifted each of us to "utter speech" to "reveal knowledge" of His perfect will. We have been invited to cooperate and co-create with God. He has provided us with this ability to join Him on His mission, to assist in revealing His truth in the world through the unique gifts and talents He has placed within our vessels.

God also speaks through His Word—God Himself. When we begin to look around the world with our spiritual eyes—our new eyes of understanding—we see the glory of God all around us. Remember, this is while our eyes are still somewhat cloudy as long as we remain on this darkened earth. Cloudy vision is mentioned in Scripture by stating, "We are looking through a glass darkly" (1 Cor. 13:12), seeing only part of God's glory. But one day, we will see God's creation in living reality. But for now, there is plenty to see. Someone once said, "God has left His fingerprints all over creation." Even the non-evangelical British Philosopher John Stuart Mill admitted, "The argument from design in the universe is irresistible. Nature does testify to its Maker." And one of the greatest medical scientists in human history, France's Louis Pasteur, said, "The more I study nature, the more I am amazed at the Creator." We don't have to be philosophers or scientists to find God's "fingerprints" in nature and His clay creations. We simply must open our God-given sense of sight, touch, smell, hearing, and taste. We do that every day, yet how often do we stop and think how fruit, sunsets, bird songs, fragrant flowers, or soft fur are evidence of God's infinite creativity and His love for us? Even in a creation that longs to be free, there is beauty, joy, and pleasure all around us if we take the time to discover it. [16]

I remember watching the movie *National Treasure*, starring Nicholas Cage. In the film, he finds one of the clues to help locate the sought-out treasure of all time. He finds a set of old glasses or spectacles that have colorful lenses. He finds that as he wears them to look at the map, a whole new dimension of colors is seen. As he looks through the lenses further and manipulates them, it reveals a portion of the unseen map to the naked eye. He receives illumination as to where the treasure is buried. If we look at nature through God-colored glasses,

it will show us dimensions of Him that we can't see anywhere else. The evangelist Dr. David Jeremiah once said, "Creation is not something to be used; it is something to discover and enjoy, something to be good stewards of." God calls us to steward the gifts He has given us (see Lk. 13:42-48). That includes our time, energy, finances, raising our children, growing friendships, and using our gifts of creativity for the Kingdom of God. [13] Ultimately, God wants us to give Him praise and glory because, "Every good gift is from above, coming down from the Father of heavenly lights, who does not change like shifting shadows" (1 Chron. 16:11-12). What has clouded your vision from seeing clearly through the glass? Do you need a bit of spiritual eye surgery to circumcise your eyes and remove the veil over any aspects of your faith?

Trust in the Lord with all your heart, and do not lean on your own understanding. In all your ways acknowledge him, and he will make straight your paths.

—Proverbs 3:5-6

Visual Journal & Creative Space

Expression #1

EARTHEN VESSELS

When we wake up in the morning, we have the privilege to see the goodness of the light. The Creator was exceedingly kind in separating the light from the darkness. He has a special place in His eye for the light. Genesis 1:4 says, "God saw the light," He looked upon it with pleasure and said, "'It is good.'" God has given each of us a light to share with others. He even looks at that light with great interest; it is not only a reflection of God's handiwork but because it is an attribute of Himself, for "He is light." That light is always in the forefront of His own eyes. He never loses sight of this beautiful treasure He has placed in our earthen vessels. There are times we cannot see the light, but He never ceases to see that marvelous light within us. You may be upset or down on yourself because of a particular sin or darkness in your life, but God still sees the light in your heart because He put it there. All the "cloudiness" and desperation of your soul cannot conceal the light from the grace of His own eye. You may be full of despair, but if there is any longing in your soul to be made right with the Potter, and seek rest in His finished work, then God sees the light. He preserves His treasured vessels. When we feel powerless and weak to press on, He takes over, and the sun's light breaks like the dawn. [16]

Some people know their exact calling or vocation in life. They are born knowing what they were destined to accomplish with the talent deep within their soul. For others, it is a journey that takes years to discover. It is wonderful to be doing something you were made to do. How about you? Do you love what you are doing and feel it is part of the reason God created you? God has some significant plans for you regardless of whether you feel it. Our feelings

can be very fickle and unwavering. God's Word says, "I know the plans I have for you," declares the Lord, "plans to prosper you and not harm you, plans to give you a hope and a future" (Jer. 29:11).

His Workmanship

First, you must understand that you are God's creative workmanship, and God created you for a special purpose. Do not be discouraged if you are unsure what those specific plans are yet, or if you do not feel you are doing what you were made for. You can find God in creation, but you can also find Him in you. God has filled you with exceptional talents, gifts, interests, intelligence, experiences, and burdens. He has given each one of us a unique vessel. Scripture says, "But we have this treasure in earthen vessels, that the excellency of the power may be of God and not of us" (2 Cor. 4:7). His Word also tells you and me, "He is not far from each one of us" (Acts 17:7), and "As each one has received a gift, minister it to one another, as good stewards of the manifold grace of God" (1 Pet. 4:10). With Jesus Christ as your Savior, you are on your way to fulfilling your calling. Even when you feel lost along the journey, you must realize that you are His workmanship.

Fearfully and Wonderfully Made

Second, you must realize that you have been designed and are "Fearfully and wonderfully made" (Ps. 139:14). The author of this psalm, David, also wrote, "O Lord, you have searched me and known me. You know my sitting down and my rising up; You understand my thoughts afar off. You comprehend my path" (vs. 1-3). We need to take this psalm and turn it into a prayer to the Creator. Offer up a prayer like this, *Lord, you know*

all about me, where I am, where I am going, what I am thinking, and the path I should take. Creatively guide me with your skillful hands into all truth. Even if you cannot "see" too far ahead right now, He can. Take the time to meditate on this knowledge and praise Him for what He is doing and will do in your life! Verse 10 says, "Your hand shall lead me." By faith, we need to imagine and build a picture in our mind of seeing this a reality in our lives. He will lead you on the path He has already set before your feet, the way for your life, and when you are met with that path, you will know it. Following verse 11 are some of the most beautiful truths about you in the Bible. God is for you and not against you. Meditate on the verse below and make it your prayer: "You made all the delicate, inner parts of my body and knit me together in the mother's womb. Thank you for making me so wonderfully complex! Your workmanship is marvelous—how well I know it. You watched me as I was being formed in utter seclusion, as I was woven together in the dark of the womb. You saw me before I was born. Every day of my life was recorded in your book. Every moment was laid out before a single day had passed" (Ps. 139:13-16, NLT).

What beauty, love, security, and skilled creativity! How many of us have prayed, *Thank you, God, for making me so wonderfully complex!?* Have you thanked Him for planning out each day of your life before they came into existence? When David wrote this psalm, he did not have the wealth of information we now know about our bodies with the amazing advances of technology! He did not know about our incredible respiratory system or the 60,000 miles of blood vessels in our body. David did not know about the 37 trillion cells that make up the human form. He would never have dreamed about the 250-mph information transfer from one part of the body to another. Not to mention the complexity and mystery of exactly how our human body

works. [16] This should make our jaws drop in wonder and praise to God. The complexity of our physical body is just one part. We are made up of three parts—body, soul, and spirit. There is a deep emotional side that makes up our soul. If our bodies are exceptionally complex, think of the intricacies of how God made our eternal and spiritual selves. Our desire should be to submit all we are to His perfect plan for our lives!

A House of Miracles: A gifted temple

Third, you and I are highly gifted *Temples of the Holy Spirit*. We were made and fashioned to house the Spirit of God. 1 Corinthians 6:19 says, "Don't you realize that your body is the temple of the Holy Spirit, who lives in you and was given to you by God? You do not belong to yourself." Yes, God Himself wants to dwell in and through you. You and I were meant to be a house of miracles where all faith, hope, love, and healing flow. When Jesus was talking to the Pharisees, He declared, "My house will be called a house of prayer" (Matt. 11:17). Later, after Jesus cleansed the temple on the Sabbath, the Jews demanded that He perform a sign before them to prove He had the authority to do so. Jesus answered, "Destroy this temple, and in three days I will raise it up again" (Jn. 2:19). This would be the ultimate miracle. You see, Jesus was not referring to the holy temple in Jerusalem—a house of prayer made of stone and mortar—He was speaking about the miracle of His resurrected body, and the redemption of ours as well. When Jesus was talking about being raised from the dead and conquering the grave, He wasn't just talking about Himself; He was pointing to the fact that because He would rise again, our temples made of flesh would be rebuilt and raised to life too! His resurrection is our promise that we are the *Temple of*

the Holy Spirit. We are truly a house of miracles. We have the power through Jesus' Spirit to operate in the gifts of miracles each day. We were created to be vessels that house the flood-waters of Heaven, streams of the supernatural that flow into our lives, bringing healing through the Spirit that dwells in us. We have the power of miracles in our hearts made of flesh, and out of our hearts should flow streams of living waters. We must put the weapon of faith into action to operate in the inheritance the Creator purchased for us. [8]

Ask yourself these questions: *What am I good at? What do I enjoy doing? What fulfills me? What tangible gifts has He placed in me that can be used to reveal the truth of God?* Submit these questions to God in prayer, and He will show you. As I mentioned in the introduction to this book, I knew God placed the gift of visual art and many other talents in my vessel. I cannot deny that fact. I must be a good steward of this gift in my own life and the lives of others. It all began with a choice—faith or fear; do things my way or surrender to His ways. It all begins here for you as well. Do not underestimate yourself because then you will be underestimating the God who made you. You are designed, gifted, and one of a kind. He will make it obvious as you seek His will for your life. Jesus said, "Seek, and you will find. Knock, and the door will be opened to you" (Matt. 7:7). He also tells us to seek the truth using the imagery of a treasure hunter who seeks to find the hidden treasure (Matt. 13:44). He has called you to be a house of miracles.

Molding Moment

The following portion of scripture found in Isaiah 53:1-12 (NASB), is one of the most important sets of scripture pertaining to your right as a child of God to be healed and completely whole. Take the time to meditate on every word. Build a picture in your mind through the eyes of faith and your creative imagination of what Jesus Christ did for you. Your past, present, and future disease or sickness has already been purchased. It is time to believe and receive these life-giving words. Hold onto them tightly, and do not let go until you receive all He has promised you in His Word. He who promised is faithful!

"Who has believed our message? And to whom has the arm of the Lord been revealed? For He grew up before Him like a tender shoot, and like a root out of the parched ground; He has no stately form or majesty that we should look upon Him, nor appearance that we should be attracted to Him. He was despised and forsaken of men, a man of sorrows and acquainted with grief; and like one from whom men hide their face He was despised, and we did not esteem Him. Surely our griefs He Himself bore, and our sorrows He carried; yet we ourselves esteemed Him stricken, smitten of God, and afflicted. But He was pierced through for our transgressions, He was crushed for our iniquities; the chastening for our well-being fell upon Him, and by His scourging we are healed. All of us like sheep have gone astray, each of us has turned to his own way; but the Lord has caused the iniquity of us all to fall on Him. He was oppressed and afflicted, yet He did not open His mouth; like a lamb that is led to slaughter, and like a sheep that is

silent before its shearers, so He did not open His mouth. By oppression and judgment He was taken away; and as for His generation, who considered that He was cut off out of the land of the living for the transgression of my people, to whom the stroke was due? His grave was assigned with wicked men, yet He was with a rich man in His death, because He had done no violence, nor was there any deceit in His mouth. But the Lord was pleased to crush Him, putting Him to grief; if He would render Himself as a guilt offering, He will see His offspring, He will prolong His days, and the good pleasure of the Lord will prosper in His hand. As a result of the anguish of His soul, He will see it and be satisfied; by His knowledge the Righteous One, my Servant, will justify the many, as He will bear their iniquities. Therefore, I will allot Him a portion with the great, and He will divide the booty with the strong; because He poured out Himself to death and was numbered with the transgressors; yet He Himself bore the sin of many and interceded for the transgressors."

Your simple everyday life creativity, regardless of your method of expression, is like a seed. After the seed is planted, watered, and nurtured—planted by faith, watered with hope, and nurtured with love—will produce a harvest that captivates the viewer's senses and their heart in an instant. It is transformational.

—Timothy J. Kosta

Visual Journal & Creative Space

Expression #2

WORK IN PROGRESS

Your life and the world around you may appear to be a mess and in disarray, but fear not. Do not worry. The good Creator ALWAYS finishes what He starts. Amid these fast-paced and hurting lives, all of creation groans, longing to experience the reality of their belonging to the One who made them. Whether humanity realizes or desires to accept this truth, we are all earthen vessels. We are a temple created to house the Spirit of God. He wants to commune with us through a deep, meaningful, and satisfying relationship. One person may ask, *How can I escape feeling spiritually numb? Is there a God, and does He exist and care about me?* A lonely student may want to know, *What can I do to know that God is with me?* Another may want to be closer to God. A mother grieving her child's tragic death asks, *Has God abandoned me because of something I did or didn't do?* These questions that creation asks all have something in common. This desire gnaws deep within our souls while we continue searching for what we must do to try and "make" this happen in our strength. There is an answer, but it lies with the craftsman sculpting the pot or painting the masterpiece. He sees the result and knows precisely its purpose. The answer to life's questions resides in the Creator, not within the created.

I understand this desperation. When I was younger, I thought my failures and wrongs were due to my youth. When I was older, I believed that I would have learned what I needed to know and master the art of Christian living. Now that I am much further from my youth, hidden secrets still need to be hunted for and discovered. I am not embarrassed or afraid to admit I am unfinished, incomplete, and imperfect—I am

a work in progress. God is not surprised either. God's work in my life will never be finished until I am in the presence of Jesus, but even then, it will only be the beginning. Desiring to follow the Creator is not about being complete and perfect; it is about doing the best I can through the Holy Spirit within me and trusting God to finish the work He began. I believe my longing to please God does please Him. Even though the clay in the Potter's hands slides to the left and the right, becomes clumsy, and makes erratic efforts to be formed by His fingers, any measure of desire to be moldable is irrefutable proof that God is at work in me and you. I would never yearn to follow the Creator if His Holy Spirit did not pursue me first. As it says, "No one can come to me unless the Father who sent me draws them, and I will raise them up at the last day" (Jn. 6:44).

Jesus responds to our honest, heartfelt desire and never restricts or ignores that expression. Countless examples within scripture reveal how people pursued Him, interrupted Him, yelled at Him, desperately touched His garments, screamed terrible obscenities at Him, and ripped apart ceilings in homes to get to Him. The Creator cares deeply about our desires. They are more precious to Him than they are to us. He loves to respond to people's desperation, allowing their desire to draw Him into their needy and personal situations. When the Savior hears the earnest pleas from His created vessels, His soul is activated to move on their behalf as a good father does in response to his children. Whether they are misguided, self-serving, destructive, or sincere anxieties and needs, the Creator sees them as an opportunity to commune with us intimately. While I agree with the scripture that God "is at work in you" (Phil. 2:13), there are times when my own life has been consumed with overcoming my weakness, getting rid of unpleasant habits, and trying to have intimacy with God all

by my efforts. There have been moments where I have exerted great energy trying to please God—desiring to win His favor and fix myself—when He already has accomplished the marvelous work of redemption. One of the greatest treasures I found in my life is the mysterious reality of my oneness with the Creator, who loves me unconditionally just the way I am. I am far from perfect, but I have discovered that I do not have to strive to earn God's approval and grow closer to Him. My life is being reconstructed, renovated, healed, transformed, and sanctified from the inside out by the One who dwells within.

Molding Moment

If you declare with your mouth, "Jesus is Lord," and believe in
your heart that God raised him from the dead, you will be saved.
For it is with your heart that you believe and are justified, and it
is with your mouth that you profess your faith and are saved.

—Romans 10:9-10

There are two definitions for the word *believe*. One is to "suppose or think" that something or someone is true or real. The second is to have "trust and confidence" in a statement or promise of another person. [3] These are two vastly different meanings. One involves only the person's head, and the other engages the heart. One is of the mind and the other of the soul. It is one thing to "think" something is true, but it is quite different to "know" it is true. The scripture above tells us that when we believe something with our hearts, it will produce spiritual results. Not always immediately, but gradually over time. Spiritual thinking is more concrete than carnal thinking. Our carnal thinking is limited and bound and can keep us from our complete healing. The thoughts of our mind are fleeting, but believing with the heart is a firm foundation on which we can stand. In Matthew 12:34, Jesus said, "Out of the abundance of the heart the mouth speaks." What is in your heart will eventually be verbalized with your mouth. That is the process in which healing can begin to manifest in your body. It all starts with what you verbally say. When Jesus faced the temptations in the wilderness, He spoke directly

to Satan by declaring, "It is written..." (Matt. 4:4). He spoke the Word of God verbally with boldness and courage. The book of Proverbs says that "Life and death are in the tongue" (18:21); therefore, we must be careful with what we say. Our words are creative; they can either build up or tear down. They can produce a harvest of life or a harvest of death. We must be careful about what we say about our condition. Our words must always line up with what the Word of God says. Do you trust and believe that God has permitted this current situation in your life because He loves you and has a beautiful plan for your life? He is your healer, and His Word is truthful. Two elements bring about a profound change in the circumstances you are facing; *believing with your heart, and confessing with your mouth.* This is not a "name it and claim it" theology. It is simply acting upon the Word of God because He cares for you. He wants you healed, restored, and delivered because He finished the work thousands of years ago at the cross. We must be filled with confidence and faith in His spoken Word. We must confess His Word in our circumstances. Do not let your condition speak to you as you continue this journey. Let the *Great Physician,* the *Righteous One,* bring order and healing to any areas of chaos in your life.

For we are His workmanship.

—Ephesians 2:10

Visual Journal & Creative Space

Expression #3

PART 2
MESS TO MASTERPIECE

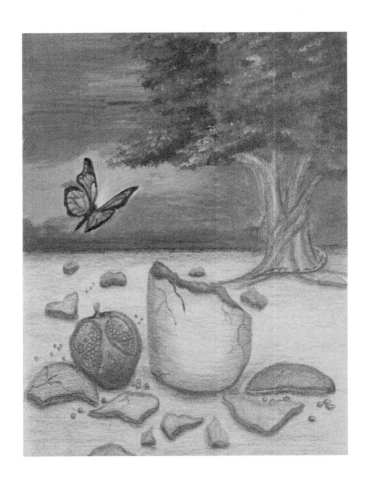

For all have sinned and fall short of the glory of God.

—Romans 3:23

CHAPTER 1
WHAT A MESS!

If we open our eyes and look at what is happening all around us in our present world, it is evident that we are living in a disintegrating culture. We live in a broken world with many broken hearts, lives, and families. This generation is living in the end times. Sometimes, our lives seem like shards of broken clay scattered in hundreds of pieces. I have made some bad choices and decisions in my own life, which I regret. I am sure we can all relate in some shape or form. People are constantly running, hiding, and trying to cover the messes in their own lives and the lives of others. Have you read the paper today? What about the news? Have you watched the latest breaking story? If you haven't noticed, our world and culture are a complete mess, and unfortunately, it continues to worsen. How did we get to this place in our society, you might ask? It comes down to personal decisions and choices.

This year alone, the world has been battling: the COVID-19 pandemic, racial and social injustice, violent protests, looting, vandalism, terrorism, lawless acts against our cities and law enforcement, hate crimes, the death of millions of babies due to abortion rights, rumors of wars, violent tornadoes, volcanic eruptions, intensifying earthquakes, famines due to locusts, dust storms, persecution against Christians and Jews, voter fraud, discussion of global resets and one-world governments, the Russia/Ukraine war, the rise in gas prices, threats of food shortages, and the list goes on and on. Yes, we are not doing well on many levels. The alarming fact is that we are beginning

to see these events converge simultaneously and with greater intensity. In the last days, the Bible says in 2 Timothy 3:1-5, "But understand this, that in the last days there will come times of difficulty in the last days. For people will be lovers of self, lovers of money, proud, arrogant, abusive, disobedient to their parents, ungrateful, unholy, heartless, unappeasable, slanderous, without self-control, brutal, not loving good, treacherous, reckless, swollen with conceit, lovers of pleasure rather than lovers of God, having the appearance of godliness, but denying its power." Are all these things not happening before our very eyes? It is as if a woman is in labor with intensifying birth pangs, which signifies that the time of delivery is drawing near. As the baby comes forth, contractions become more frequent and intense. That is what we are seeing today. You may say, *Tim, we have had natural disasters, sickness, wars, and civil unrest for centuries.* Yes, I agree with you, but not to this severity. The contraction times are getting closer and closer. The keyword here is—*Convergence.*

"You will hear of wars and rumors of wars but see to it that you are not alarmed. Such things must happen, but the end is still to come. Nation will rise against nation and kingdom against kingdom. There will be famines and earthquakes in various places. All these are the beginning of birth pains. Then you will be handed over to be persecuted and put to death, and you will be hated by all nations because of me. At that time many will turn away from the faith and will betray and hate each other, and many false prophets will appear and deceive many people. Because of the increase of wickedness, the love of most will grow cold, but the one who stands firm to the end will be saved. And this gospel of the kingdom will be preached in the whole world as a testimony to all nations, and then the end will come" (Matt. 24:16-14). These prophecies were written

over 2000 years ago and are being proven visually right before our eyes each day. All one must do is watch the news for five minutes or pick up and read the newspaper, and you will see the evidence of these spoken words. In today's world, it is hard to know who is telling the truth, yet there is one voice that has proved truthful every time—the Word of God.

The truth is we are all broken vessels. We may portray a different view on the outside and do an excellent job of keeping it all together in public, but we know we are nothing but broken shards of clay when all is set and done. I see a great shaking taking place within our world. Don't you see it? The shaking will continue to intensify until its purpose is fully accomplished. Many in the world are already broken, yet they strive to keep it together. In the end, many other areas within our lives still need to be shaken. Those who are surrendered to the Potter—true disciples (followers of the Creator)—will become stronger and endure to the end. The shaking has begun. We must come to grips with the condition of our hearts, the choices we have made in our lives, and the lives of others. I have made big mistakes and bad choices that have left me in a cracked and broken state. I am sure you have made some choices you are not proud of either. Yes, you and I are broken clay—we are a mess. I know it doesn't seem pleasant, but there is great hope, a hope where light shines through the darkest of nights. Deep inside, we hope to revert to the way things once were. A place where a beautifully harmonious and peaceful unity existed. A place where our earthen vessels were once completely whole.

Molding Moment

The arrogance of man will be brought low and human pride humbled; the Lord alone will be exalted in that day, and the idols will totally disappear. People will flee to caves in the rocks and to holes in the ground from the fearful presence of the Lord and the splendor of his majesty, when he rises to shake the earth. In that day people will throw away to the moles and bats their idols of silver and idols of gold, which they made to worship. They will flee to caverns in the rocks and to the overhanging crags from the fearful presence of the Lord and the splendor of his majesty, when he rises to shake the earth.

—Isaiah 2:17-21

"When he had entered Capernaum, a centurion came forward to him, appealing to him, "Lord, my servant is lying paralyzed at home, suffering terribly." And he said to him, "I will come and heal him." But the centurion replied, "Lord, I am not worthy to have you come under my roof, but only say the word, and my servant will be healed. For I too am a man under authority, with soldiers under me. And I say to one, 'Go,' and he goes, and to another, 'Come,' and he comes, and to my servant, 'Do this,' and he does it." When Jesus heard this, he marveled and said to those who followed him, "Truly, I tell you, with no one in Israel have I found such faith. I tell you, many will come from east and west and recline at the table with Abraham, Isaac, and Jacob in the kingdom of heaven, while the sons of the kingdom will be thrown into the outer darkness. In that place there will be weeping and gnashing of

teeth." And to the centurion, Jesus said, "Go; let it be done for you as you have believed. And the servant was healed at that very moment" (Matt. 8:5-13).

Even though this was an official, and there are many religious and social reasons why Jesus should not have gone to the man's house, Jesus tells him, "I will come and heal him." All religious customs, social constructs, and political correctness had to be disregarded to heal this man's servant. God was so moved by the response of this official and his heart of faith. Even though this Centurion was a man in authority, he chose to "humble" himself before Jesus. He put aside his position, title, and pride by responding to Jesus, "Just say the word and I know my servant will be healed." What faith! When we submit to God, He is willing to come to our house to bring healing. He is ready to step into "our mess" and get His hands dirty. There is no mess or brokenness that He is unable to clean up. He knocks on the door of our hearts desiring to come in and pick up the broken pieces. We must take the first step by acknowledging we have a mess on our hands—a mess we cannot clean ourselves. We have no idea how to put the broken pieces back specifically in the correct order. We need divine help. Answering the brushstrokes of His hand on the canvas of your life is the first step to healing. Invite Him to come into the remains of your vessel and allow him to rebuild you from the ground up. When we welcome Him in, truth inevitably follows. With truth comes beauty, and with this beauty, freedom before God.

Just remember, every flower that ever bloomed had to go through a whole lot of dirt to get there!

—Barbara Johnson

Visual Journal & Creative Space

Expression #4

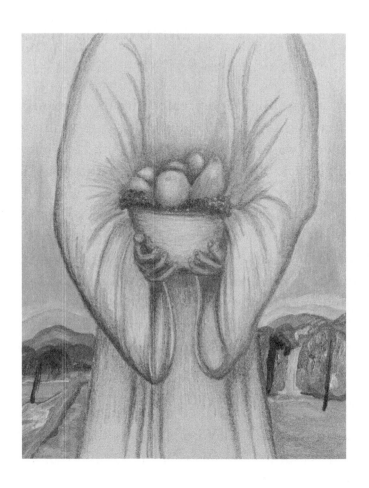

For I know the plans I have for you, declares the Lord.
Plans to prosper you and not to harm you,
plans to give you hope and a future.

—Jeremiah 29:11

CHAPTER 2
EMPOWERED TO CREATE

In the beginning, God created the most beautiful garden and everything in it. If you thought the famous artist Michelangelo was the greatest, think again. He could use the power of His voice like a master painter with a brush in hand, or a sculptor with a chisel to create anything and everything. He has some serious creative power, my friend! In the book of Genesis—Jesus, the master artist—created everything. "In the beginning was the Word, and the Word was with God, and the Word was God. He was with God in the beginning. Through him all things were made; without him nothing was made that has been made. In him was life, and that life was the light of all mankind. The light shines in the darkness, and the darkness has not overcome it" (Jn. 1:1-5). When it came down to the crown of His creation, the Creator took on the role of a "Potter" as He decided to sculpt man out of the dust of the earth (Gen 2:7 CEV). The Potter formed him to be a living clay sculpture. He was a functional piece of art in the form of a container to hold the attributes of God (His Spirit and the fruits of the Spirit), created in His own image. He breathed life into him; a soul and a spirit with the capabilities to think, reason, feel, love, and make decisions and choices. He was given a free will. The Creator desired to share his creativity and co-labor with His creation from the beginning. Soon after, He took creativity to a whole new level—He created culture.

Dirt is messy yet miraculous. If you think about it, everything we currently have in the world was once found in the

dirt. For example, trees make homes, elements and minerals melted down can form iron and steel to build with, grains of sand melted down creates glass, dirt (clay) formed from the dust of the earth creates man, and the list goes on and on. When God created the world on the third day, He created the dry land—dirt, soil, and clay. I once heard a teaching by pastor Andrew Womack who shared how God placed everything the world would ever need into the dirt. His Word spoken is like a seed, and that seed is the catalyst that draws all the potential out of the dirt He made. Scripture says, "And God said, 'Let the earth bring forth grass, the herb yielding seed, and the fruit tree yielding fruit after his kind, whose seed is in itself, upon the earth;' and it was so'" (Gen. 1:21 KJV). Notice the phrase, "Let the earth bring forth." This gives us a clue that all of the potential within the soil, the animals, plants, elements, natural resources, humans, etc., have a genesis in the dirt God created. They *came forth* from the earth. We may not be able to fathom this concept, but dirt is supernatural. When God speaks, His Word is the seed (the catalyst) that brings forth new life (Lk. 8:11). When you look at dirt for what it is, it looks messy, plain, and muddy. For example, no one would ever think there could be a giant acacia tree growing in that mess, which would later be used to build the Ark of the Covenant and the first temple—the Tent of Meeting in the wilderness. Nor would anyone dream that plain mud could house the Spirit of God. But the Creator doesn't see a mess; He sees a masterpiece.

Culture is what we make of the world in both senses. Culture is the objects and materials we make of the world. It is also the sense we make out of the world. Culture is the material, and culture is the meaning that comes forth. We make sense of the world by creating new and extraordinary things. The way we find our way to meaning is to make something

new. Culture is really "meaning-making." Culture is made of the raw material created by God first and foremost. We are not the ones who first developed the essence of culture. God did. Genesis 2 presents God himself as a culture maker, a cultivator making something from the world's raw material. Unlike Genesis 1, where God is about *creatio ex nihilo*—Latin for creating something out of nothing—He is now about *creatio ex creatis*—creation out of what was created. He does this by creating something new out of what He has already made. The Lord God said, "It is not good for the man to be alone. I will make a helper suitable for him" (Gen. 2:18). As we read further, starting with verse 21, "So the Lord God caused the man to fall into a deep sleep; and while he was sleeping, he took one of the man's ribs and then closed up the place with flesh. Then the Lord God made a woman from the rib he had taken out of the man, bringing her to him. The man said, "This is now bone of my bones and flesh of my flesh; she shall be called 'woman,' for she was taken out of man. That is why a man leaves his father and mother and is united to his wife, and they become one flesh" (Gen. 2:21-24). God used a part of Adam to create someone completely new, a helper with whom he could collaborate!

Don't you love that one of the first things God chose to reveal to the world about Himself is that He is a creative God? He created everything good until His reflection, His own image—*imagio dei*—was seen in all things, especially humanity. Artmaking is good. Art is also a gift, a calling, and obedient worship unto God Almighty. All art is a gift and not just an achievement. Art establishes its purposes, not in its utility but in something much bigger, like the gospel itself. It is His grace. And like worship, it pulls us into something so much bigger than who we are, pulling all our play and our pain

into the beautiful life of God in Christ. Do we believe that art and creativity are a gift, a calling, and obedient worship? How we answer this question will determine what we do with the materials He has placed deep within us. Along with His commands, God Himself is the essence of beauty; everything has the mark of His hands, and "It is good."[31]

Culture, the Trinity, and the Color Theory Connection

We first see the idea of a culture originating during the first six days of creation. Before the fall, when God introduced the idea of creating His masterpiece on the sixth day, He said, "Let *us* make man in *our* image, in *our* likeness, and let them rule over the fish of the sea and the birds of the air, over the livestock, over all the earth, and over all the creatures that move along the ground. So, God created mankind in his own image, in the image of God he created them; male and female he created them" (Gen. 1:26-27 emphasis added). We see evidence from the beginning that the God of all creation is triune—3 in 1— *Yahweh.* In the New Testament scriptures (2 Cor. 13:14, 1 Jn. 5:7), the doctrine of the Creator exists in a *Holy Trinity.* The Bible does not specifically call it, *The Holy Trinity,* yet it describes the system of three distinct persons within the Godhead, each with their distinct roles; the Father, the Son, and the Holy Spirit, yet all three are equally God unified as *one.* The Old Testament scripture declares, "Hear, O Israel: The LORD our God, the LORD is *one*" (Deut. 6:4). Jesus himself said in John 10:30, "I and the Father are *one.*" As Jesus is ready to depart this earth, He indicates that the Holy Spirit will come soon after, "When the Helper comes, whom I will send to you from the Father, that is the Spirit of truth who proceeds from the Father, He will testify about Me and lead you into all truth" (Jn. 15:26). The Father,

Son, and Holy Spirit collaborated as *one*. Their perfect love, harmony, and unity were the foundational elements that inspired them to create man (Clay) in their own image. How amazing is it that the three-in-one God desired to collaborate and work together to create! It is beautiful to know that the God of the universe is a God of relationship. He created and designed us for relationships because God Himself is the relational inventor. It also reveals an important truth about the creative process in our own lives—it is the most effective when collaborating with others. We were never meant to do everything on our own. We were meant to thrive in a relational community. The "Trinity" worked together to design the blueprints for all of creation. [32]

In our world, we see evidence of the triune system operating. Let's start with us. Man, just as his triune Creator has a threefold nature; he is a triune being encompassing a spirit, soul, and body. The apostle Paul confirms this truth in (1 Thess. 5:23), where he states, "Now may the God of peace Himself sanctify you entirely; and may your spirit and soul and body be kept complete, without blame at the coming of our Lord Jesus Christ." The design and pattern of all creation, both in the physical and the spiritual realm, reveal the nature of the Creator. All of creation is completely imprinted with God's threefold image. The Spirit of God declares in Romans 1:20, "The invisible things of him from the creation of the world are clearly seen, being understood by the things that are made." All creation bears the design of its Creator. Here are some good examples of the Trinity system imprinted upon humanity: [32]

- The Atom: Atoms consist of three parts, protons, neutrons, and electrons.
- Matter: Solid, liquid, and gas.
- Space: Length, width, and depth.

- Time: Is threefold, past, present, and future.
- People: All people come from one of three extractions, Mongoloid, Negroid, and Caucasian.
- The flesh: has three layers of skin; the epidermis, the dermis, and the subcutaneous tissue.
- Family: The family consists of a man, woman, and children.
- The sun emits three types of rays: alpha, beta, and gamma.
- The soil's three essential elements cause plants to grow; nitrogen, phosphorus, and potash.
- Blood: solids consist of three primary cells, platelets, red cells, and white cells.
- Human capability consists of thought, word, and deed.
- Colors: There are three primary color pigments from which all other colors are derived, red, yellow, and blue.

Now let's take a moment to focus on color. The color spectrum is not a new idea, but the renowned mathematician Sir Isaac Newton invented the first color wheel in 1666. While studying white light reflecting off prisms, he noticed that the light reflected a spectrum of colors. In observing this miraculous light show, Newton carefully made artistic notes of the different hues seen within the spectrum. He believed the rainbow of colors shared a harmonious relationship. To see color, you need a light source as light rays are needed to reflect off objects. In the beginning, God said, "Let there be light" (Gen. 1:3). This reveals that the Trinity is a God of great light. We are called to reflect the light and produce color in our world. One of the greatest discoveries in the world was the observation of the wide spectrum of colors generated from three primary colors—red, yellow, and blue. Here is another prime example of a triune system creatively collaborating at strategic times to create something new. These are pigments that naturally exist

within creation and can mix to create other colors known as *Secondary* colors (orange, violet, and green). Today, mixtures of the *Primaries* such as magenta (red & blue collaboration), yellow and cyan (blue/green) are used in color printers and other devices to create brilliant arrays of Secondary colors. When two Secondary colors are combined, the third order of color, known as *Tertiary* colors (yellow-orange, red-orange, red-violet, blue-violet, blue-green, and yellow-green), is created. As we observe these systems, we can begin to see the Godhead imprinted within the foundations of art, particularly color.

Primary- Secondary- Tertiary Color Wheel

As I reflect on the organization of color on the color wheel, I see a great sense of divine order, just as master impressionist painters Pierre-Auguste Renoir and Claude' Monet sought to perfect their paintings. I began to pray and ask the Holy Spirit to show me the deeper meaning behind the foundations revealed through color. He began revealing to me that the *Primary* colors of red, yellow, and blue can be representations of the Trinity, the nucleus or the epicenter of all creativity and creation. These three represent the Father, Son, and Holy Spirit. Contained within this perfect and eternal relationship comes the foundational attributes of faith, hope, and love. "In the beginning," the Godhead collaboratively worked to create

the crowning jewel of creation—man and woman. Later, as God commands them to be fruitful, their children multiply and fill the earth with various cultures, tribes, and nations. This is represented by the *Secondary* colors and reveals the ongoing collaborative creating process. God is at the center, then all of man is created in the image of God, which is secondary. The last ring, known as the *Tertiary* color, represents humanity's final redemption. After Jesus' crucifixion, He was placed in the tomb, but on the third day rose again. One can only imagine the amount of pure and brilliant light that penetrated the dark tomb. Out of this resurrected light comes forth variations of colorful beauty! It must have been an amazing explosion of unfathomable colors of promise and redemption. Not to mention all the values and tones of color we will encounter in the creation of the "New Heaven and New Earth" after Christ's millennial reign! After all, as it is written, "What no eye has seen, nor ear heard, nor the heart of man imagined, what God has prepared for those who love him" (1 Cor. 2:9).

As we look closer at the Trinitarian relationship, the Father is God, the Son is God, and the Holy Spirit is God. Each one is fully God yet distinct. The other amazing attribute of the Godhead is that they indwell each other in perfect harmony. The Father is in the Son, the Son in the Father, the Spirit in the Father, etc. As you view the Trinity through the Biblical lens of collaboration and creativity, one can see an organized and loving system where the Father, Son, and Holy Spirit are primary; each plays a vital role. Although understanding the Holy Trinity can be difficult to fathom, I sometimes envision the Godhead as three executives in a company. Even though each one is fully in charge and has an equal share in the company, they are distinct and play various roles. They commune regularly with love and respect for each other and the good

of the organization. I know this is a weak example compared to the Trinity, but it serves as a starting point in producing a mental image for understanding. We will never fully comprehend the inner workings of the Holy Trinity until we get to Heaven, and even when we arrive, it will take an eternity to comprehend His grandeur fully. [29]

Creative Inheritance within Humanity

Mankind received their first responsibility from their triune God, followed by a commandment, "Be fruitful and increase in number; fill the earth and subdue it" (Gen. 1:28). God again extends His creative collaboration to create a richer, more diverse culture. They were given to one another in the bond of love and unity through marriage. The two created beings were now unified as one flesh and were given the power to collaborate creatively in their work, communication, and intimacy. [20] Through this bond of love, the Creator equipped them with the life-giving ability to create a whole new being made in their own image. What a miracle and work of excellence! The Lord then *planted* a garden in Eden. A garden is not just nature. A garden is both nature and culture. The first gardener—the first one to plant, water, select, protect, weed, and nurture, was not Adam; it was God.

Culture was God's gift to His living vessels. Without culture, without a garden itself, how could they ever survive? God planted a garden to begin the work of culture before He gave the work over to Adam and Eve. Culture is created by God just as much as nature. God blessed the ground so His children could be a rich blessing. It all started with the Creator, and culture was God's vision. The Lord God made to grow every tree pleasant to the sight and good for food out of the ground. It was not just

a vegetable and fruit garden for nourishment. It is also a great place of beauty. Over time, Adam and Eve received sovereignty over creation, and they were given the authority from God to rule over and be good stewards of His creation. The mantle of creativity and culture-making was placed on the shoulders of humanity. What a great inheritance, privilege, and responsibility for a creation made in His image. [31] Yes, whether you believe it or not, you, my friend, are an artist! Today, God shares His creativity equally with the righteous and the unrighteous (Matt. 5:45). God, because He is infinite, can create out of nothing by his spoken word. Because we are finite, we must create from something else that has already been created. You may not necessarily be a professional visual or performing artist, but you are an artist personally. Each created being has been called to faithfully put their gifted dose of creativity into action every day. Everything from getting dressed, styling your hair, preparing breakfast, planning your route to work, problem-solving, and engaging in everyday life tasks and relationships is a process that requires artistic thinking. It points to the great love of God upon ALL His creation! It does not just include our gifts and talents but the basic gifts that are easily overlooked, such as the air we breathe, sunlight, and nature. One might ask, "What is the culture God created in the garden?" It was a culture made up of the primary attributes of faith, hope, and love; a culture of creativity, relationship, peace, and security. It was a symphony of true worship rising from His vessels of clay.

Jesus refers to this commandment or mandate in response to the Pharisees about the greatest commandment. Jesus said, "Love the Lord your God with all your heart and with all your soul and with all of your mind. This is the first and greatest commandment. And the second is like it: love your neighbor as yourself" (Matt. 22-37-39). True love is deeply concerned about

the well-being of one's neighbor and is the most important act of worship. The triune God set the example for us on how to love one another by what He created in the beginning. [15] The Apostle Paul said it this way: "If I speak in the tongues of men and of angels, but have not love, I am only a resounding gong or a clanging cymbal. If I have the gift of prophecy and can fathom all mysteries and all knowledge, and if I have a faith that can move mountains, but have not love, I am nothing" (1 Cor. 13:2). The cultural mandate to create using the most important ingredient, love, has never been removed, and it will be in effect until the Potter returns.

In the garden, the fruit on the trees were always ripe, and each one mouthwatering, sweet, and satisfying. Their given work to harvest the fruit and vegetables in the garden was rewarding and met with satisfaction. They worked joyfully, and God gave them the increase. The Creator gave them the strength to meet each challenge with success, as they served God, each other, and all the creatures the Potter had made. He even gave Adam the job of naming each one with divine intellect and wisdom. Everything was good back then. The soil, water, and temperature were perfect for growing. Even the air they breathed had a sweet, peaceful scent. Most of all, their relationship with the Potter was good. The collaborative work given to Adam and Eve in the garden was enjoyable. It gave them a sense of purpose and belonging to be part of the Creators' work. As the parents of Adam and Eve, the triune God had the joy of watching His children grow happy and reach their full potential. And Adam and Eve worshiped their Father, learned from Him, and wanted to imitate His attributes. One of their favorite parts of the day was when they had finished their work, and the Potter would come to walk and talk with them in what he called "The coolness of the day" (Gen. 3:8).

This was a refreshing moment when He praised their hard work and assured them that they were His treasures—His very own masterpieces.

The man and woman observed the Potter make good decisions as they followed His lead. They were about to learn that doing what is right is not always easy; it is costly. But in the end, it will always lead you back to God's peaceful garden. He shared His plans for them, plans for a great future, and hope. He was loving, kind, gentle, generous, and trustworthy, which is a brief list compared to all He is. He treated His creation like gold, and they knew they were safe in the palms of His hands. After all, He made us—His clay—and we belong to Him.

Molding Moment

For in the gospel the righteousness of God is revealed—
a righteousness that is by faith from first to last, just as it is
written: The righteous will live by faith.

—Romans 1:17

From the beginning, the Potter intended for us to live supernatural lives. The supernatural should become a natural part of our being. In Matthew 4:4, Jesus said, "Man shall not live by bread alone, but on every Word that proceeds from the mouth of God." The living Word of God must be such an essential part of our lives that we can respond with faith to any situation we may face with our God-given creativity and giftedness. Natural bread will only get us so far, but we must rely on the supernatural. We need to believe the Word that Jesus is speaking to us. This is how we receive our healing; by believing every Word spoken. Therefore, taking the time to meditate on His Word every day through creative implementation is crucial. We must be able to respond to His Word spoken over our lives; creative action must follow faith. Looking back to the garden, we must get to that special place where we walk with the Creator hand in hand in the "coolness of the day" to receive divine inspiration.

An artwork has value as a creation because man is made in the
image of God, and therefore man not only can love and think and
feel emotion but also has the capacity to create. Being in the image
of the Creator, we are called upon to have creativity.

—Francis A. Schaeffer, "Art and the Bible"

Visual Journal & Creative Space

Expression #5

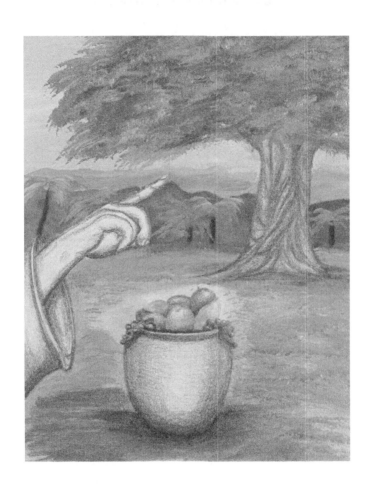

If you love me, keep my commands.

—John 14:5

CHAPTER 3
THE COMMAND

One afternoon, during one of Adam and Eve's special walks, the Potter took them past a tree in the middle of the garden that they had never picked from before. It had the most extraordinary fruit growing on it! The fruit was large and ripe; they thought they would have one of the best harvests. But what the Potter said next surprised them. Instead of telling them to pick the fruit, He gave a command stating that they were free to pick fruit from any tree in the garden except one. It should've been an easy command to follow. After all, the Potter shared His whole garden with them both. It was the least they could do. Then He gave a stern warning explaining that if they chose to take the fruit from this tree and disobey His command, they would die and turn back to the dust of the earth. Ouch! They did not like the sound of that as they began to think about what that truly meant; a broken friendship with the Potter, becoming nonexistent, and an end to being in His beautiful garden. It was a loving warning of protection and one of Adam and Eve's most serious talks with the Potter. With their best intentions, they chose the obvious answer. To obey the Potter, of course. Or would they?

The well-respected A.W. Tozer once said, "God never violates our freedom of choice. When the Potter formed us in the beginning, He molded us in His image. He gave us emotions, intellect, creativity, and a will—a free will. [34] Since God's very nature is the spirit of "freedom," He built the joy of freedom into each of us. He has given us the ability to make conscious

choices of our very own. He enables us to choose to abide by a command, choose our profession, make daily choices, and select our companions for this world and the next; it enables us to yield our soul to whom we will, to give allegiance to God or the devil. And God respects this freedom. God once saw everything He made and said that it was very good. To find fault with the smallest thing God has made is to find fault with the Maker. So highly does God regard His handiwork that He will never violate it. He will take ten steps towards us, but He will not take the eleventh. He will incline us to repent, but He cannot do the repenting for us. Repentance can only be done by the one who committed the act to be repented of. God can wait on the sinning man, and He can withhold judgment. He can exercise long-suffering to the point where He seems lax in His judgment, but He cannot force a man to repent. To do this would violate the man's freedom and void the gift God molded within him. The believer knows he is free to choose. With this freedom and knowledge, the hope is that we will always choose the blessed will of God."

God has given us His laws and commands for a purpose. He is the essence of the law because it is who He is. Anyone who does not follow the law is lawless. The laws themselves have the creative power to keep us safe and fulfill our potential. His commands lead us to a life of true freedom. When we follow His commands and make wise choices, our spiritual and physical health, marriages, relationships, and even finances are at their best. God Himself is the perfect reflection of the law, and the foundations of His kingdom itself are built upon it. Everything He designs and creates works perfectly in divine order. Just look at our complex body systems. We can take no credit for the complex collaboration under our fragile frames at every moment. He knows what is good for us. He knows

what is right for His creations. Even the hairs on the top of our head are numbered (Lk. 12:7). He knows because he fashioned and wired us in His image. And because of the wonderful gift of being made in the Maker's image, we have all been given the freedom to choose. The Potter loves freedom. He is the essence of true freedom.

God's commandments are a pristine set of standards that cannot be fully obeyed by humanity. We may feel we excel in many areas but fall short in others. According to God's standard, "Whoever keeps the whole law but stumbles at just one point is guilty of breaking them all" (Jas. 2:10). That is how Holy and righteous God is. There is not one speck of darkness in Him. It all started with the first act of disobedience by our great grandparents—Adam and Eve. Edith Schaeffer says, "The making of human beings with a capacity for creativity was not an accident, but glorious creation which could bring a two-way communication, a response to what God has given so generously and lovingly to be enjoyed. The heart of man, the heart of woman, the hearts of children, had people not been blinded by selfishness and sin, would overflow with thankfulness in every form that fertile imaginations could express it! Worship and adoration of the magnificent Creator would have been spontaneous, had it not been horribly spoiled."[26] This generational curse directly resulted from their deliberate choice to ignore God's specific command, leading to a significant consequence. As we know, all our choices have consequences, whether good or bad. This resulted in the generational forfeit of our ownership by the Creator over to Satan—the deceiver. Every human that came forth after Adam and Eve inherited a sinful nature. Scripture says that "We all have sinned and fall short of the glory of God" (Rom. 3:23). If you deny this fact by saying you are without sin, you have just broken your first

commandment—lying—and according to the Bible, you are now guilty of them all! Welcome to the club. Now you know you are and have always been a doomed sinner. Because of the sinful nature active within us, we are physically unable to obey God's just and righteous commands. God gave us His perfect laws not to take away our fun or keep us from enjoyment. On the contrary, His laws are meant to protect and save us from the sin nature. God gave us His perfect laws to show us how incapable we are of keeping His Holy commands. His perfect law reveals that we cannot save ourselves in our strength or suitable methods. Who or what can reverse this curse that has affected the past and future generations? Is there any hope?

Molding Moment

*Jesus went throughout Galilee, teaching in their synagogues,
proclaiming the good news of the kingdom, and healing every
disease and sickness among the people.*

—Matthew 4:23

We all have sinned, the one who sins is a slave to sin, and
the wages of sin is death (Rom. 3:23, 6:23, Jn. 8:34). If you
have not realized it yet, we are in a war—a war against slavery
to sin. Abraham Lincoln and many brave soldiers fought hard
to end slavery in America. He didn't just talk about ending
slavery, he did something about it. He put his words into
action by fighting for freedom. God did the same thing to
save us from slavery to sin. He sent His own Son to proclaim
the good news, live a sinless life, and die in our place to set us
free from the bondage of sin, sickness, and death. Scripture
states, "Since then, the children share in flesh and blood, He
likewise partook of the same, that through death He might
render powerless him who had the power of death, that is,
the devil; and might deliver those who through fear of death
were subject to slavery all their lives" (Heb. 2:14-15). The
Potter takes great action to set us free from the effects of sin.
He forcefully demonstrated His love for us by healing every
kind of disease and sickness among the people. Look to His
command and His promises. If you place your faith in Him,
He will set you free from every condition you find yourself in
bondage, physically or spiritually. [22]

The Creator has made us each one of a kind. There is nobody else exactly like us, and there never will be. Each of us is His special creation and is alive for a distinctive purpose.

—Luci Swindoll

Visual Journal & Creative Space

Expression #6

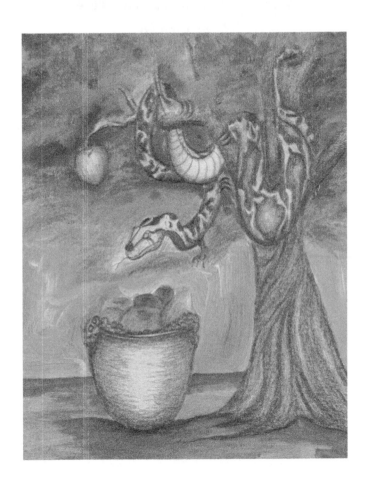

Enemies disguise themselves with their lips, but in their hearts they harbor deceit. Though their speech is charming, do not believe them.

—Proverbs 26:24-25

CHAPTER 4
MET WITH TEMPTATION

I would like to begin this chapter with a portion of text I wrote from the original children's chapter book entitled, *The Adventures of Clay, The Hidden Treasure:*

"They did everything they could in their own strength to stay far away from the tree as they went about their business. During one of their fruitful harvests, they came a little too close to the tree. I can only imagine what they might have thought to themselves as they peeked up at the fruit, *'Wow, I still can't believe how big and juicy that fruit is.'* It was large, and the color was glorious! But they quickly remembered the Potter's command and moved along. They probably minded their own business when suddenly, a calm, soothing voice came from the tree. After all, the Potter mentioned something about it being a "tree of knowledge." Out of curiosity, they turned around to see this amazing sight. As they got closer and closer and looked harder and harder, there it was. Resting in the tree was a beautifully camouflaged serpent. I can only imagine some things the Serpent might have said to Eve, *'Sorry I startled you; did you know this is the sweetest treasure in the garden? I eat its fruit, and it is delicious. See for yourself.'* He was right. It did look delicious. Her eyes got bigger and bigger, and her mouth began to water. In their heart, their struggle with temptation had begun. They had the truthful command of the Potter all along, but it was now met with a foreign voice of reason. They were enticed by the fruit but knew it was not theirs to take. Well, I guess it could not hurt them to just dream about having it, right?"[18]

We may do everything in our power to stay away from temptation, but let us face the facts. We will be tempted in some shape or form throughout our lives. The question remains, *Are you prepared to fight against it?* Adam and Eve were tempted by what they were commanded not to take. The fruit from the "Tree of Knowledge of Good and Evil" belonged to God Himself; He alone provided everything and protected them from all evil. All He required from His creation was their faith, hope, and love. Because of the early rebellion in the heavenly realm with His created angel Lucifer and one-third of the angel hosts being deceived, God allowed His beloved clay vessels to be tested. God tests His children to grow their faith and build their trust in Him, but He does not tempt anyone. We know this because scripture states, "Let no one say when he is tempted, 'I am being tempted by God,' for God cannot be tempted with evil, and he tempts no one. But each person is tempted when he is lured and enticed by his own desire'" (Jas. 1:13-14). Would they remain faithful to His command, or would they disobey and follow the alternative voice? After all, if one of God's top angels could rebel against his Creator, what about these new creations made in God's image? All of heaven was poised as they waited to see the outcome of humanity's testing experience. How would their Creator respond? Adam and Eve had good intentions and obeyed the Potter until they were met with the sound of an intriguing voice. Satan's smooth, sly, and cunning voice of Satan—possessing the serpent's body first tempted Eve, the weaker of the two created vessels. Well dressed in camouflage, the serpent appeared to be an angel of light bringing illumination, sophistication, and eclectic thinking—a true "great thinker" of the day. Whether they realized it or not, Adam and Eve were falling for the biggest lie the world had ever known.

It's important to understand that all temptation is rooted in selfishness. Jesus stripped Satan of his power two thousand years ago, leaving him with only one real weapon—deception through selfish desire. The Bible tells us exactly what they are in 1 John 2:16, "For all that is in the world, the lust of the flesh, and the lust of the eyes, and the pride of life, is not of the Father, but is of the world." And in James 1:14, we read, "But every many is tempted, when he is drawn away of his own lust, and enticed." Satan is not limitless; deception is his only weapon. All he can do is try to deceive us into thinking that God really cannot or will not fulfill our lives and keep His promises. Every single temptation of the enemy is packaged in the form of the lust of the flesh, the lust of the eyes, or the pride of life. Selfishness is always Satan's "go-to" method. When selfishness rules our lives, we open the door to his deceptive schemes.

On many occasions, Jesus, Himself was tempted as Satan's prideful heart attempted to use God's law to destroy Him (see Matt. 4:1-11). Satan's plan failed, and Jesus remains without sin. What audacity Satan has! The Creator was sinless but understood our frailty. We know this as it is revealed in Hebrews chapter 4, "This High Priest of ours understands our weaknesses, for He faced all of the same testing's we do, yet he did not sin" (v. 15). One might say, *Sure He was sinless, He is God, and was able to withstand the temptations of the smooth-talking, handsomely camouflaged angel.* Being fully God and fully man, Jesus was faced with difficult temptations throughout His life yet was without sin. He was and is the spotless Lamb of God. Romans 2:6-8 says, "Who, being in the very nature of God, did not consider equality with God something to be used to his advantage; rather, he made himself nothing by taking the very nature of a servant, being made in human likeness. And being found in the appearance as a man, he humbled himself by becoming obedient to death—even death on a cross!"

How Do We Fight Temptation?

As I mentioned earlier, if your answer is, *I do not struggle with temptation,* you are not being honest. Fighting temptation and sin is a common characteristic that marks the life of all humanity of every culture, especially Christians. We have already been set free from the power of sin, but that does not mean we will live a perfect and sin-free life. We are all called to "put off the old man and put on the new man by walking in the newness of life" (Eph. 4:22-24). As we mature in our walk with God, one temptation may be conquered, yet another may be revealed. What does God say about this? If He set the example for us and conquered temptation and sin Himself, then we must also be able to conquer them. The Bible is noticeably clear on how we can keep ourselves from temptation. Strategies and powerful truths found in the Word of God will help you resist temptation and overcome sin. My first question for you is, *Who do you allow yourself to associate with? Is it good company that speaks the truth and has your best interest in mind? Who and what do you listen to? What are you watching? Where do you spend your time? Are you sober-minded and watchful?* Where you set your ears and eyes will affect your heart; it will eventually direct your path to either death or life.

A Real Enemy Seeks to Destroy You

> *Be sober-minded; be watchful. Your adversary the devil prowls around like a roaring lion, seeking someone to devour.*
>
> —1 Peter 5:8

You must realize you have a real enemy that desires to destroy you. Satan hates God; His laws, precepts, and created

vessels made in His image—you! Satan wants to destroy, deface, and vandalize God's masterpieces because of the image we all bear. He wants to devour us like a lion on a furious rampage by making us unfruitful for the Potter. We must be on guard and resist him (1 Pet. 5:9). If we deny that Satan exists or take God's warning lightly, we set ourselves up for easy attacks. Let us learn from Adam and Eve. When tempted, remind yourself of the consequences if you decide to give in to the temptation. Even if you conclude that your choice will not hurt any earthly relationships, remember, you are hurting the one who loves you the most—your God and Creator. Therefore, Satan wants us to reason away our conscience by giving in to temptation because it hurts God and, ultimately, you. We are to stand firm in the faith against the wild schemes of the devil (Eph. 6:11).

A Warning to Artists & Creative Individuals

Satan tempts everyone but in diverse ways. I have found that he particularly LOVES to tempt creatively inclined individuals. These individuals are in touch with their emotions, such as artists and visionaries in the visual and performing fine arts, with temptations that warp true beauty. He loves to distort vessels that have extra doses of creativity built into the walls of their DNA. Distorting the lives of these clay vessels is his primary goal because visual creativity connected to truth is extremely dangerous and a serious threat to Satan's regime. From my discussions with other artists and creative people, it is interesting to hear how they are faced with similar temptations. You are not alone. Because artists and creatives have an extra dose of the Creator's image woven into the fabric of their lives, you are even more on Satan's "hit list." If you are a creative person, this is by no means meant to scare you, but let

it serve as a warning for you to be even more watchful and alert to the enemy's schemes. Satan throws these common tactics to tempt and destroy you from the inside out; he uses lust, sexual distortions, pornography, homosexuality, identity, insecurity, depression, and anxiety. He uses these tactics to warp the meaning of true beauty and distort your God-given creativity. Your creative gift is a superpower that has been entrusted to you by the Potter Himself. You have the God-given ability to imagine, dream, construct, build, and make creativity a reality here on earth. What an honor and privilege! Art and creativity are birth-giving. Many believe the distorted lies of Satan and abort the treasure that is deep inside of themselves. Do not let him win. It is a well-planned assassination attempt! Your emotions or your feelings do not rule you. You must search for the deep treasures of God's truth found in His Word—the Bible. The one who created you reminds you of who you are as a person, artist, husband, wife, son, or daughter. Some promises will lead you on the path to life and free you from any distortion. These promises are only found in the light of God's Word.

You are Not Alone in your Temptation

No temptation has overtaken you that is not common to man. And God is faithful; he will not let you be tempted beyond what you can bear. But when you are tempted, he will also provide a way out so you can endure it.

—1 Corinthians 10:13

People worldwide are dealing with the same temptations that lead them into darkness. Do not believe the lie that you are the only one facing that same struggle. It will only lead

to more depression and anxiety. If people were honest, you would be surprised to learn about how many are struggling with the same temptation you are, along with WHO is facing the battle. You would be shocked if you only knew. If you feel alone, the best thing to do is be honest with a trusted friend or pastor about your struggle. Scripture promises freedom when we confess our wrongs and struggles with the body of Christ, as this starts the healing process. Satan wants to lie to you by shaming you into thinking you are all alone in your struggle and that you are some sort of freak for dealing with it. He also condemns you, making you feel unworthy of God's love. It is not true, and it is a ploy to destroy you! You must hold on to this truth, "Therefore, there is now no condemnation for those who are in Christ Jesus" (Rom. 8:1). As I mentioned earlier, we were not meant to do life alone. We were meant to do life together, in a community with one another.

Resist Temptation, Obey God, and Win

If you believe in Jesus Christ, you have already passed from death to life. You are filled with the Holy Spirit and already have the weapons necessary to stand firm against every temptation. The question is, *Are you putting on the equipment and using it?* If you have not surrendered your heart and life to Jesus, you will have an opportunity to do so at the end of this journey together.

2 Peter 1:3 says, "His divine power has granted us all things that pertain to life and godliness." This verse tells you and me that we already have the equipment needed to live a godly life, a life that is pleasing to the Creator and conquers our temptations. We can stand in front of the temptation with the armor on, but are we engaging in warfare with the resources

and tools God has given us? God has made spiritual armor available to protect us against the enemy's attacks. He has given us His Word, which can train us in righteousness (2 Tim. 3:16-17), keep us from sin (Ps. 119:11), and be a sword in battling temptation (Matt. 4:1-11).

God has also given His creation the Holy Spirit to help us fight sin in His power and not our strength. The Holy Spirit gives us life and the power to fight sin and submit to God (Rom. 8:5-11, Gal. 5:16). Even though we may face strong temptations, God promises that they will not be too strong for us to overcome them. If we find that they are too strong, we need to analyze our struggles and the events that led to that temptation. For instance, next time, you should not be alone in a room on the computer if that was the event that intensified the temptation, or maybe you need to throw out movies you are gravitating towards to crush the temptation. God will always give you an "eject" button to escape the crash. It might be a call on the phone, a worship song that pops into your head, your wife calling you for dinner, etc. God is creative in how He throws you a lifeline to safety. The key is not to ignore it! My pastor always says, *You have to deal ruthlessly with sin and temptation, or it will deal ruthlessly with you.* Satan is no respecter of your feelings. He is a terrorist. You might be saying to yourself, *Tim, I am aware of these things, but I am not gaining victory.* Is it possible you are not suiting up your spiritual armor that Paul talks about in Ephesians 6:10-20? God has given us tools for success. Depend on God and pray that He will help you realize all He has given you and use it to stand firm in Christ. You must be militant and envision yourself wearing *The Armor of God* throughout the day. [29]

Engage in Warfare: Taking Back What the Enemy Has Stolen from You by Faith

Therefore, put on the complete armor of God, so that you will be able to [successfully] resist and stand your ground in the evil day [of danger], and having done everything [that the crisis demands], to stand firm [in your place, fully prepared, immovable, victorious]. So stand firm and hold your ground, HAVING TIGHTENED THE WIDE BAND OF TRUTH *(personal integrity, moral courage)* AROUND YOUR WAIST *and* HAVING PUT ON THE BREASTPLATE OF RIGHTEOUSNESS *(an upright heart), and having strapped on* YOUR FEET THE GOSPEL OF PEACE IN PREPARATION *[to face the enemy with firm-footed stability and the readiness produced by the good news]. Above all, lift up the [protective] shield of faith with which you can extinguish all the flaming arrows of the evil one. And take* THE HELMET OF SALVATION, *and the sword of the Spirit, which is the Word of God.*

—Ephesians 6:13-17 (AMP)

Humanity is very clever at finding ways to sin and then cover it all up. To gain true healing and freedom, one must repent of their sins. In Greek, the word used for sin is *hamarti'a*, meaning "miss the mark."[11] When you are aware you have sinned, you must go to God with a heart full of repentance and confess (telling Him with your mouth); He is gracious to forgive you (1 Jn. 1:9). You may have lost some of your battles, but not the war! You must realize, "Though the righteous fall seven times, they rise again" (Prov. 24:16). Yes, we may fall, but we must repent, get back up, and move forward. Many people constantly struggle with temptation because they work harder to enter it rather than avoid it. Cut the temptation at the root cause.

I had tons of poison ivy around a particular oak tree in my backyard one year. I kept spraying the plants with various vine killers, but it kept rearing its ugly head. After thorough investigation and knowledge by a professional, I realized that an enormous poison ivy vine about two inches thick had climbed to the top of this large oak tree. I never knew that a poison ivy vine could grow so big and thick. It grew in disguise for years, while I thought it was just an old vine. Knowing the truth, I took out my axe and severed the vine. Sure enough, my itching skin irritation went away over time, and so did the poison ivy. You must sever the vine of temptation and disconnect yourself from anything that leads you down the path of destruction.

In each case of temptation, first, investigate where the temptation starts and dig out the intertwining vine by its roots. If not, it will continue to grow until you sever it with an axe. During those times, ask God to reveal where the genesis of this temptation began and what feeds it. Pray to God for help against temptation and remind yourself of the truths of scripture to prevent lies from taking root in your mind. What we fill our minds with, and let ourselves dwell upon, has a significant impact on our lives. We need God's Word to fill our minds with truth to counterattack the lies that try to penetrate. If anything causes you to sin, cut it out and put it to death (Rom. 8:13). Ask God to help you cast off sin and everything that entangles you, so you can run the race God has set before you (Heb. 12:1-2). One way to cut off the sin is to have an accountability partner. This needs to be someone you can trust. Someone who will always be honest with you and speak the truth in love. Someone who knows what you are struggling with and will agree to pray, encourage, and battle alongside you. Put on your armor and use it in faith!

How to Use the Armor Successfully: Offensively & Defensively

The armor of God is a metaphor used in the Bible that the apostle Paul used under the inspiration of the Holy Spirit. The armor reminds Christians about the reality of the spiritual battle we face on a daily basis. Each piece of armor is a metaphor for how it can protect you and me against temptation and spiritual attacks.

Shield of Faith

While all the weapons God has given us through Jesus Christ are important, some may debate which one's are the most important. Ephesians 6 tells us, *"Above all,* lift up the shield of faith" (v. 16 Emphasis Added). The shield of faith is crucial to the Christian warrior and is one of the primary attributes of the Holy Trinity. The Bible teaches that you cannot be saved without faith, you cannot be healed without faith, and you cannot receive the baptism in the Holy Spirit without faith. The shield of faith is an offensive and defensive piece of armor. When Paul wrote this passage of scripture, Roman soldiers surrounded him. In ancient times, soldiers carried heavy shields covered with animal hide. As they prepared to go into battle, they would drench their shields in water to quench the fiery darts aimed at them. In the same way, we as Christians need to dip our shields every day in the water of God's Word to extinguish every enemy's lie. Each fiery dart launched by the enemy is weaponized thoughts that burn into our minds. They can be thoughts of death, lies, perversion, identity crisis, etc. As stated earlier, the enemy tries to attack us on three levels, "The lust of the flesh, the lust of the eyes, and the pride of life" (Matt. 4 & Lk. 4). As Satan tempted Jesus in the desert, He was tempted on these three progressing levels of temptation. The only way

we can grow in our faith to quench these darts is by hearing the Word of God. One of God's greatest weapons used by God to combat Satan and his evil forces is His creative and powerful Word. The truth of His Word says, "Faith comes by hearing and hearing by the word of God" (Rom. 10:17). You can carry the shield of faith by picking up and reading the Bible. Find verses that increase your faith and read the many examples of people doing extraordinary things by putting their faith into action. Place your faith in the never-failing character of God.

The Belt of Truth

Some translations speak of "girding your loins with truth." The loin refers to the lower back and includes the crotch area. Throughout history, men would wear long robes that would get in the way of work or fighting. In this case, they would wrap up the draping material. This is an example of girding up the loins. The Lord knew that our loins needed to be strapped and wrapped in truth. God has seen all the paths we have willingly and unwillingly walked down and knows where we have been hurt. He knows that we need the truth to stay on a straight path. Our identity consists of more than our sexuality, but this is one facet of our lives that we often view as a definer. One of the first areas in our lives that the enemy likes to target is our sense of identity. The areas relating to sex are easy targets for him. We need freedom regarding sexuality, and we need the truth about who we are. Who God says I am. Jesus is the only truth that can set us free. The belt of truth is one of the first pieces of armor we are to put on. Where do you go to find the truth? Social media, magazines, your doctor, the news, your friends, your own thoughts? The meaning of truth means something is absolute, and the other things are lies. Seek the

truth of His Word. You can put on the belt of truth by praying God's Words. Use His word to guide your prayers. Memorize the truth by writing it down on post-it notes or index cards, and then put them by your computer, in your car, on the mirror in the bathroom, etc. Whatever will help you remember and internalize the truth, do it! Use the *Visual Journal & Creative Space* provided to help you meditate on God's Word. Writing and drawing about scripture helps solidify God's Word and nourishes your heart, mind, and spirit with the truth.

Breastplate of Righteousness

Righteousness means being made right. Scripture refers to the righteousness that Jesus Christ gives us, which is His righteousness (2 Cor. 5:21). Sometimes the scriptures refer to the righteousness that God may carry out through us as soldiers enlisted in His army. An example of this is the righteous acts of the saints (Rev. 19:8). Both forms of righteousness protect our heart during a spiritual attack. We need the perfect righteousness of Christ and the righteousness that happens as a response to God's wonderful gift. God desires to protect our hearts from being wounded by sin and poor choices, just as a good parent wants to keep their children from harm. No matter how many temptations the enemy throws at you, the breastplate of righteousness protects your heart and integrity. You can put on the breastplate of righteousness by obeying instructions given by the Lord. Ask your accountability partner or someone you can trust to pray with you if you struggle with being obedient. Obedience always brings blessings into your life! Paul also tells us in 1 Thessalonians 5:8 that we should "put on *FAITH* and *LOVE* as a breastplate, and *HOPE* of salvation as a helmet"—our primary elements.

Gospel of Peace

Peace is the essence of who God is and foundational in His Kingdom (Gal. 5:22). In the Greek translation, *peace* means "oneness or wholeness." The Gospel—*the Good News*—is the forgiveness of sin that gives access to the "oneness" with God through faith in Jesus Christ. This oneness with God creates "shalom," which is peace in our lives. It creates the other primary attribute known as hope. The book of Ephesians continually reminds us to stand firm. One of the ways the enemy succeeds in shaking our lives, causing us to lose our firm footing, is worry and fear. We are completely robbed of God's peace when we carry this burden. But the gospel of peace keeps our feet firmly anchored into solid ground. Hope keeps us pressing forward towards the finish line during the race of life. You can put on the gospel of peace by asking the Lord to remind you of how the gospel has transformed your life and the lives of others. We also need to set our security and identity in His work, not ours. Submerge your thoughts with the Word of God that continually speaks the truth against fear, worry, and anxiety.

Helmet of Salvation

Salvation comes into our lives as soon as we place our trust in the death and resurrection of Jesus Christ as payment for our sins. Our salvation continues to go through an amazing process of sanctification throughout our lives. The helmet of salvation rests on the work of Jesus Christ to save you; it is not by your own doing or your good works. As a potter works with his clay through wedging, forming, and molding processes, the Holy Spirit will work out our salvation in every part of our lives and thoughts. Many times, the enemy begins the spiritual attack on our minds first. Our mind is indeed a

battlefield. Thousands of thoughts filter through our minds every day. Satan tries to bind and roadblock our minds with lies and distractions. You can put on the helmet of salvation by surrendering your thoughts that do not line up with scripture. You must also "set your mind on the things above, not on earthly things" (Col. 3:2). Wash your mind with the renewing of God's Word. Romans 12:2 says, "Do not conform to the pattern of this world but be transformed by the renewing of your mind. Then you will be able to test and approve what God's will is, his good, pleasing, and perfect will." The helmet strapped to our mind fills us with hope; thoughts filled with hope for all we are meant to be and will become.

Sword of the Spirit

The sword of the spirit is the Word of God. It is the only piece of armor that is both defensive and offensive. We see a prime example of this when Jesus was in the wilderness for forty days and forty nights and was tempted by the devil (Lk. 4:1-13). Jesus used the Sword of the Spirit to slay the enemy's lies each time He was tempted. In each of these instances, He declared, "It is written." Jesus spoke the truth of the Word, and we must follow His example. Wield the sword of the Spirit, and you will win every time! [15, 19]

The Weapons of Mass Destruction: Love & Revelation

Faith, Hope, and Love are like arrows in the quiver of every believer's life used to counterattack the enemy. Scripture says, "Now these three remain: faith, hope, and love. But the greatest of these is love" (1 Cor. 13:13). Based on this scripture, I believe God's greatest weapon in His arsenal that is freely accessible

to us is love. Even though love is considered a characteristic, it is also the most powerful weapon. Scripture tells us in John 13:34-35, "A new command I give you: Love one another. As I have loved you, so you must love one another. By this, everyone will know that you are my disciples, if you love one another." The greatest weapon from God to humanity and culture is love. God's love covers a multitude of sins because it is demonstrated visually through action, color, and creativity. Jesus poured out His blood like paint on a canvas. His blood stains the canvas of our lives and marks us all with His ownership. His blood purchased us and is a visual reminder of that fact. Whether we like it or not, the crimson stain upon all our lives is permanent. We are His creation and not our own. His blood is everyone's lifeline, but we have free will to receive or reject His love. Deep down, everyone wants to be loved regardless of the hard or soft exterior we present. People cannot resist love—true, genuine, and continuous love. [15]

You may now ask, *What is the greatest weapon that threatens Satan and the kingdom of darkness?* After Paul shares about the weapon of love in Corinthians 13, he says in chapter 14:1, "Follow the way of love and eagerly desire gifts of the Spirit, especially *prophecy*" [revelation]. It is the power of revelation, the revealing or uncovering of something profound that is hidden and made known. It is a revelation from God Himself that threatens Satan. Paul knew this firsthand. He knew that God's revelations to his mind and spirit brought about "spiritual attacks" upon his life because he was given revelations to share with the church of Thessalonica. Look at Paul's accounts in Acts 14:19 and 2 Corinthians 11:25-27. It says, "So to keep me from becoming conceited because of the surpassing greatness of the revelations, a thorn was given me in the flesh, a messenger of Satan to harass me, to keep me

from becoming conceited" (2 Cor. 12:7). Satan is so threatened by the revelations of God that he will do whatever he can to prevent that revealed truth from being made known to the world. We can even see this throughout Jesus' life. For example, the revelation of Christ's birth brought about an evil satanic attack by King Herod, killing all the male children ages two and under to prevent revelation from coming to pass (Matt. 2:16-18). When Jesus was baptized, the Holy Spirit was revealed through a powerful audible voice and the visual manifestation of a dove. Immediately following this event, Jesus was led into the desert and attacked by Satan through temptation. Before Christ laid down His life as a sacrifice for the world's sins, He was attacked by Satan in Gethsemane to the point of sweating drops of blood. Satan attacked every disciple of Jesus Christ, and each one laid down their lives for the revelation of Christ's death, resurrection, and forgiveness of sin. Instead of Satan successfully suppressing the gospel of Jesus Christ, the church's persecution created the exact opposite effect—it spread the gospel throughout the entire world! Satan's plans always backfire as we face him head-on with the full armor of God. It shows us that God's revelations are wonderfully true, powerful, and deadly to Satan. The apostle Paul exhorts us by saying, "I pray that the eyes of your heart may be enlightened in order that you may know the hope to which he has called you, the riches of his glorious inheritance in his holy people" (Eph. 1:18). This scripture is profound because it reveals to us that as our eyes are open to understanding, as we gain spiritual vision, it will expose the works and plans of the enemy. As we move ahead, fully fitted with the armor of God and with the arrows of warfare, we must remember, "The weapons we fight with are not the weapons of the world. On the contrary, they have divine power to demolish strongholds" (2 Cor. 10:4).

Your creative gifts and talents have the power to redeem culture through the revelation of faith, hope, and love found in Jesus. Through the Holy Spirit's power, it can turn the world upside down just as He did through the apostles. With this knowledge, do not let the enemy try to suffocate your gift and talent. He will try everything from fear, self-doubt, perfectionism, lack of courage, comparison with others, etc., to stop you from bringing revelation into the lives of others. Do not fear the potential or actual attacks of the enemy because he is already defeated. If you stand firm in Christ, you will be victorious no matter what. You are invaluable to the Kingdom and a significant threat to the enemy. Do not fear because you are not alone. God empowers us with His Holy Spirit to accomplish any task He places within our lives (Phil. 4:13). You have the power to expose the lies of Satan and administer healing to a disintegrating culture. Through Jesus Christ, you are empowered to be a history maker!

Molding Moment

And a woman was there who had been subject to bleeding for twelve years, but no one could heal her. She came up behind him and touched the edge of his cloak, and immediately her bleeding stopped. "Who touched me?" Jesus asked. When they all denied it, Peter said, "Master, the people are crowding and pressing against you." But Jesus said, "Someone touched me; I know that power has gone out from me."

—Luke 8:43-46

This woman was so sick that no one could heal her. The reason is that healing requires power. Doctors and physicians can give us medicine, perform surgeries, and stitch up wounds, but they cannot heal. We must realize sickness and disease is a spiritual attack upon one's body. We are constantly in spiritual warfare, just like Ephesians 6:12 says, "Our struggle is not against flesh and blood, but against rulers, against powers, against world forces of this darkness, against spiritual forces of wickedness in heavenly places." Sickness and disease are allied with the power of death. I love the persistence of the woman. She was desperate for healing. She reasoned that if she could just touch the hem of His garment, she would be healed. That is great faith. She was persistent and did not let the crowds pressing on Him stop her from receiving her healing. She was determined to touch His garment. In doing so, Jesus responded, "Who touched me?" He felt power leave His body. The Greek word used to describe this power is *Dunamis,*

which means "dynamite." This force of energy came out of the body of Christ and flowed into the woman, stopping the bleeding condition instantly. There was something different about this touch. It was a desperate touch of faith. There was a significant surge of light that overcame the darkness. Light always overcomes the darkness. Jesus is the "Light of Life" that can overcome any sickness, disease, addiction, or temptation that tries to dominate you. Let His light illuminate every area of your vessel. As you put on the whole armor of God daily, you will be able to press through every obstacle to reach the Potter through the power of the Holy Spirit. [22]

Every misfortune, every failure, every loss may be transformed. God has the power to transform all misfortunes into God-sends.

—Mrs. Charles E. Cowman

Visual Journal & Creative Space

Expression #7

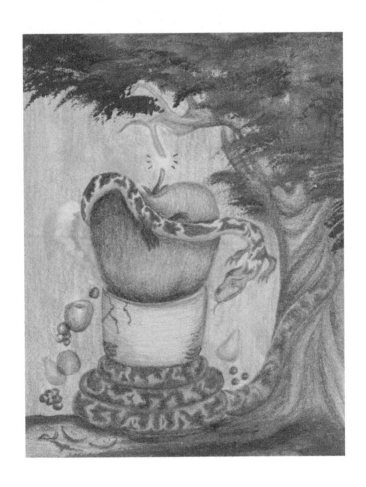

Pride goes before destruction, a haughty spirit before a fall.

—Proverbs 16:18

CHAPTER 5
IDENTITY THEFT & THE FALL

Satan, who comes in the appearance of light, used a very tactical questioning technique that caused Adam and Eve to stop, think, and question their Creator's motives. The three tactics that scripture points to are the "lust of the flesh, lust of the eyes, and the pride of life" (1 Jn. 2:16).

First, Satan said to Eve, "Has God indeed said, 'You shall not eat of every tree of the garden?'" (Gen. 3:1). Isn't it interesting when you tell a child they can't have something, they immediately become preoccupied with the very thing they were commanded not to do or touch? Here, Satan guided Eve's attention to fixate on what she could not have, which caused her to contemplate what God said. Lust began to burn in her heart for the forbidden fruit, not just the fruit itself, but what lay behind it. For obvious reasons, Adam and Eve were probably getting hungry from working all day, and at that very moment, Satan capitalized on this prime opportunity. The flesh was at its weakest at this point. Don't you notice that you are more likely tempted when tired or hungry? Beware of these moments when you are most vulnerable.

Second, they were visually tempted. Satan targeted Eve first, the weaker of the two creations. Eve answered the serpent with the command that God gave them, "We may eat the fruit of the trees in the garden, but of the fruit of the tree which is in the midst of the garden, God has said, 'You shall not eat it, nor shall you touch it, lest you die'" (Gen. 3:2-3). Here, Eve declared the law but then received a counterattack

by the lawless one who spoke a half-truth, saying, "You will not surely die" (v. 4). Satan knows the law inside and out. Satan is a good lawyer because he was there when the law was written in heaven. But remember, there is a Jewish lawyer who knows the law inside and out—His name is Jesus. Satan loves to mix the truth with lies, and this situation is a perfect example. It was true that if they ate the fruit from the tree, they would not die immediately, but they would die eventually. Unfortunately, we are all physically dying over time as a direct result of our great-grandparents' disobedience. The other effect is spiritual death—separation from our Creator—the sustenance of life. Indeed, we will all live forever because we are made in the image of God, and God is an eternal being. He shared this privilege with us after He sculpted our frame from the dust of the earth. He then did something extraordinary—He breathed His own life into our nostrils.

Eve was so intrigued by her newly found knowledge that it caused her to desire the fruit even more. Not only this, but the fruit was physically appealing, and it looked delicious! Here is an example of how powerful visuals can be in past and present cultures. The lust of the flesh had captured her attention and the lust of the eyes. But what came next was what pushed her over the edge. Satan said, "For God knows that in the day you eat of it your eyes will be opened, and you will be like God, knowing good and evil" (v. 4). Wow! Satan tried to craft an argument that God was hiding something good from her. In essence, he was saying that she didn't need God. If she obtained this confidential information on her own, she could be "like God" by having wisdom about what is good and evil. That doesn't sound like a bad thing to know about, right? But this act was clear, blatant disobedience to God's command. If both Adam and Eve could be like God, it would allow them

not to follow what the Creator said anymore. They could call the shots and be their own god. Satan fed their ego and pride, which led to their overall demise.

The pride of life always leads to destruction, just as it did for Satan. His prideful heart caused him to fall from heaven like lightning (Lk. 10:18). Adam and Eve would be able to do things their own way; they would be able to make decisions about when, where, and how they would do things, or so they thought. Scripture says, "So, when the woman saw that the tree was good for food, that it was pleasant to the eyes, and a tree desirable to make one wise, she took of its fruit and ate. She also gave it to her husband with her, and he ate" (v. 6-7). Along with exploration within the garden came exploitation. In the garden was this one tree that was explicitly said to be "good for food and, a delight to the eyes—nourishing and beautiful like all the other trees. But it is also "to be desired to make one wise" (Gen. 3:6). That is what the woman thinks and what the serpent implies. How can fruit make one wise? That is not what God said. God simply said it was the *Tree of Knowledge of Good and Evil*. To be wise is not only to know what is good but to choose good and resist evil. There was nothing in the fruit to make that wisdom come to pass. After Satan successfully deceives Eve, he targets Adam by using her sweet and seemingly wonderful discovery to convince him to partake in the meal. At this point, Adam completely trusted his wife and failed to ask her from where this beautiful fruit came.

Identity Theft

Throughout history, one of Satan's main tactics has been the attempt to steal our identity. Adam and Eve were given all authority and dominion in the garden, yet Satan was able to

steal and distort the vision of their true identity. You and I were created to be children of the Most-High God. He created us to be either male or female by His choice. Any other deviation from His original plan directly results from humanity's fall. We were created to be fruitful and commanded to multiply. But this is not all. He called the male and female into a deep, intimate relationship with each other and communion with the Creator. You must know your identity in Christ. Satan wants to cause confusion and doubt over our self-image (how we see ourselves), self-concept (our thoughts of who we are), and even more prevalent is the enemy's lies about one's sexual orientation and gender. In our culture, we consistently hear people say, *Well, this is how I feel inside, and I was born with these tendencies. So, this must be who I am. If it is all in the name of love, why should it matter who I choose to have an intimate relationship with?* Everyone was born with immoral and sinful tendencies, but that doesn't make it right. For example, even though someone was born with the tendency to steal, should they just go on stealing because they "feel" like it? Sure, they could. We have free will and can choose. But is this the right thing to do? Absolutely not! Out of God's great love for us, He has created a way for each vessel to be born again. We need a new nature because our old nature has been corrupted and broken through sin, but Jesus Christ provided the way to healing, redemption, and restoration. Jesus said Himself, "Very truly I tell you, no one can see the kingdom of God unless they are born again" (Jn. 3:3).

The thief hates our identity because it is rooted in the Creator Himself. His very image is imprinted on each of our lives, so he must do everything he can to distort that pure image. He desires to take mud and dirt and splatter it all over the beautifully painted canvas of our lives. He is like a roaring lion in the middle of a potter's shed, seeking to smash

and destroy each masterpiece. Why? Because he hates God's creation and hates everything created in His image. He is a murderer who seeks to destroy your destiny because within your vessel is the creativity to redeem culture. There is a serpent in every garden of your identity; the garden of who you are and what you are called to do needs to be properly maintained. As it says in Proverbs 4:23, "Above all else, guard your heart, for everything you do flows from it." There is a serpent in everyone's garden that wants to tell convincing and logical lies, yet they breed destruction to our self-image, self-concept, and our true identity. In a humble spirit, we must know who we are in Christ. One way that Satan distorts our identity is through comparison. He wants us to define who we are in the light of those around us while allowing jealousy and envy to take root in our hearts. Satan tries to blind us to all the gifts and talents God has placed in our lives. It is natural for us to want approval and affirmation of who we are as creations. The question is, *Where are we going to gain this? Who are we lending our ear to receive this information? Is it dictated to us by our past or present voices whispering into our ears? Where do you go to get recognized or feel a sense of belonging?* God has given each of us a unique identity rooted in one key person—Jesus Christ. You are a beloved son or daughter of Christ. Satan knows if he can cause us to question our identity, everything else will become diluted and eventually lead to self-destruction. Holy Scripture tells us, "The thief comes only to steal and kill and destroy; I have come that they may have life and have it to the full" (Jn. 10:10). When it comes to identity, Satan wants to sink his teeth and dismantle the truth of who we are in Christ.

As Satan enticed both Eve and Adam with his smooth speech (Eve's compromised will), it was as if he continued to coil his body around their vessels as he slowly squeezed the

life out of them, inch by inch. Adam and Eve focused their attention on the one thing they were told they could not have. In doing so, they willingly exchanged all the Potter gave them for the lie of momentary pleasure. This one decision was going to change everything and everyone for eternity.

Temptation & Resistance

Yes, we are all tempted and have sinned. We all fall short of God's glory. No matter how good we try to be, we all find ourselves down paths and alleyways that lead to dead ends. Satan is a liar, and he will do anything to make you believe that the grass is greener on the other side of the fence. He tries to isolate us, so we begin to trust our own judgment and make up our own rules, when in the end, it only leads to depression, fear, doubt, and condemnation. It is time to get out of isolation. The COVID-19 pandemic has forced many into physical isolation, causing them to feel as if they are alone and left to their own devices. But despite the health crisis, there have been many living in spiritual isolation for a long time. In the name of Jesus, it is time to come out! I have heard countless stories of increasing alcoholism, depression, pornography, drug use, and suicide. God never intends for us to be alone and isolated. We are never alone because Jesus said, "I will never leave you or forsake you" (Heb. 13:5). Satan wants you to believe this is a lie when he is the force behind it. It all leads to greater isolation and eventually physical and spiritual death.

How can one resist temptation? You must plan and be prepared. If we look at 2 Chronicles 12:14, it says, "And he did evil, because he prepared not his heart to seek the Lord." This scripture is about the king of Judah, Rehoboam, the son of Solomon. He was faced with many temptations and succumbed

to them because he was unprepared. Being unprepared will cause you to lose the battle. Before Jesus went off into the wilderness to be tempted, He was filled with the Holy Spirit during His baptism. He was prepared to go on the 40-day journey. It is imperative that after you repent of your sins and receive Jesus as your Lord and Savior, you receive the baptism of the Holy Spirit. You may not have received this free gift yet, but if you have, you must stay full of the Holy Spirit. This gift is essential to be prepared to fight temptation. Jude 1:20-21 says, "But you, dear friends, by building yourselves up in your most holy faith and praying in the Holy Spirit, keep yourselves in God's love as you wait for the mercy of our Lord Jesus Christ to bring you to eternal life." Praying in tongues builds us up in our faith. We often go through trials and sufferings, feeling as if we have no control over the situation. It is as if we were thrown into the back seat of the car and forced to go for the ride of our life, yet we have not used an important weapon God gave us—the gift of the Holy Spirit. The verse also says that we keep ourselves in the love of God when we speak in tongues. We do not have to ask for God's love because He gave it to us already. All we must do is stir up His love for us by speaking in the tongues. Isaiah 28:11-12 (KJV) says, "For with stammering lips and another tongue will he speak to these people. To whom he said, this is the rest wherewith ye may cause the weary to rest; and this is the refreshing: yet they would not hear." God wants to bring the strength and refreshment you need through speaking in tongues. I like to think of it as a fire in a fire pit. As the fire dies out, we need to stoke and stir up the embers. Before you know it, the fire is burning bright once again. Speaking in tongues does the same thing in the Spirit. Without using this gift, we risk defeat in temptation (see Appendix on the Baptism of the Holy Spirit).

Another way to resist falling into temptation is knowing your identity in Christ Jesus. When Jesus was tempted in the wilderness in Matthew 4 and Luke 4, one of the tactics Satan used with Jesus was doubt. Satan tried to make Him doubt who He was. Satan did the same things here with Adam and Eve. Satan told Eve she would be like God even though she was already made in His image. Eve was so blinded by what she desired that she didn't even realize this fact. She had completely forgotten where her true identity came from (Gen. 3:5). Jesus did not sin in the Garden of Gethsemane because He already knew who He was. He knew His true identity.

Getting back to identity, God wants us to know that our identity is rooted in Him. Your identity is not in your past, present, or future temptations or sins. If you are in Christ, you are a new creation! Satan is always prowling around like a lion seeking whom he can devour. He is looking for areas of weakness and insecurity where he can plant seeds of doubt in our minds. As we have heard before, our mind is a battlefield. When Satan tempted Jesus, it was as if he said to Him, "If You're really the Son of God, if what You heard from the Father in an audible voice is really true, then prove it, and turn this stone into bread" (v. 3). Turning a stone into bread was not a sin in itself. But it would have been a sin if Jesus had doubted the words of His Father by declaring who He was by placing more faith in a miracle. Don't you see? God is not only interested in healing your physical body and mind; He is interested in healing your spirit. We must know who we are if we want to overcome temptation and be healed. No matter what form Satan's temptations may take, they are all directed at causing us to doubt who we are and who God is. God says you are more than a conqueror; you are a child of God, a citizen of heaven, a royal priesthood, a son, and daughter of the Most-High!

Molding Moment

You cannot be tempted unless you first focus on an idea, desire, or want that burns within you. It starts with meditating upon that idea in your mind, and as we already know, your mind loves to think in pictures. This is your God-given imagination. Using your imagination is not wrong; it is a creative gift from God and a result of being made in His image, just as He has given you a voice. But as we know, we can use our voice to build up or tear down. It is the same with our imagination. We can use it for good or for evil. All temptation is linked to your mind and your thought process. What you feed your heart and mind will eventually make its way to your hands. Therefore, control your thoughts, and you will control temptation. This is a simple but profound truth. It's the reason most people fall into temptation. Philippians 4:8 says this, "Finally, brethren, whatsoever things are true, whatsoever things are honest, whatsoever things are just, whatsoever things are pure, whatsoever things are lovely, whatsoever things are of good report; if there be any virtue, and if there be any praise, think on these things." Temptations will come, but it is hard for the devil to deceive you when your mind stays on the things above. Satan can only work with what you give him, so do not give him any real estate in your mind. You will be able to avoid many of the temptations you face if you put this into practice. Verbally quote the Word of God. Wield your sword to slay the tricks of the devil!

Your thoughts are the determining factor as to whose mold you are conformed to. Control your thoughts and you control the direction of your life.

—Charles Stanley

Visual Journal & Creative Space

Expression #8

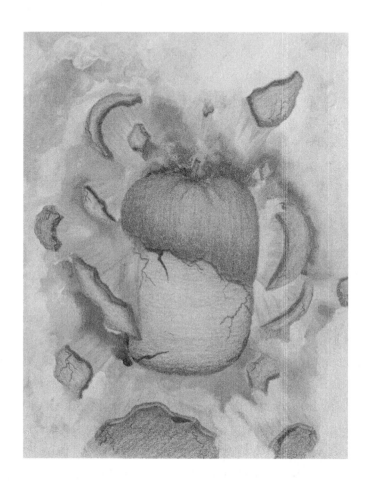

Then, after desire has conceived, it gives birth to sin; and sin,
when it is full-grown, gives birth to death.

—James 1:15

CHAPTER 6
BOOM!

"Then the eyes of both of them were opened and they realized they were naked" (Gen. 3:7). As soon as they stole the forbidden fruit by taking the lie of Satan on the inside, something immediately died. On the inside, their clay hearts exploded into hundreds of pieces that left them in a state of brokenness. The peace and oneness they shared with the Potter, not to mention each other, now felt unstable as a surge of anxiety began to manifest within their lives. They received what they desired. Their eyes were now opened to the knowledge of what was good and evil, and as a result, they had to come to terms with their nakedness. They were never uncomfortable in their own skin before, so why now? Fear and shame began to threaten the peace they had always known because of their foolish actions. By missing the bullseye of this testing experience, sin entered the world. As a result, humanity forfeited its God-given authority over to Satan. Not only this, but their relationship with the Potter and each other was now fractured. For the first time in history, the "Coolness of the Day" became a dreaded time of fear and anxiety for Adam and Eve. The holy and reverent fear they had for the Potter was replaced with carnal fear, which caused them to hide in gross anticipation of the Creator's response. The nightmare of what He said loomed in their minds. Would the Potter bring judgment? And if He did, what exactly would be the consequences? They waited in silence, but their minds were actively devising a plan to cover up the mess.

I always think about what it would be like if Adam and Eve had never sinned. It is easy for you and I to say, *I would've never given in to that sly Devil.* It is easy for us to look back, point our fingers, and allow our pride to get the better of us. If it were not Adam and Eve who made the wrong choice, it would have happened sooner or later by another. In scripture, we later see how Cain—one of Adam and Eve's sons—murdered his righteous brother, Abel. The curse of sin was already at work within our clay vessels. If we look at the metaphor of the armor, looking from the outside in, we can see that Adam and Eve did not use it effectively. They came too close to the tree they were warned about and flirted with danger. They also gave their ears to a foreign voice they had never heard before. This voice introduced them to an alternative method contrary to the Potter's plan, which was a complete lie. Eve responded to the serpent with God's command, but he twisted the command in his favor as Satan usually does. At any point, Adam and Eve could have called on the name of the Creator for help. But they chose not to. They secretly liked what they saw and heard, just as we do at times. Their guilt-ridden conscience waged war in their hearts as they continued to push the voice of truth into the back of their minds. They miss calculated their next move, shattering them into hundreds of pieces. After all, they were now given the alternative to be like God (which they already were). All around us, pride is at work. One must admit that we, too, have walked around with our problems, temptations, and situations with the sense of, "I got this." Pride is a lethal weapon, and unless it is dealt with ruthlessly, we can expect a sonic BOOM to rock our world.

When working with pottery, wedging is important to soften the clay. It is a process of constant pushing, rotating, and squeezing to make the clay soft. This process ensures that there

are no pockets of air left inside the body of the clay. I like to think of these "air pockets" as areas of pride within our clay walls. If the clay is not wedged properly and then left to thoroughly dry, these air pockets will remain hidden like landmines waiting for someone to take one false step. After the clay is dry, it is placed in the kiln (clay oven) for firing; followed by exposure to elevated temperatures with excessive pressure. The pressure builds up in these "puffed up" areas, and the ultimate explosion can result. This not only affects the individual clay but all the other fired vessels. One act of disobedience on our part has enough power to affect future generations; it gives birth to broken vessels, lives, relationships, and futures. Adam and Eve had no idea what was in store for them down the road and the ramifications of their disobedience. While the greatest tragedy of all time began to unfold, the ultimate redemption was already on the horizon.

Molding Moment

"For I know the plans that I have for you,' declares the LORD,
'plans for welfare and not for calamity to give you
a future and a hope.'"

—Jeremiah 29:11 (NASB)

You may not feel like God has a plan for your life based on your current circumstances, but He makes it well known that He does. If many of us had our way, we would want to know every detail of our lives. If there were something we didn't like, we would want to change or alter it. We would get our hands involved in governing our lives and most likely get ourselves into a deeper mess because of our pride. The Potter has a plan for each of us, and He is in complete control. We don't have all the details as to why certain things collide into our lives at specific times, but if we know Christ, we are in the safest place we could ever be. When the disciples were in the boat during the storm, and Jesus was sleeping despite the turmoil, the disciples were in the safest place they could ever be because Jesus was in the boat with them. Jesus tells us that His plans are for our welfare. Welfare? Wait a minute. God wants me to be on welfare? Yes! But it is God's welfare system. Welfare means "exemption from misfortune, sickness, calamity, and evil." It also means "enjoyment of life, prosperity, happiness, and well-being." [22] Who wouldn't want that? In God's economy, He desires for us to depend upon Him completely because He is our "Jehovah Jireh," our provider. He doesn't want us to

depend upon ourselves but fully lean upon Him. Pride in our flesh does everything to resist this. Pride says, "I don't need anyone's help. I got this." It is this attitude that leaves us open to impending danger.

We can never let the enemy lie to us and say that sickness, disease, injury, or addiction is part of God's plan for our life. It is not! God's plan exempts you from sickness and disease. He wants us to enjoy health and have peace within our vessels. God says His plan is not for "calamity." Calamity is misfortune, distress, adversity, and misery. This is not God's plan for your life. He says that you have hope and a future. Even if you feel as if your life has just blown up into hundreds of pieces, you must realize the Potter is planning ways to release you from your condition and repair your brokenness. Don't let the devil deceive you; don't let him lie to you and make you believe God doesn't care or your welfare is not His top priority. The devil is a liar. If there is sickness and pain in your body, it is from the evil prince of this world. God will always turn what the enemy meant for evil and turn it around for good to those who love God. He always turns messes into masterpieces.

I believe that the Creator of this universe takes delight in turning the terrors and tragedies that come with living in this old fallen domain of the devil and transforming them into something that strengthens our hope, tests our faith, and shows forth His glory.

—Al Green

Visual Journal & Creative Space

Expression #9

For my people have done two evil things: They have abandoned
me—the fountain of living water. And they have dug for
themselves cracked cisterns that can hold no water at all!

—Jeremiah 2:13

CHAPTER 7
THE COVER-UP

Human beings tried to make something of the world that the world could not produce. This is where culture oversteps its boundaries. Adam and Eve tried to use the world for more than it could ever be. They were replacing their relationship with God—the only trustworthy source of wisdom—with a created thing. It wasn't enough for Adam and Eve that their world was beautiful and good; they wanted to be self-sufficient. Humanity wants to be self-sufficient within God's world, which was never its purpose. They began to believe the lie that there would be no more waiting for the Creator to walk with them in the garden in the cool of the day, no more lengthy conversations, the long process of maturation, and education in obtaining wisdom. By taking the fruit and disobeying, the man and woman set into motion the process by which everything God had originally given as a gift—a sign of relationship and dependence upon Him—became twisted into a human right. They tried to develop something that would insulate them from needing a relationship or dependence on another. Adam and Eve felt great shame and nakedness, so they did everything to clean up their act. They borrowed the serpent's creative idea of camouflage and became masters of disguise. They desperately tried to cover up the wrongs they had done. In the spirit of pride, we see creativity used in their own strength and ingenuity as a new culture is born.

What is the first thing that happened after the man and woman had eaten and disobeyed God's command? Culture.

Adam and Eve took their God-given creativity into their own hands as they "sewed fig leaves together and made loincloths for themselves" (Gen. 3:7). They make something of the world to ward off their shame and sudden exposure to one another and God. Culture is instantly used negatively as a defense mechanism to ward off the biggest threat; the threat of being known, trusting a created creature in the garden and not the Creator Himself. They became so disillusioned that they believed they could fool the Potter by making coverings to hide their guilt and shame. Sewing together our manufactured and makeshift coverings will never suffice. Sure, I do not doubt that we can fabricate something that may last for a time, but it will never truly fix the brokenness deep inside. It only serves as a temporary bandage that will eventually fall to the ground and leave us broken once again.

Look at what masks have done in our present culture regarding COVID-19. In some instances, masks have hidden our facial expressions, silenced our voices, caused us to be more introverted, and led us down a path of isolation—particularly in the education system. As an educator of middle school students, this is a dangerous position. Masks may help prevent symptoms for a short time, but they are not the prescription to bring true healing. It only paints a false picture. Humanity prides itself in making good, camouflaged cover-ups, fake it until you make it ideology, and self-help remedies. When you have a deep cut, a bandage can only stop the bleeding for so long before the wound calls for the professional doctor to administer the remedy—stitches. The sinful, prideful nature of humanity says, *I don't want anyone to know my weakness or the struggles I am facing. I can do this on my own. I can fix this myself. I don't need anyone's help.* I believe Adam and Eve were not necessarily sorry for what they had done immediately.

Like most of humanity before salvation, our initial response is, "How can I get away with what I have done without being caught." This attitude keeps us from the true healing we seek deep down inside. Scripture says, "God resists the proud, but gives grace to the humble" (Jas. 4:6-7). Humility is one of the ingredients needed to cure us and the world.

Adam and Eve worked hard to create their hand-crafted garments to blend into the natural surroundings. Whether they realized it or not, they were in the process of creating a new culture. A culture of "covering up" the condition of one's tainted heart. They were learning how to cover their sins creatively. They hoped that the Potter simply wouldn't recognize them amongst the trees. How often have we thought we were all alone to commit our sin in secret? The four walls of a room or hiding among the trees is no match for an omnipotent and omniscient God of the universe. There is a way to cover one's sins, but it must be the remedy prescribed by the "Great Physician." When you go to the doctor for an ailment or sickness, the doctor will give you a prescription with specific directions to follow. I don't know about you, but I usually follow the doctors' orders when I go to the doctor. When receiving the prescribed medicine, you must follow the directions to avoid taking too much or too little, resulting in dangerous side effects. If we go to the doctor and plan on not following their instructions, it is a complete waste of time. Why go to the doctor in the first place? God has only one remedy to cover humanity's sins: believing in the death and resurrection of Jesus Christ, God's one and only Son—the Lamb of God. The blood of the lamb covers all our guilty stains.

We are very good at hiding and blending into the crowd. We truly have become "masters of disguise" like the Devil himself. We are masters at trying to cover up the guilt and

shame by transgressing from God's Holy laws. We put on all types of masks. Some of us may profess to be a follower of Jesus on Sunday, but our actions speak otherwise for the rest of the week. We are all like swine—who love to go back to the stinky mud hole and wallow in our sins after taking a bath. We know how to play the game and work the system. We try to get clean but with no success. We try to smell pretty, act as an angel of light, and play it cool, but we are all pirate rebels marked with death. We will try to use different methods to cover our shame and pain. We may hide under the cover of alcohol, drugs, sex/pornography, gambling, witchcraft, sports, hobbies, etc. Only you know what serves as a "cover-up" in your life. But God wants to remove all the masks and heal your vessel by His power and grace. There is only one who can bring transformation into your life. Trying to fix yourself with bandages of more knowledge, better behavior, try harder next time mentalities are all temporary fixes that repair one's brokenness. But true transformation can only occur when the Spirit cultivates an intimate relationship between a believer and the Creator. Don't allow the enemy to convince you to hide any longer and keep you in bondage. His Kingdom is all about freedom and liberty. Come out of the darkness and into His marvelous light!

Molding Moment

For true healing to unfold, we must stop hiding our sins and bring them before the Potter. Satan desperately wants us to keep our sins covered so we do not come to the Savior in repentance. He wants us to believe that it is ok to go on sinning and that there are no real consequences for our actions. He wants us to consider the lie, "We are only human, and God will understand. It is His fault for this sin problem." The more Satan can get us to cover up our sins, the deeper we will fall into a disillusionment that will cause us to drift from God's healing truth. As we believe this lie, our vessel continues to crack and break more and more. We continue to put on various masks and costumes to cover our guilt and shame, where we don't even recognize who we are. Sadly, we begin to lose our identity in Christ; we become whatever our society says we are as we exchange the truth for a lie.

I find it interesting that during the COVID-19 pandemic, students and teachers wore masks with various symbols, designs, and colors to visually express their interests and outwardly represent who they are personally. Face coverings try to mask our authentic voice and keep us silent. The outward "mask" is an attempt to "mask" us internally. I know there were times when I wanted to share something with another individual but remained silent because I thought to myself, *They aren't going to be able to hear me with this mask on anyway. What's the use? Don't even bother.* Satan has tried to silence our voices, but He will not succeed. God doesn't want us silent anymore! He wants us to stop hiding and come into the light of His truth.

He wants us to confess our sins before His holiness so that we may exchange our guilt and shame for a robe of righteousness and healing. Now is the time for action. Now is the time to refuse to be speechless. Instead, praise God even more. Storm the gates of Heaven with your cries for healing, deliverance, restoration, and repentance. The time is now!

Let us watch against pride in every shape—pride of intellect, pride of wealth, pride in our own goodness, pride in our own deserts. Nothing is so likely to keep a man out of heaven, and prevent him seeing Christ, as pride. So long as we think we are something, we shall never be saved.

—J. C. Ryle

Visual Journal & Creative Space

Expression #10

If I say, 'Surely the darkness will hide me and the light become night around me,' even the darkness will not be dark to you; the night will shine like the day, for darkness is as light to you.

—Psalm 139:12-13

CHAPTER 8
THE POTTER'S WALK

Based on Genesis 3:8, as God took His walk in the garden, His movement was tangibly made known by either a sound or a voice. Adam and Eve heard a "sound" made by the Lord. Whatever form God had taken in the garden was marked by a distinct sound production. God loved the intimate relationship He had with His creation, but the walk in the garden must have been challenging on this particular day. I can only imagine the thoughts that must have been streaming through the Father, Son, and the Holy Spirit. The triune God knew what had just happened and the sacrifice needed to solve the problem. In the same way, God knows everything that we think, say, and do. Nothing can hide from His sight. God must confront the sinner and issue a judgment for the wrongs committed in His sovereignty. Justice is only part of who He is. Walking through the garden, He saw what the future would hold. He saw the lamb in the thicket, the cross, and the promise of resurrection. He saw the forgiveness of sin, but there was only one remedy; life-sustaining blood. Some interpretations suggest that the idea of God walking in the garden refers to a *Theophany*. It is a word used to describe "an appearance of God in a tangible, human form." Theologians who believe this viewpoint may refer to Genesis 18, where God appears as one of three visitors to Abraham. The "cool" of the day translates to *Ruach*, meaning "spirit, breath, and wind." This force may have been a strong wind blowing in the garden that frightened Adam and Eve. As God made His approach in the garden, it could

have been a strong wind that shook the trees. This may have been another reason for them to hide. One can only imagine, but God "called" or "summoned" Adam to face judgment. [6] An observation like this is not foreign in scripture. If we fast forward thousands of years later and look at Acts chapter 2, the Holy Spirit came, preceded by the sound of a violent wind. God also spoke to Job out of a whirlwind in Job 38:1. Here we see God manifesting Himself through something He made—wind. God always speaks to us one way or another. It may be through scripture, prayer, worship, creation, a friend, a pastor, a dream, a vision, or art. As God called out to man, "Where are you?" everything within their flesh tried to keep them silent, but they had no choice; they had to respond to the concern of their Father's voice. [20]

Humanity had a beautiful walk with the Creator before making the costly choice to sin against God's command, yet amazingly, He still desires to do so today. He continues to walk down the beaten paths of the created world. Despite the circumstances of our lives, He offers each one of us permanent healing and redemption. Because the forgiveness plan extended to all generations, we can walk with the Potter in fellowship. I have been walking with Christ daily since I was a child, and my relationship with God has been beautiful despite all my faults and shortcomings. Remember, out of all the places God could dwell, He chose His dwelling place to be you and me (1 Cor. 3:16). He is always ready to walk with us hand in hand when we respond with an open heart, humble spirit, and a posture of repentance.

Molding Moment

So then, each of us will give an account of ourselves to God.

—Romans 14:12

One way or another, we will all have to respond and give an account for our lives (Rom. 14:12), whether we have done good or bad. There is no hiding what we have done from an all-knowing and all-powerful God. The Potter desires us to humble ourselves before Him, be honest, and be truthful. Every moment of the day, people are transitioning from this earthly life to their spiritual eternity. Jesus, Himself will also be returning soon, "like a thief in the night," to bring His faithful church home.[13] We must be ready spiritually, watching, and praying. God says, "If we confess our sins, He is faithful and just and will forgive us and purify us from all unrighteousness" (1 Jn. 1:9). God wants to breathe the life of His Spirit (*Ruach*) afresh upon you just as He did back in the garden.

*The Christian Gospel is that I am so flawed that Jesus had to die
for me, yet I am so loved and valued that Jesus was glad to die for
me. This leads to deep humility and deep confidence at the same
time. It undermines both swaggering and sniveling. I cannot feel
superior to anyone, and yet I have nothing to prove to anyone.
I do not think more of myself or less of myself.
Instead, I think of myself less.*

—Tim Keller

Visual Journal & Creative Space

Expression #11

Whoever conceals their sins does not prosper, but the one who confesses and renounces them finds mercy.

—Proverbs 28:13

CHAPTER 9
CAUGHT IN THE ACT

Adam probably made like nothing had happened as he emerged from the dark cover of the trees into His marvelous light. At the feet of the Potter, Adam hoped that He wouldn't have noticed a change in him. But Adam and Eve were both marked with a symbol of death because of their actions. It was hard to keep the broken clay pieces inside of them from rattling like a runaway train. The Potter stared down at them with piercing yet loving eyes, clearly seeing right through them as transparent glass. The Creator stood there gazing at His creation as Adam broke the silence, "I heard you in the garden, and I was afraid because I was naked, so I hid" (Gen. 3:10).

Scripture tells us that in Genesis 3:7, "The eyes of (Adam & Eve) were opened, and they knew that they were naked." The interesting thing is that no one specifically told them they were naked. They were created naked yet were innocent and unashamed. Scripture also gives us some clues that they were clothed in the marvelous light of God's glory before the fall. Psalm 104:2 says, "You are dressed in a robe of light as with a garment, stretching out the heavens like a tent" (ESV). We also see a "clothed in light" reference when Jesus is transfigured in Matthew 17. "There he was transfigured before them. His face shone like the sun, and his clothes became white as the light" (v. 2). So, what happened? Who said they were naked? Taking advantage of Eve's lack of precision with God's Word, the serpent takes this vulnerability to his advantage by persuading the couple to trust in their evaluation and understanding

of what is good. In doing so, he then encourages them to take the fruit and eat it. The term "naked" used in Genesis 3 is the Hebrew word, *Erom*. It means "unclothed" or "nakedness." But this word can mean more than unclothed. This word carries the idea of being guilty, exposed, and vulnerable to God's judgment (see the similarity in Deut. 28:15). Adam and Eve realized that their nakedness went far beyond being unclothed. They both knew they were guilty of breaking God's command and are now under God's judgment. Think about it. When someone robs a bank and there is a warrant for their arrest, what do they do when they hear police sirens? They run and hide. Why? Because guilt and condemnation drive them to cover their wrongdoing. Adam and Eve's nakedness exposed their guilt before God, which resulted in judgment, condemnation, and ultimately death. Man, like God, was wrapped in His marvelous light before the fall. But when sin entered the world, darkness followed, and the light was exchanged for flesh; a nature opposite of God, who is spirit (Jn. 4:24). By the sin of the first Adam, we are all born as children of "flesh," sinful, and carnally minded. They were caught in the act and now had to face the truth.

Molding Moment

*Whoever conceals their sin does not prosper, but the one who
confesses and renounces them finds mercy.*

—Proverbs 28:13

Deep down inside, we all know we are sinners and deserve
punishment, so we try to avoid a Holy and just God. Because
of our guilt and shame, we would much rather confess our
wrongs to someone other than Him. When we feel sick, we
would much rather go to a doctor than go to God. We tend
not to feel guilty before the doctor because he is not our
judge. But the truth is, we are all guilty before God. This guilt
can cause significant stress in our physical bodies, leading to
sickness. Guilt is a sickness that can spread to all areas of our
lives and the lives of others. We try to do everything we can
to be free from it. We may deny it, suppress it, push it onto
others and even perform religious duties to dissolve it. This
guilt is a stumbling block that keeps us from getting to God's
throne. But He provided a way to eliminate our guilt and save
us from the penalty of sin. This gift from God is eternal life!
This means that we have access to healing in our bodies and
within our whole being. By removing our guilt, God can free
us from all sources of stress so we can be healed spiritually,
emotionally, and physically.

God does not eliminate guilt in our lives just by giving us
a free pass and forgetting what we have done. This would not
make Him a righteous and just God. A Holy God cannot let
sin go unpunished. Just as a good judge cannot let one guilty

of a crime go unpunished either. But through His excellent, loving care for you and me, He allowed the punishment to fall upon the shoulders of someone else—the scapegoat—His son, Jesus Christ. "But God demonstrates His own love towards us, in while we were still sinners, Christ died for us" (Rom. 5:8).

Self-righteousness is the devil's masterpiece
to make us think well of ourselves.

—Thomas Adams

Visual Journal & Creative Space

Expression #12

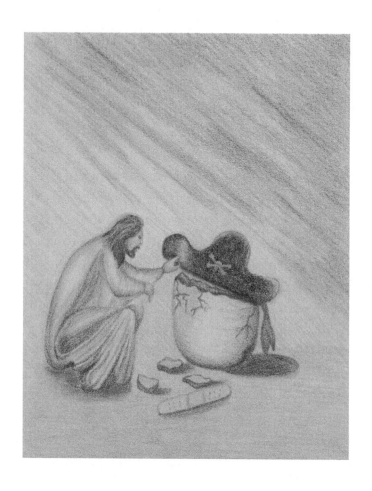

For all that is secret will eventually be brought into the open,
and everything that is concealed will be brought
to light and made known to all.

—Luke 8:17

CHAPTER 10
THE MOMENT OF TRUTH

What a sobering scene this must have been, as many emotions were portrayed between the Potter and His chosen vessels. I can imagine the Potter slowly kneeling in front of them with His divine light shining into every dark corner of their vessels. His warm light—like a microscope—inspected and exposed all the enemy's lies, revealing the absolute truth. He knew exactly what happened, but He wanted His creation to confess and lay bare their wrongdoing. Then He said with His loving yet powerful voice, "Who told you that you were naked? Have you taken the fruit from the tree that I commanded you not to eat from?" (Gen. 3:11). I imagine the Potter being a good physician at this moment, carefully removing Adam and Eve's hand-made coverings, which revealed the total damage their choices produced. He removed some of the broken clay pieces and inspected the many cracks on their vessels. The Potter was saddened. I can imagine Him saying, *Oh my, what have you done?* Adam could have given God a straightforward and honest answer. Still, due to the condemnation he felt inside, along with the covering of sin elevating his conscience to a new level, the "blame game" began. When you look closely at what just occurred, Adam first blames the Creator for his wrong choice and then blames his wife, Eve. Adam says, "The woman you put here with me —she gave me some fruit from the tree, and I ate it" (v. 12). Eve then places the blame on the deceiving serpent. After the blame game, God addresses the woman to hear her side of the story. "What is this you have done?" The

woman said, "The serpent deceived me, and I ate" (v. 13). This has been a problem for humanity since the beginning. Instead of assuming responsibility for our behavior, it is easier to point fingers and pin the problem on someone else. Many times we assign blame to our issues without changing our behaviors. Only when a person identifies, admits, and takes responsibility for their sin is there hope for renewal and healing. But none of this was news to God. We are all unqualified, and our imperfection (sin) would lead the Potter to display His love for the clay. As a result of our fallen nature, we are all prone to wander from God and blame others for our wrong actions.

The Potter peered off into the distance staring at a tree. But it wasn't the *Tree of Life* or the *Tree of Knowledge of Good and Evil*; it was another tree that would be the tool for demonstrating primary redemption through faith, hope, and love for all creation. He knew what the future would hold for Him. I can imagine the Potter picking up a few broken shards of his handiwork while quickly making his way to the middle of the garden. Adam and Eve must have thought to themselves, "That serpent is going to get it now!" The Creator was on a rescue mission. He was like a father, ready to meet the enemy who hurt his beloved child.

Molding Moment

God laid upon Jesus Christ the punishment we all deserve for sin. For a moment, on a rough wooden cross, God allowed the world's sin to be placed on Christ's shoulders. He was sinless and didn't deserve this terrible punishment because He had done nothing wrong. God didn't allow sin to bind Him forever. But God raised Him from the dead (Acts 4:10). Sin does not go unpunished. So, the question is, *Would you accept the punishment you deserve, or would you rather have someone else take the punishment for you? Would you let someone else pay your debt?* In your pride, you might be tempted to say, "Absolutely not. I will accept the punishment and pay my debt." Some may let the willing person pay the debt, while others may want to be a hero and pay the debt for selfish gain. But in reality, just because you are doing something good for someone else doesn't guarantee your forgiveness. Remember, you are still a sinner, and sin must be punished justly. No one is "good" in the world because of the sinful nature embedded in the fabric of our being. There is only One who is sinless, and His name is Jesus Christ. Only by His work—it is His sacrifice—that provides you with the eternally acceptable payment for sin. It is only by His stripes that can make you whole. [15]

You can base your identity on a thousand things; the degrees you've earned, the positions you hold, the salary you make, the trophies you've won, the hobbies you have, the way you look, the way you dress, or even the car you drive. But if you base your identity on any of those temporal things, your identity is a house of cards.

There is only one solid foundation: Jesus Christ. If you find security in what you have done, you will always fall short of the righteous standard set by the sinless Son of God. The solution? The gospel. There is only one place in which to find your true identity and eternal security—what Christ has done for you.

—Mark Batterson

Visual Journal & Creative Space

Expression #13

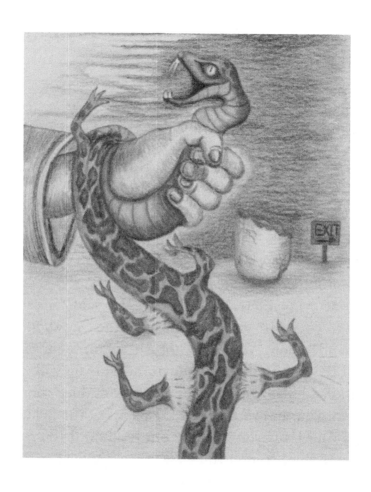

*I am the L*ORD *who exercises loving kindness, justice and*
righteousness on earth; for I delight in these things,
*declares the L*ORD.

—Jeremiah 9:24

CHAPTER 11
JUDGMENT

With a powerful outstretched arm, the Creator said to the serpent, "Because you have done this, cursed are you above all livestock and all wild animals! You will crawl on your belly and you will eat dust all the days of your life. And I will put enmity between you and the woman, and between your offspring and hers; he will crush your head, and you will strike his heel" (Gen. 3:15). To the woman, He said, "I will make your pains in childbearing very severe; with painful labor you will give birth to children. Your desire will be for your husband, and he will rule over you" (v. 16). To Adam, He said, "Because you listened to your wife and ate fruit from the tree about which I commanded you, 'You must not eat from it,' cursed is the ground because of you; through painful toil you will eat food from it all the days of your life. It will produce thorns and thistles for you, and you will eat the plants of the field. By the sweat of your brow you will eat your food until you return to the ground, since from it you were taken; for dust you are and to dust you will return" (v. 17-18).

The Lord God made garments of skin for Adam and his wife and clothed them. "And the Lord God said, 'The man has now become like one of us, knowing good and evil. He must not be allowed to reach out his hand and take also from the tree of life and eat and live forever.' So, the Lord God banished him from the Garden of Eden to work the ground from which he had been taken. After he drove the man out, he placed on the east side of the Garden of Eden cherubim and a flaming

sword flashing back and forth to guard the way to the tree of life" (Gen. 3:14-24).

Wow. There is much we can learn from the judgment of God. Our Creator is a God of great mercy and justice. The job of a judge is not easy. A good judge must punish individuals who break the law and do wrong things. Their job is to hear a case from both parties, enforce the given laws, and administer a judgment for the crime committed. We can't get mad at those for doing their job and upholding the law. Instead, we would say that they are excellent judges. No one likes or wants to be punished, but that's why we need to be wise and think before we make our choices. We must ask ourselves, *How will this imminent decision affect me and others?* Remember, every choice we make has a positive or negative repercussion in the present moment and far into the future generations. The choice that Adam and Eve made created a fracture that seemed unrepairable. God did what Adam and Eve always saw Him do; He did what was just. The Potter kept His word no matter how difficult the situation.

In verses 14-15, the Lord proclaims judgment on Satan and proclaims his destruction (crushing) by the second Adam (Jesus, Yeshua) who would come through a woman (the virgin Mary), yet He will receive a "strike" to the heel (Jesus wounded and pierced). Satan's fate was made final through this first spoken prophecy in Genesis. He was punished once by being cast out of heaven, but now, his days are numbered due to God's judgment. When the end comes, he will be punished for eternity. A time is coming very soon: "The devil, who deceived them, was thrown into the lake of burning sulfur, where the beast and the false prophet had been thrown. They will be tormented day and night forever and ever" (Rev. 20:10). Satan is our defeated

foe and has no power over you if you are connected to the One who defeated him. [1]

The judgment pronounced for Adam and Eve was difficult to bear. For Eve, her childbearing would be marked by pain, and her husband would rule over her. For Adam, since he immediately listened to his wife without questioning her or inquiring of the Lord, the ground became cursed. This meant the fruitful and pain-free work he enjoyed would now become difficult. As the Potter had mentioned from the beginning, their physical body would experience the sting of death and return to the dust from which they came. This death was physical and spiritual separation from His presence. Adam and Eve were once clothed in light, but it was now removed due to their choices. Their glory and honor were forfeited over to the darkness when He wanted to crown them with favor like a shield. The Creator could have destroyed His vessels right then and there in the garden, but He didn't. Even though we became "enemies of God," He still showed them His mercy and love by doing something unprecedented. It says that "The Lord God made garments of skin for Adam and his wife and clothed them" (v. 21). Do you realize the significance of what just happened? The Creator sacrificed one of His loved creations (most likely a lamb) and crafted "garments of skin" and clothed them. This was a great sign of God's faith, hope, and love for Adam and Eve and the entire world!

Adam and Eve worked hard at crafting their own garments to fix the problem; it was smart, sophisticated, and ingenious from the world's perspective, yet far from sufficient from God's point of view. Because of these choices, "The wages of sin is death, but the gift of God is eternal life in Christ Jesus our Lord" (Rom. 6:23). From the beginning, the price to be paid to forgive one's sins is life-giving blood. Adam and Eve learned that there is a high price for disobedience. From that

day forward, their minds were forever stained with the images of sacrifice; their bodies were now sufficiently covered by the skin of a once-living creature—a pure, spotless, and innocent lamb that willingly died in their place. [31] As it is recorded in Hebrews 9:22, "And according to the Law almost everything is cleansed with blood, and without the shedding of blood there is no forgiveness [neither release from sin and its guilt, nor cancellation of the merited punishment]" (AMP).

After they were clothed, the Lord said, "The man has now become like one of us, knowing good and evil. He must not be allowed to reach out his hand and take also from the tree of life and eat and live forever." So, the Lord God banished him from the Garden of Eden to work the ground he had been made from. After he drove the man out, he placed on the east side of the Garden of Eden cherubim and a flaming sword flashing back and forth to guard the way to the tree of life" (v. 22-23). The last part of their punishment seems very harsh but was necessary. Adam and Eve were now marked with death. If they could remain in the garden, they could have had the opportunity to eat from the *Tree of Life* and live forever. If God allowed this to happen, we would be forever doomed in our sinful state with no way of escape or hope of redemption. Out of God's abundant mercy and grace, knowing humanity's weakness, He removed Adam and Eve from the garden to avoid the temptation to eat from the tree of life. And as you can see, He took extreme precautions to prevent such an event: "After he drove the man out, he placed on the east side of the Garden of Eden cherubim and a flaming sword flashing back and forth to guard the way to the tree of life" (Gen. 3:24). Our eternities were at stake, and desperate times call for desperate measures. God has always been for us; His love, mercy, and grace are forever abounding. But to receive this gift, we must

personally choose to accept it by our own will. We must learn to obey God's commands even when the circumstances don't make sense. "I am the Lord who exercises loving-kindness, justice, and righteousness on earth; for I delight in these things," declares the Lord (Jer. 9:24).

Molding Moment

Jesus did not die for Himself. He died for the sins of every guilty man, woman, and child who ever lived or will live on the earth. He already suffered the punishment for your sins; therefore, there is no other debt that needs payment. He gave His one and only son to die in our place so we would not have to die. God loves you and wants you to live with Him forever in heaven. He eliminated our guilt by providing us the opportunity to simply believe that Jesus paid the penalty for you and me. Romans 10:9 says, "If you confess with your mouth Jesus as Lord and believe in your heart that God raised Him from the dead, you will be saved." You and I can now have the confidence to know we are no longer guilty. We are guilt-free. This confidence is not self-confidence as it was in the garden, but our confidence can now be entirely placed in the One who saved us, our high priest—Jesus.

Just as we have been forgiven, we must also let go of any unforgiveness within our hearts. Healing can only manifest itself completely in our lives when we fully forgive ourselves—and others—over past offenses and hurts. The only one who suffers from unforgiveness and bitterness is you; it will only breed sickness physically, spiritually, and emotionally. The Potter is unable to fix a pot that is willingly harboring unforgiveness. Just as the Potter has forgiven us for ALL of our crimes, we must freely forgive others. Forgiveness heals us from the inside out. God made a way to clothe our nakedness and crown us with His glory. He is the *One* who makes us holy, heals, and sanctifies us. He is the *One* who is our light

and our shield. Because of this, we are far above every power of darkness. We may have lost God's Glory in the garden for a time, but through Jesus, we have the remedy to take back the Glory that is rightfully our inheritance as sons and daughters of the King.

> *Brothers and sisters, I do not consider that I have made it my own yet; but one thing I do: forgetting what lies behind and reaching forward to what lies ahead.*

—Philippians 3:13 (AMP)

Visual Journal & Creative Space

Expression #14

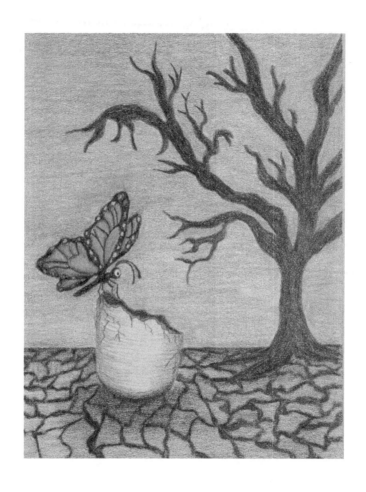

*You, God, are my God, earnestly I seek you; I thirst for you,
my whole being longs for you, in a dry and parched land
where there is no water.*

—Psalm 63:1

CHAPTER 12
HOPE IN THE DESERT

Is it true that the riches of life are found in a desert? Can they be found in a place of extreme heat, loneliness, and difficulty? According to the scripture found in Hosea 2:14-15, it can be. God says, "I am going to allure her; I will lead her into the desert... There I will give her back her vineyards." Yes, God knows our need for a desert experience. He knows exactly where and how to produce enduring qualities within us. The person who has been adulterous, idolatrous, has been rebellious, has forgotten God, and has said with self-will, "I will go after my lovers (v. 5), will find their path blocked by God. She will chase after her lovers but not catch them; she will look for them but not find them" (v. 7). Once she feels hopeless and abandoned, He will lead her into the desert and speak to her tenderly. It is the same with us and our sinful nature. The desert experience is necessary for a successful life in Christ. God leads us into complicated and difficult places at times, but it is in this very place I realize I am where an eternal fountain lies—the fountain of hope.

A scripture found in the Bible states how an absence of hope can lead to emotional and physical sickness. It is found in Proverbs and says, "Hope deferred makes the heart sick, but a longing fulfilled is a tree of life" (Prov. 13:12). Yahweh is a God of hope! As your hope grows, reflect on the hand of the Almighty working on your behalf in the past, present, and future circumstances. As Paul wrote, "And we know that in all things God works for the good of those who love him, who have been called according to his purpose" (Rom. 8:28). As

we learn to look for God, we'll often see His hand in our life circumstances. These are not just happy accidents that occur regularly. For example, you accidentally ran into someone you know in the least expected place. On your way to work, you "happened" to take the wrong exit to learn later of a deadly accident that took place up ahead. Maybe you received a check in the mail just before a huge bill was due to be paid. Maybe your ski equipment was stolen on your vacation as you were inside having lunch (this happened to me) that may have thwarted a major ski accident on the slopes. We must look at these as not just "coincidences" but the hand of a loving God at work in our lives. Psalm 37:23 says, "The steps of a good man are ordered by the Lord." This means that even the unexpected detours, turns, and stops as we travel on the road of life have a purpose. God doesn't just oversee history as it unfolds right before our eyes, but He also supervises every detail in the lives of His vessels.

The new land Adam and Eve found themselves in was dry, hot, and seemed fruitless. The good Potter was right; life was going to be difficult, and going back to the garden sounded good at that very moment. But they couldn't return, nor would their emotions allow them to. They were utterly hopeless and lost. It was as if their clay vessels were cracked, broken, and empty, no longer useful for the Potter's service. [18] They struggled to hold onto hope as they navigated feelings of guilt, shame, and condemnation. Their conscience was activated because they disobeyed God's command in the garden, and the enemy's lies were intertwined with the truth. If they hadn't disobeyed, they would have never had to walk around with such a heavy burden upon their backs. Our burdens are always meant to be light despite the trials we face. We are never to bear the weight of the burden ourselves. It is a constant

war—a daily battlefield within the mind. But God gave them hope. Matthew 5:45 reveals God's great love and kindness by saying, "He causes his sun to rise on the evil and the good and sends rain on the righteous and the unrighteous." When we face difficult moments, we must remember how God worked on our behalf in the past. This will help build a new surge of security within us in our lives. Take King David, for instance. He started as a shepherd who faced a series of tests that built his faith. He fought off lions and bears from devouring his beloved sheep in the pastures. Because of his prior experiences with trusting God at monumental moments, David had the faith, security, and hope needed to defeat the giant, Goliath, who threatened his people. He had the victory, and so can you!

When my family and I were hiking on a camping trip in Massachusetts, we explored a rocky and rugged area. There, I was amazed to find a healthy tree growing out of the face of the rock. The seed, blown by winds of adversity, found itself in a rock in a hard place. It seemed hopeless, but a miracle sprouted in a place of difficulty. It struck me with awe as it became such a symbol of hope! This incredible experience in the rough terrain reminded me of how life can seem hopeless and hard even for the believer in Jesus. Troubles can seem insurmountable, and like the cries of the psalmist David, our prayers sometimes seem to go unnoticed, "Hear me, Lord and answer me, for I am poor and needy" (Ps. 86:1). But David goes on to share that we serve a "faithful" (v. 11), "compassionate and gracious God" (v. 15), "who abounds in love for all who call on Him" (v. 5). "He does answer" (v. 7). Sometimes, God reveals that nothing is too difficult for Him in the barren and hardened areas of our lives, and no one is ever too difficult to reach. Even as we patiently await the day of His return, we can experience God's deliverance out of our "desert experience."

May we join the psalmist in proclaiming, "You are great and do marvelous deeds; you alone are God!" (v. 10).

Learning to see God's hand of providential influence in our past and present gives us hope for the future. In the uncertain times of Adam and Eve, as it is today, our ways are never hidden from Him, who orders our steps and the unexpected stops. Even frightening global events that scripture predicts are no cause for alarm deep in the soul of the Christian. Our attitude about the future should overwhelmingly be hope! I encourage you to read Luke 21. In this chapter, Jesus describes the end-time events that will take place. His description of the world's end gives us hope by sharing, "When these things begin to take place, stand up and lift your heads, because your redemption is drawing near" (v. 28). We cannot live in fear of the bad when we have such a good Father who has our back. We must learn to trust Him in everything and give Him thanks in all circumstances. This will give us peace about what lies ahead. We can have the assurance that we will see God move actively on behalf of His children, regardless of what may come our way, because ultimately—He is already there (Read Ps. 20). Adam and Eve had hopes of a new garden and a new order. They had hopes of forgiveness and restoration in their relationship with the Father. All creation longed for a savior, but when and how could this be done? One creature served as a symbol of hope for Adam and Eve in the wilderness; a creature that fluttered around them day after day—the butterfly.

We learn so many lessons from science and God's creation. Science is meant to prove the existence of God and the wonders of creation's intricacies—never disprove it. The purpose of science is to reveal the glory of God, which should lead us into the posture of praise and worship to the One who does all things well in a spirit of excellence. The many processes we

see in God's creation teach us many spiritual truths mirrored in our own lives. For the butterfly, the amazing process of metamorphosis teaches us powerful truths with rich spiritual application. This transformation is packed with the hope of a brighter future for you and me! If we study each step during metamorphosis, we will learn God's perfect truth and the foreshadowing of salvation if we are willing to hear it. [16] You are still the Potter's treasure no matter what you have done or where you are in life. Inside you might be thinking to yourself, *How is that possible? How could there be hope for me even with all my wrongs?* You don't see a butterfly when you look at a caterpillar, but God does. He always has the finished masterpiece in the forefront of His mind. If butterflies could speak of their testimony, I am sure we would have much in common. We might hear something like: *I felt hopeless once, too; I didn't always look as grand. I was just a creepy-crawly caterpillar. Then I became entangled in a tight cocoon that felt like an eternity. I was trapped, inundated with my thoughts, ideas, and emotions. I was alone and felt useless. I thought my life was over, but I had a choice to make, which would cost me something. Did I want to stay the way I was, or did I want to change? My faith grew and grew inside that cocoon. Then something miraculous happened that was beyond my comprehension. I began to grow wings. I was transforming into a butterfly! After increased faith and strength, I could break out of that cocoon. I was a new creature. I was a modern-day Transformer as I learned that I could now fly!*

By the first Adam, sin and death came into the world. But through the death of the second Adam (Jesus, Yeshua), we can be reborn as children of "light" (1 Thess. 5:5). Jesus, the Light of the World, also calls you and me to become the world's light (Matt. 5:14). How can we accomplish this? We do this by putting off our old self and being renewed by the

Spirit (Eph. 4:22-24). You put off the old "caterpillar" body and exchange it for a new, "super" body with wings capable of soaring to new heights. This process is happening in our own lives right now, but we must be honest and repent for what we have done in the past, receive and release forgiveness in the present, and expectantly look to what lies ahead in the future. There is hope for you and me—the clay. Butterflies are living proof of that change. A great treasure lies ahead of us if we seek, find, and accept it. Hope plants seeds of good news deep down within our clay vessels. The Potter is speaking life to us again, just like He used to in the garden. It is as refreshing as Adam and Eve's long walks in the coolness of the day. As we go about each day of our lives with this knowledge, I pray we will see our situations through the lens of God's hope instead of hopelessness and despair. May we see our fight not against flesh and blood, but the unseen enemy that seeks to destroy those who serve Him. May we have the faith to believe that our mighty God can break the power of sin through His love. Have you yet to see God's greater purpose for your life? Maybe you are waiting for healing to take place physically or emotionally? Have you been waiting for a dream or vision to come to pass but have no idea how? Have you given up on God's desire to use your life and talents for a greater purpose? God's message to you is: *I am not done yet.*

Molding Moment

Through the desert experiences in our lives, we can come to the end of ourselves, look up to heaven, and cry out for help. There is no telling how long this desert experience must go on, but the faster we submit our will unto God, the faster we will become all that the Potter has called us to be. Be encouraged. He is bringing you to the moment you have been waiting for. His deliverance is already upon you. Your healing is already purchased, and the battle is already won! Put your faith and confidence in the One who loves you unconditionally. Remember, to receive all that God has, you must acknowledge your sins. You must accept and believe in the sacrifice of Jesus Christ as full and final payment for your sins. You must allow God to free your conscience of all guilt by receiving forgiveness. And you must be willing to cooperate with God's work in your life. As we do these things, God will give us victory.

Choosing hope reminds me of the prophet Micah. He, too, faced a very dire situation. The Israelites had turned away from God, and there seemed to be not one "upright person" within the land (Mic. 7:2). Micah had many reasons to lose hope, yet he refused. I love this prophet because he trusted that God was at work even though he couldn't see it with his physical eyes. Even amongst all evil and negativity, he put his hope in the Lord. Our hope in God is never wasted (Rom. 5:5). A time is coming when there will be no more mourning or pain (Rev. 21:4). Continue to rest in the Potter, confessing, "My hope is in you" (Ps. 39:7). I encourage you to read and meditate on Psalms 20. It is a psalm of victory that will fill

your vessel with great hope. "May the LORD answer you when you are in distress; may the name of the God of Jacob protect you. May he send you help from the sanctuary and grant you support from Zion. May he remember all your sacrifices and accept your burnt offerings. May he give you your heart's desire and make all your plans succeed. May we shout for joy over your victory and lift our banners in the name of our God. May the LORD grant all your requests. Now, this I know: The LORD gives victory to his anointed. He answers him from his heavenly sanctuary with the victorious power of his right hand. Some trust in chariots and some in horses, but we trust in the name of the LORD our God. They are brought to their knees and fall, but we rise up and stand firm. LORD, give victory to the king! Answer us when we call!"

Allow your dreams a place in your prayers and plans. God-given dreams can help you move into the future He is preparing for you.

—Barbara Johnson

Visual Journal & Creative Space

Expression #15

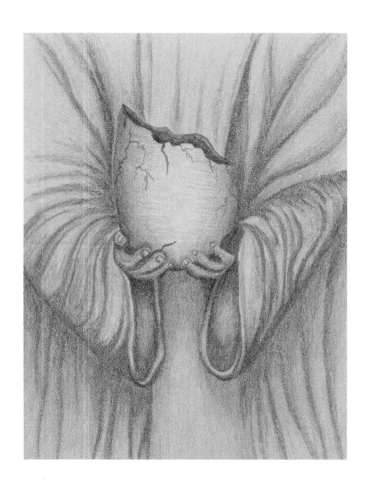

For the Son of Man came to seek and to save the lost.

—Luke 19:10

CHAPTER 13
LOST & FOUND

Much time had passed in the wilderness as Adam and Eve became used to doing things their way. The sinful nature continued to grow and fracture all of creation. They suffered personal loss by the severe effect of sin, as it manifested through the lives of their children, Cain and Abel. Genesis 4 tells a story of rebellion, judgment, and grace. Abel was a shepherd, and Cain was a farmer. When the time came to offer a sacrifice unto the Lord, Abel brought the best of his flock, and Cain brought the fruits from his harvest. We learn that God looked with favor on Abel's sacrifice but rejected Cain's. Cain became very angry. Scripture shares God's response to Cain's anger in Genesis 4:6-8, "Why are you angry? And why do you look so despondent? Don't you know that as long as you do what is right, then I accept you? But if you do not do what is right, watch out because sin is crouching at the door, ready to pounce on you! You must master it before it masters you." They were reminded by their skins and the institution of animal sacrifice that there is a high price for disobeying the Law. The consequence of breaking the law (sin) demands death, death of the individual, or the life of another to take their place. This was a painful reality that continued to plague their lives. Cain knew what the law required; a sacrifice that came from the willingness of his heart to give his best. That is what God wants from you and me—our best.

We sometimes accept everything the way it is. Our clay hearts slowly harden as we wander in the blazing desert sun.

Nothing quenches our thirst, and when times are truly desperate, we may long to turn back to the dust. At our wit's end and at the point of being unable to go on any further, a still small voice calls out to us from afar. It calls out to us not once, not twice, but three times as we hear our name summoned: *Turn yourself around, follow me, and I will restore you. I will make you a new creation.* In the distance, a figure stands as bright as the sunrise—it's the Potter! He stands with a satchel across His chest with His staff in hand. His hair is windswept with the dust of the desert sand. We are shocked and speechless; He must have traveled far across the land and the sea. He is like a shepherd who left the 99 to find His one lost sheep. Can you believe He would travel this far just for you, even after all the wrongs you had done? From a long way off, the Potter sees us. Filled with compassion, He runs over and wraps his arms around us with a warm embrace. For so long, we may have envisioned this very moment. With a broken and sincere heart, we must approach Him with reverence and repentance. It's true; we are not worthy of being called His chosen vessels. But the one who calls out to us, "Come to Me all you who are weary and heavy laden, and I will give you rest" (Matt. 11:28), is worthy. We are broken and disobedient works of art, no longer worthy of being used in His service. But He kneels in front of us, smiles, and says, *I forgive you.* He then picks us up in His arms as we begin the long journey home. We no longer carry the heavy burden of what we have done. He is the one who is now carrying us. We have been forgiven. We can be free! Let the Prince of Peace embrace you as you have never felt Him before. With open arms, He accepts and does not reject you. At this very moment, let us remember the butterfly, a beautiful example of hope and transformation. A new day is about to dawn as we view it through the eyes of faith.

Many times, we wander from God and His paths of righteousness. But the Potter's heart always looks towards restoration. He desires to restore our thirsty souls and bring us back into His fruitful ways of righteousness. God is near the wanderer in the desert and is always prepared to meet us on the dusty road. The road back home can seem long and arduous. When God led the Israelites out of Egypt (Ex. 13:17-18), He chose a longer route through the desert. The people complained during this time, but the Potter knew exactly what He was doing. Little did they know that the "shorter" route to Canaan was filled with danger from their enemies. This longer journey also gave them more time to strengthen themselves physically, mentally, and spiritually for future battles. Remember, our comfort is not always at the top of God's priority list, but your faith and trust is. The shortest distance traveled isn't always the best. Sometimes, God lets us take the long road in life to prepare us for the journey and the molding process ahead. The most beautiful part about this journey and the relationship between the Potter and His clay is that He is the burden bearer. He carries us all the way home, even with our cracks and bruises; He carries all our baggage and the weight of our sin. He calls us to cast our cares upon Him because He cares for us. He tells us in Isaiah 53:6, "All of us like sheep have gone astray, each of us has turned to his own way; but the Lord has caused the iniquity of us all to fall on Him."

The Creator of Covenants

Since the beginning of time, God has had a creative covenant process in the making for humanity. In English, the word covenant has roots in a Latin word that means "coming together." The Old Testament covenants demonstrate God's

loving, creative plan for redemption. The future nation of Israel was a monumental part of that creative artistry, but the covenants first came to God's chosen vessels. Yet, some conditions had to be met by those involved. First, God made a covenant with Abraham.[1] In Genesis 12:1, God told Abram to leave his country and go to the land that He would show him. In Genesis 12:2-3, God tells Abraham, "I will make him into a great nation and I will bless you...and all the nations of the earth will be blessed through you." After repeated promises of God's covenant, Abram began to believe. Abram "believed the Lord, and he credited it to him as righteousness" (Gen. 15:6). Abram was in his seventies at that time. When he is in his late nineties, the Lord reminds him again of the covenant, but God adds some conditions (God is God, and He gets to draw up the conditions whether we like them or not). God says, "I Am God Almighty; walk before me and be blameless. I will confirm my covenant between you and me and you will greatly increase your numbers" (Gen. 17:1-2). As a sign of Abrams' agreement, he fell face down before the Lord. To mark the commitment of both God and Abraham, God changed the names of Abram and his wife. Abram became Abraham, and Sarai became Sarah. This covenant established a promised people, a promised blessing, and a promised land—Israel.

The Mosaic Covenant

God's covenant process moved forward as a great nation was born. God raised Moses to leadership and told him what he should say to the people about His covenant with them. Moses went up to God, and the Lord called to him from the mountain and said, "This is what you are to say to the house of Jacob and what you are to tell the people of Israel: 'You

yourselves have seen what I did to Egypt, and how I carried you on eagles' wings and brought you to myself. Now if you obey me fully and keep my covenant, then out of all the nations you will be my treasured possession. Although the whole earth is mine, you will be for me a kingdom and priests and a holy nation.'These are the words you are to speak to the Israelites'" (Ex. 19:3-6). This covenant was conditional: "Obey me fully and keep my covenant." The Mosaic Covenant was based on the faithfulness of both God and Israel. Israel failed, but the Creator is faithful, even when His creation is not. On Mount Sinai, God brought Israel into a covenant relationship with himself by giving them the Law (The Ten Commandments) through Moses. That law was not the finished masterpiece. The Creator still had major finishing touches to add to this picture. The Creator had plans to bless all the world's people, not just Israel. The Creator chose Israel to be the canvas. It is the foundational layer to paint upon, and yes, He loves that canvas dearly. This canvas would illustrate a beautiful master-piece revealing the process of redemption for every culture. The world at this time was not ready for the unveiling of this beautiful portrait.[9]

The Davidic Covenant

The Davidic Covenant was the perfect bridge between the Old Testament Covenants and the New Testament Covenant. Just as God gave Moses a message to pour out to Israel, God gave the prophet Nathan a divine covenant to pour into King David's life (2 Sam. 7:5-16).

"The Lord declares to you that the Lord himself will estab-lish a house for you: When your days are over and you rest with your fathers, I will raise up your offspring to succeed you,

who will come from your own body, and I will establish his kingdom. He is the one who will build a house for my Name, and I will establish the throne of His kingdom forever. I will be his father, and he will be my son. When he does wrong, I will punish him with the rod of men, with floggings inflicted by men. But my love will never be taken away from him, as I took it away from Saul, whom I removed from you. Your house and your kingdom will endure forever before me; your throne will be established forever" (2 Sam. 7:11-16).

Here, there are no conditions placed on this covenant. God would do everything that He mentioned. In this scripture, there are important connections to David's son Solomon. But there are also many references to a throne and kingdom that would last forever through another son—God's one and only son—Jesus (2 Sam. 7:13, 16). In this prophetic picture painted by God, we see how the Old Testament proves that the Creator had a plan for redeeming His creation. The sculpture was not complete with just the Old Testament, and the story doesn't end there. His finished work would be uncovered and released after the completion of the New Testament. [1]

Molding Moment

For the Son of Man came to seek and to save the lost.

—Luke 19:10

(Read the parable of "*The Lost Sheep*" in Luke 15:1-7)

The Bible says, "There is none that seeks after God, no not one" (Rom. 3:11). But God will often use the circumstances of life to get us to do what we usually would not do—to seek Him. He not only wants us to seek Him, but once we find Him, He wants us to follow Him. Jesus constantly told people to follow Him. We must be determined to follow hard after Jesus. Why? Because He was determined to find us amongst the rubble and the mess. In Israel, people traveled long distances, 20-30 miles on foot, to get to specific destinations. Many sought out Jesus and traveled to great lengths because they had the unwavering faith that God could heal them of their sicknesses and diseases. They were determined to reach Jesus at any cost. Jesus did the same for us. We are all His lost sheep, and He traveled far and wide to redeem us. No road was too long, no desert too vast for the unconditional love of the Good Shepherd. He drew near to us and bid us draw near Him. Don't let the past dictate your future.[15] Any obstacles of unbelief, discouragement, condemnation, loneliness, and rejection must be left in the dust. John 10:27 says, "My sheep hear My voice, and I know them, and they follow Me." Follow the Good Shepherd, and He will heal you. Allow yourself to be carried in His tender arms of love, mercy, and grace. Don't

let Satan rob you by making you think back on what you have done in the past. He wants to steal your forgiveness. Romans 8:1 tells us, "There is therefore now no condemnation to them which are in Christ Jesus, who walks not after the flesh, but after the Spirit." Continue to walk in the power of the Holy Spirit so you will not fulfill the lusts of the flesh, which leads to bondage. You have been set free. Now walk on the narrow path that leads you back home! "The Lord God will save his people on that day as a shepherd saves his flock. They will sparkle in his land like jewels in a crown" (Zech. 9:16).

Our yesterdays present irreparable things to us; it is true that we have lost opportunities which will never return, but God can transform this destructive anxiety into a constructive thoughtfulness for the future. Let the past sleep, but let it sleep on the bosom of Christ. Leave the Irreparable Past in His hands, and step out into the Irresistible Future with Him.

—Oswald Chambers

Visual Journal & Creative Space

Expression #16

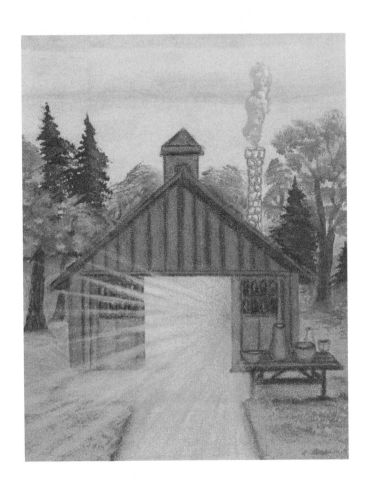

But you are a chosen people, a royal priesthood, a holy nation,
God's special possession, that you may declare the praises of him
who called you out of darkness into his wonderful light.

—1 Peter 2:9

CHAPTER 14
THE ROAD TO HEALING

The longer we walk with God, our confidence in Him grows. We begin to settle into His warm embrace and find ourselves turning to Him in the quietness of strength. He never fails to meet our needs. There is no fear of shame and past regrets because His great sacrifice dissolves the things of the past. This reality began to dawn on the disciples when some of those following Jesus were offended by His teaching. He asked the disciples, "Do you also want to go away?" And Peter replied, "Lord, to whom shall we go? You have the words of eternal life" (Jn. 6:66-68). The more we embrace God's perspective and spend time with Him, our confidence in Him grows. He is a God of forgiveness who loves to take our messes and transform them into masterpieces. We realize that He is the bread of life, and He has all the provisions we need to lead us on the road back home.

The prodigal son knew this very well. In Luke 15:11-32, we find a young man who desired to have his share of his inheritance early in life. His father agreed, divided the land, and gave his son his share of the profit. Sure enough, the son left home to live a lifestyle of recklessness. He squandered all his money, living a life of sin and foolishness. One day a famine arose in the land, and he had to seek out work to survive. There he found himself feeding pigs. He became so desperate and hungry that he began to eat the pigs' food. At that moment, as he hit rock bottom, he reminisced about all the love his father showed him throughout his life. He thought

back to how his father always had enough bread at his table, and he never found himself in want. The young man's spiritual blindness began to leave him. He started to come back to his senses and began to have a repentant heart.

"I will arise and go to my father, and I will say to him, 'Father, I have sinned against heaven and before you. I am no longer worthy of being called your son. Treat me as one of your hired servants.' And he arose and came to his father. But while he was still a long way off, his father saw him and felt compassion and ran and embraced him and kissed him. And the son said to him, 'Father, I have sinned against heaven and before you. I am no longer worthy of being called your son.' But the father said to his servants, 'Bring quickly the best robe, and put it on him, and put a ring on his hand, and shoes on his feet. And bring the fattened calf and kill it and let us eat and celebrate. For this my son was dead, and is alive again; he was lost, and is found.' And they began to celebrate'" (v. 18-24).

The Table of Communion

The Potter is a master storyteller, and here is another beautiful example. Despite what we have done, He stands at the door with the warmth of His light, illuminating the pathway home. He longs to embrace us as if it was the first time He has ever laid eyes upon His craftsmanship. He longs to give us what we don't deserve, adorning us with rings and robes of His righteousness as He covers our nakedness. After our embrace, He leads us to a candle-lit table set with abundant provision; the bread of life and the precious blood of the lamb. The Father prepares the best for His children; a table of provision, healing, forgiveness, and restoration. He bids all the weary and heavy-laden to rest, sit and eat. No matter who we are or what

we have done, we are all welcome to feast at the table of the Lord. The word *saved* in Greek is translated as "Sozo," which means "to save, rescue, deliver, protect, preserve, and heal." The words above describe the life-giving nourishment we receive when we come to the table of communion. [22]

Condemnation is a tool to keep us from turning to God. Satan tries to lie and convince us that we are too dirty to run to His table. He tries to fill our minds with thoughts of past regrets and insecurities. He tries to make us believe the lie that we must clean up our act before falling at the feet of the Potter. Meanwhile, Satan continues to win the battle by keeping us from receiving our forgiveness, healing, and deliverance. Since God knew we could not make ourselves presentable to Him in our strength, He does not expect this of us. We have an open invitation by the King Himself to sit at the communion table where we can be delighted. To accept this invitation, all we must do is call upon Him. We must accept His cleansing work and receive what He did for us by faith.

Jesus said in John chapter 6, "I am the bread of life. Your ancestors ate the manna in the wilderness, yet they died. But here is the bread that comes down from heaven, which anyone may eat and not die. I am the living bread that came down from heaven. Whoever eats this bread will live forever. This bread is my flesh, which I will give for the life of the world." Then the Jews argued sharply, "How can this man give us his flesh to eat?" Jesus said to them, "Very truly I tell you, unless you eat the flesh of the Son of Man and drink his blood, you have no life in you. Whoever eats my flesh and drinks my blood has eternal life, and I will raise them at the last day. For my flesh is real food, and my blood is real drink. Whoever eats my flesh and drinks my blood remains in me, and I in them" (v. 48-56). This was a very controversial teaching that left some

people confused. In this case, Jesus was not speaking about or endorsing cannibalism. Jesus even says in Matthew chapter 4, while being tempted in the wilderness, "Man shall not live by bread alone, but on every word that proceeds from the mouth of God." Bread is accessible and essential to life. But the bread that Jesus was talking about was the Word of God. When Jesus said we must "eat His flesh," He was speaking about His essential being, the Word of God in the flesh and body of Jesus Christ. He is the living, abiding Word of God (Jn. 1:1). We must make the Word of God the staple, the bread of our lives for provision and sustenance. We do this by reading, studying, and meditating on God's Word. We must act upon God's Word and put it into action. [20]

The power of communion demonstrates that God continues to create in an *excreatis* fashion. Towards the end of His life, Jesus sets into motion a creative and important practice essential to our physical and spiritual health. On the night before Jesus would suffer the worst that wayward human culture could unleash, He does something amazing: He takes the created bread and wine into His hands, lifts them, and blesses them. He took bread and wine, not wheat and grapes. Bread and wine are culture, not just nature. They are both nourishing to the body and beautiful. Jesus takes culture, blesses it, breaks it, and gives it to His disciples. Out of the given culture that God and man stepped into, something completely new is created—remembrance of His loving sacrifice and supernatural health to the physical bodies of those who partake in the meal. Communion became a sign and presence of God in the world. Luke chapter 22 records the story of the Last Supper. "And he took bread, gave thanks and broke it, and gave it to them, saying, 'This is my body given for you; do this in remembrance of me.' In the same way, after the supper he took the cup, saying, 'This cup is

the new covenant in my blood, which is poured out for you'" (v. 19-20). When Jesus said that we need to eat of His flesh and drink of His blood, He was teaching us how to "remember" the work and the sacrifice He made. This "remembering" reveals how He took back our inheritance of healing and eternal life from Satan. His broken body and blood bring us back into harmonious communion with our Creator. There is life and healing as we partake in communion. The bread of communion represents Him as God's living and abiding Word. The cup of His blood represents the Holy Spirit of God that empowered Him in all that He did because it is the Spirit that gives life (Jn. 6:63). The same Spirit breathes life into us, and it takes place at the creative table of communion.

The way of the culture maker—the artist—is a communion of play and pain—feasting and fasting—these are the calling not just of the creative individual or the artist but of the Christian themself. In the same way, Christ's beautiful and broken body is at play and in pain to create freedom in our lives. We need to discover the power of Christ taking, blessing, breaking, and giving. To be beautifully useful to God in our city and community, we need to become more like Christ and take, bless, break, and give where we are—to be beautifully useful to God in our city and community. Through the supernatural power of communion within us—our physical bodies, surrounding communities, and cities are no longer commonplace, but Holy sanctuaries where the Spirit of the Living God can thrive. [31]

Molding Moment

*As for me, I will always have hope; I will praise you more and
more. My mouth will tell of your righteous deeds, of your saving
acts all day long—though I know not how to relate them all. I
will come and proclaim your mighty acts, Sovereign LORD; I will
proclaim your righteous deeds, yours alone.*

—Psalm 71:14-16

If we look at the life of David, we will find a man who
loved to praise his Creator. David knew the power of praise
by "remembering" and counting his blessings. One of the ways
that we can build our faith to conquer our present difficulties
is by recalling how God delivered us in the past. The Israelites
were called to remember the Exodus at Passover. At Christmas,
we recall the birth of Emmanuel, Jesus our Savior. At Easter,
we remember the death and resurrection of Jesus. Think back
and remember how God has saved you countless times. King
David knew the only way we can do this is through the process
of remembrance and the giving of praise. Praise can be done
through singing, playing an instrument, painting, drawing,
sculpting, writing, etc. I hope by now you are using the *Visual
Journal & Creative Space* for this type of spiritual warfare and
praise. Doing so will allow your faith to soar as healing is
released into your life.

David modeled something compelling in the Psalms, which
is the art of "remembering." The above scripture says, "My
mouth will tell of your righteous acts, of your deeds of sal-
vation all day long" (Ps. 71:15). David loved to sing and play

the harp, but he did neither of the two this time. He is now operating in the art of *remembering* and *telling*. It is powerful to tell stories of the past. As we know, Jesus was an excellent storyteller who captured many audiences. Before David was about to go out to fight Goliath, he began to recount to King Saul how God had previously delivered him from the bear's paw and the mouth of the lion. He began to praise the God of Deliverance by telling and recounting the story. God began to construct a mental picture in David's imagination that allowed him to "see" the victory before it even manifested in the physical realm through the eyes of faith. We must take the Word of God and our God-given imagination to "see" His Word come to pass in our lives through His strength. Not only do we have to see it through faith, but we must speak it out! Jesus said, "If you believe with your heart (see it, know it and receive it through eyes of faith), and confess (tell it/speak it) with your mouth, you will be saved" (Rom. 10:9, Emphasis Added). God has given each one of us an imagination with the ability to create and build mental pictures in our minds. Those pictures can be for good or for evil. They can be images of hope, faith, healing, victory, or even doubt. What we begin to see in our minds and hearts will eventually make its way to our mouths.

One of the most powerful tools to build up your faith and release healing in your life is to bring praise before God for what He has done for you in the past. I like to call them "memorial stones." God called His children (ex. Joshua) to construct "sculptures" of stone on many occasions to serve as a remembrance of what God did to deliver His children. We must do the same in our own lives. We must use the creative tools He has given us to write, draw, paint, sculpt, photograph, sew, etc., "memorials of remembrance" to remind ourselves of God's great demonstrations of power in our lives. [12] Maybe

you have never done this. That's ok. Now is the time. In your *Journal & Creative Space,* draw, write, or create poetry reminding you of what God's Word says about your situation. Begin to imagine and spiritually see yourself made whole and free from that particular sickness, disease, ailment, or addiction based on God's promises found in the Bible. Then by faith, praise God by verbally speaking out His promises over you, your family, your unsaved loved ones, etc. By faith, verbally tell someone today what God says the outcome will be. "My mouth will tell of your righteous acts, of your deeds of salvation all day long" (Ps. 71:15).

One of the greatest ways to "remember" is by sitting at the table of communion. Jesus said, "Do this in remembrance of me" (Lk. 22:19). God wants you to use the art of remembrance by using your imagination to build a picture in your mind to physically "see" what God's Son already did at the cross. He wants you to see His broken body that purchased your healing no matter what that healing needs to be. He wants you to see the stripes He bore on His back because every lash purchased, bound, and cursed every illness, every disease, and every addiction. Our sins and every curse of death are nailed to the cross, where they remain. His blood poured out releases' freedom in your life; freedom that comes through the power of the Holy Spirit. Jesus said *to do this often.* It means you can have communion personally, on your own, with the priest of all priests—Jesus Christ. Jesus sees what is done in secret, and He will reward your obedient heart. [24]

His Word says in 1 Corinthians 11:29-30, "For he who eats and drinks in an unworthy manner eats and drinks judgment to himself, not discerning the Lord's body. For this reason, many are weak and sick among you, and many sleep." Many believers don't understand that the pierced and striped bread

(Matza), representing the Lord's body, is for our health and healing. And when we take communion without discerning this truth, we take it in an unworthy manner. Jesus paid a high price for our sins. He suffered, bled, and died to purchase our healing. If we don't believe and receive this offering that He paid highly for, we disrespect all He did for us. It is an insult to Him. If someone gives you a costly Christmas gift and you refuse to open their gift, you will greatly insult them. The same can be true about Christ's sacrifice. If we accurately discern the Lord's body, we will be strong, healthy, and live longer.

Many throughout the years have misinterpreted this scripture, believing it meant that if you have sin in your life, you are unworthy and cannot participate in Holy Communion. Sadly, this is a lie, which is another tactic used by Satan to keep your body, soul, and spirit from living a happy, healthy life! What was meant to be a blessing by Jesus before He sacrificed Himself has become a curse to some. Believers who refuse to make it a habit of coming to the table of Holy Communion have been robbing themselves of its life-giving power. Truthfully, there is no such thing as a worthy person in the flesh! Even the best of us miss the mark, and Jesus knows this well. Because we are unworthy people, and He is our righteousness, we have access to every benefit that He died to give us. So, it is not whether we are worthy or unworthy but how we partake. We can come to the table of the Lord with boldness because of Jesus' precious blood sacrifice. God doesn't want us to treat it as a ritual. He desires that we receive communion with holy reverence as we move forward with faith for health, healing, and protection. As we discern the body of Christ, He makes us healthy and whole. John 1:12 says that we are His children, and as a son and daughter of God, healing is our inheritance. Part of your rightful inheritance as a child of God is your healing. Jesus said

in John chapter 6 that He is "the bread of life." Healing is "the children's bread." Healing is our rightful inheritance of provision, and we cannot let the enemy steal what rightly belongs to us. We must verbally rebuke Satan, speak the truth about what God says, and take back what belongs to the Lord—our wholeness. Even if you haven't seen the victory manifest in the physical yet, continue to feast before the Lord. Make it a point to celebrate your victories BEFORE the rescue. It's already done! We may not feel helpful at times. We may feel like we are just bread and juice, paint and a canvas, or broken shards of clay on a potter's wheel, but when God takes us, blesses, and breaks us, we take on a whole new meaning full of power and life. [24] One of the greatest images pertaining to the table of communion in the Old Testament was penned by David in Psalm 23, "You prepare a table (table of communion) before me in the presence of my enemies. You anoint my head with oil; my cup overflows. Surely your goodness and love will follow me all the days of my life and I will dwell in the house of the Lord forever" (v. 5-6).

As in Holy Communion, allow Jesus to take you and your circumstance into His creative hands to lift, bless, and break. It is out of this brokenness that something new will be created. Out of the broken kernel of wheat and the crushed body of the grape comes forth life-giving bread and new wine.

—Timothy Kosta

Visual Journal & Creative Space

Expression #17

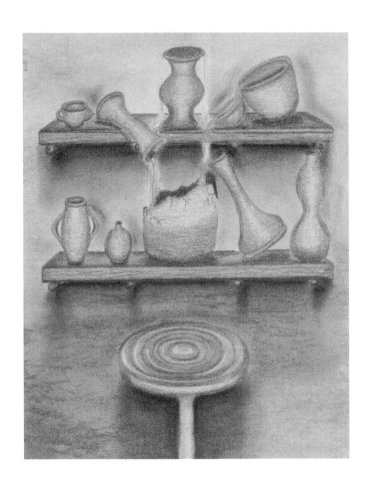

Therefore encourage one another and build each other up,
just as in fact you are doing.

—1 Thessalonians 5:11

CHAPTER 15
MEANT FOR COMMUNITY

What does the world think about God when they see the Christian community? The church is not perfect, but when people look at the church (the people of God), they should see a sharp contrast to what is in the worldly communities. It all starts with choices made by you, me, and those around us. We must choose to live by the standards of God's truth found in His Word, not ours, and be willing to allow the areas in our lives that do not align with His Word to be transformed. We are all designed with the need for community. It is seen in the early stages of life within our family, friendships, and relationships constructed at school, work, and church. As we have learned from the beginning, "The Lord God said, 'it is not good for man to be alone'" (Gen 2:18). The triune God has always existed within itself in community with the heavenly hosts. This eternal framework is the design found in our society and the foundations for the local community. Satan hates community. He hates the love between the Father, Son, and Holy Spirit. He hates that God has invited His creation into this relationship. Think about what is happening today in the family unit. He is constantly devising schemes to destroy the covenant relationship between a husband, wife, and children through sexual perversions, distorting God's plan for one's identity (physical, emotional, and spiritual) and people's view of the value of life. Just look at how Satan deceives the culture with the idea that an innocent young baby is just "tissue." Think about what has happened recently with the

effects of COVID-19. Satan has used this event to sever and isolate communities around the world. The adverse community effects have been social distancing within families, schools, and churches. We have also seen the rise in depression, suicide, anxiety, substance abuse, spousal abuse, child abuse, rioting, and community unrest. These are all attacks on the community and relational unit within society. It is the absolute antithesis of who God is and what He designed.

Don't you see it? Satan knows that relational love in a community is so powerful that he must do everything to destroy and terrorize these relationships. Scripture says that Satan "was a murderer from the beginning, and stayed not in the truth, because there is no truth in him. When he speaks a lie, he speaks of his own: for he is a liar, and the father of it" (Jn. 8:44). Satan is described in this scripture by saying, "Be alert and of sober mind. Your enemy the devil prowls around like a roaring lion looking for someone to devour" (1 Pet. 5:8). Please, ask the Holy Spirit to open your eyes to the truth of the matter. Satan simply hates God's design and anyone who holds firm to His blueprint of truth. He will use anyone and anything to dilute the truth and pervert its beauty. What is wrong has become right, and what is right has become wrong (Isa. 5). Because of the one choice made in the garden, all culture has gone astray from the divine design implemented by the Creator. Any philosophy or theology that skews off course from His revealed blueprint will only lead to a lack of peace, constant unrest, and continued brokenness. We have strayed away from our first love.

So, what is our mission in all of this? What are we to do? This answer is found in Jesus' final teachings to His disciples on the night of His arrest in the garden: "A new commandment I give you, that you love one another; as I have loved you, that

you also love one another. By this all will know that you are My disciples, if you have love for one another" (Jn. 13:34-35). The one thing Jesus wanted His disciples to be known for in the world was to be people that love one another in the same way He loved them (in the same way He loves us). The word "love" used in the context of this verse is the word *agape*. Agape love is the unconditional, sacrificial love, and brotherly kindness form of love. Agape is the deeply relational form of love, and it takes priority among godly traits in scripture. This type of love motivated the God of the universe to send Jesus, His one and only son, to redeem us from the curse of sin and death (Jn. 3:16). This love should motivate us to come alongside our brothers and sisters to encourage them and lead them on the path to everlasting. The three essential virtues are faith, hope, and love. In particular, without love, nothing else we do for God matters (1 Cor. 13:1-3, 13). The love of God naturally leads us to the nine traits or fruits of the Holy Spirit (Gal. 5:22-23). How many disagreements could be solved or avoided if the sacrificial love of God was put into practice regularly? What does all of this mean, and what are the traits required of us? It means putting humility, patience, submission, putting others first, joy, not keeping an account of wrongs, not insisting on one's way, and more. [8]

Why is love so important? It is "the glue" that keeps us connected to one another. The biblical model for our connectedness is stunning—the human body—our earthen vessels. The apostle Paul used a metaphor to describe Christian communities first used by Jesus Himself and is none other than the human body. Jesus took the bread at the Last Supper and said, "This is My body" (Matt. 26:26). Jesus said this to show the sacrificial love He was about to display for His creation. Paul wrote a lot about our connectedness to one another as parts of the human

body are connected (1 Cor. 12). All the parts of our body: our hands, feet, eyes, etc., are all part of one body, and every part is needed and has a purpose for the body to function properly. In the same way, all people have been called and gifted by God to play a part in the Christian community if we are willing to submit to His plan, purpose, and design. If one part of the body is missing, it may work, but it may not function to full capacity. The same goes for the church community. We all play a vital part in the community of God. One of the positive results of the pandemic has been the opportunity for Christian communities to demonstrate the love of Christ to the world. It has caused us all to dig deeper to spread the love of God. God did not author this worldwide pandemic, but He does allow events to take place to purge our conscience, clear our vision, and awaken the sleeper. God has called us to be His hands and feet in the world until He returns. The gifts of the Spirit represent His hands as we serve one another, and the fruit of the Spirit reveals God's heart towards others. Ephesians 2:8-10 says, "We are saved by *grace* in order to carry out the *good works* God calls us to do." It all boils down to unity among those who belong to Jesus. By being in a relationship with the Potter who shapes us, we can live in loving unity with one another to serve Him and the world He died to save.

Molding Moment

*Some men came, bringing to him a paralyzed man, carried by four
of them. Since they could not get him to Jesus because of the crowd,
they made an opening in the roof above Jesus by digging through it
and then lowered the mat the man was lying on. When Jesus saw
their faith, he said to the paralyzed man,
"Son, your sins are forgiven."*

—Mark 2:3-5

This is one of my favorite scenes in Holy Scripture. Here
we have a beautiful example of corporate faith. You have five
people with great faith trusting and believing for a miracle
to occur. Here we have four men that have enough faith to
carry the man. The paralytic had the faith to be carried. He
was unable in his own strength to get to where Jesus was, and
many obstacles stood in his way—the crowd preventing him
from moving forward and a roof of a home Jesus was teach-
ing beneath. The devil will do anything and everything he
can to keep you from getting to Jesus to receive your healing.
He may use people's words and actions to hinder your faith.
I have had doctors try to divert my faith and tell me there is
no hope. Believe it or not, family and church members may
do the same. People may even think that you must have done
something wrong or that there is some hidden sin causing
all the issues you're currently facing. This is not necessarily
the case. The question is, *Whose report do you believe? Will you
agree with what the devil says? Or will you align your faith and
thoughts on the promises of the Great Physician, Jesus?*

The paralytic had four friends "of like precious faith." They were determined to get their friend to Jesus despite the complex and seemingly impossible circumstances. They didn't let doubt, fear, discouragement, or unbelief stop them from moving forward. These men had a persistent and persevering faith. These men had the great faith to imagine and creatively collaborate a plan to get to Jesus. It is as if they said to themselves, *If only we could open that roof and lower him right down at the feet of Jesus.* Well, that is exactly what they did! They had enough faith to carry the man to the top of a stranger's roof, cut a hole in it, and lower the man down to the feet of Jesus. Amazing! They imagined this through the eyes of faith while everyone witnessed it. Align yourself with friends of like-minded faith. Encourage your fellow brothers and sisters in Christ with the words of truth. Collaborate with them in prayer. Allow them to pour into your life and fill you with greater faith. It doesn't matter if you feel you don't have many friends. You have the Father, Jesus Christ, and the Holy Spirit! He is always with you and will never forsake you. Matthew 18:19 says, "Again, truly I tell you that if two of you on earth agree about anything they ask for, it will be done for them by my Father in heaven." Get into a community with at least one other Bible-believing, promise-keeping, and faith-building brother or sister in Christ, and watch God create something out of nothing in your life.

There's no doubt in my mind that what's shaped me and my work more than any particular talent on my part has been living out a calling in the midst of a Christ-centered community.

—Andrew Peterson, "Adorning the Dark: Thoughts on Community, Calling, and the Mystery of Making"

Visual Journal & Creative Space

Expression #18

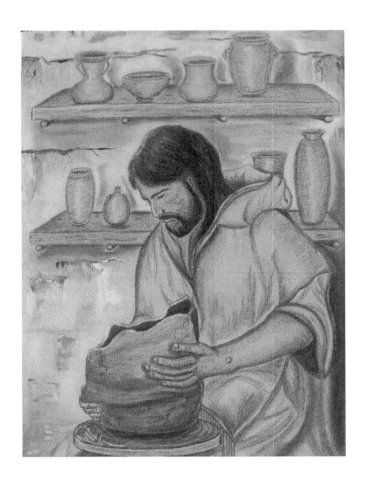

Then I went down to the potter's house, and there he was, making
something on the wheel. But the vessel that he was making of clay
was spoiled in the hand of the potter; so he remade it into another
vessel, as it pleased the potter to make.

—Jeremiah 18:3-4

CHAPTER 16
SUBMISSION TO THE POTTER'S WHEEL

I want to start this chapter with a message recorded in scripture by the prophet Ezekiel in a vision. The visual message described in this prophecy speaks of hope, not only for us as gentiles, but to God's chosen people—the Jews. More importantly, it is a prophecy where significant portions of the message have come to pass, while other components are yet to be fulfilled.

The vision is recorded in Ezekiel 37 and says, "The hand of the LORD was on me, and he brought me out by the Spirit of the LORD and set me in the middle of a valley; it was full of bones. He led me back and forth among them, and I saw a great many bones on the floor of the valley, bones that were very dry. He asked me, "Son of man, can these bones live?" I said, "Sovereign LORD, you alone know." Then he said to me, "Prophesy to these bones and say to them, 'Dry bones, hear the word of the LORD! This is what the Sovereign LORD says to these bones: I will make breath enter you, and you will come to life. I will attach tendons to you and make flesh come upon you and cover you with skin; I will put breath in you, and you will come to life. Then you will know that I am the LORD.'" So, I prophesied as I was commanded. And as I was prophesying, there was a noise, a rattling sound, and the bones came together, bone to bone. I looked, and tendons and flesh appeared on them and skin covered them, but there was no breath in them. Then he said to me, "Prophesy to the breath; prophesy, son of man, and say to it, 'This is what the

Sovereign LORD says: Come, breath, from the four winds and breathe into these slain, that they may live.'" So, I prophesied as he commanded me, and breath entered them; they came to life and stood up on their feet—a vast army. Then he said to me: "Son of man, these bones are the people of Israel. They say, 'Our bones are dried up and our hope is gone; we are cut off.' Therefore, prophesy and say to them: 'This is what the Sovereign LORD says: My people, I am going to open your graves and bring you up from them; I will bring you back to the land of Israel. Then you, my people, will know that I am the LORD, when I open your graves and bring you up from them. I will put my Spirit in you and you will live, and I will settle you in your own land. Then you will know that I the LORD have spoken, and I have done it, declares the LORD.'"

You may feel like your life is like dry bones lying in the valley of death that is dry, cracked, and broken with no hope on the horizon. God then asks Ezekiel in verse 3, "Can these bones live?" God is testing his faith, as well as our own. He asks you and me, *Can you see (imagine) the impossible becoming possible in this current circumstance? Do you believe dry bones can come back to life?* Then God tells Ezekiel to prophesy (speak the truth of God's Word) to the dry bones. Here is another example demonstrating the power of *speaking* the Word of God and His promises directly to your circumstance. It is insufficient to just think about the Word—you must verbally confess it with your mouth. Ezekiel makes a wise choice and does as God commands out of obedience. God's Word is full of the breath of life. When God speaks, His breath brings about resurrected life. As it was in the beginning, sound production was evident, as God's presence was heard and felt in the garden. In Ezekiel's encounter, a new sound was present; the great sound of a *rattle*. In the vision, the bones came back

to the fullness of life with tendons and flesh; what was dead, dry, and broken, God restored into an army! This was a vision written thousands of years ago, yet many Bible scholars believe this vision came to life on May 14, 1948, when Israel became a nation again. God's promise was beginning to take on shape and form! "Now learn this parable from the fig tree: When its branch has already become tender and puts forth its leaves, you know that summer is near. So, you also, when you see all these things, know that it is near—at the doors!" (Matt. 24.32, 33).

Since the fig tree's fruit was established in the Old Testament scriptures as symbolizing the spiritual state of the people of Israel, many see this coming "summer crop" as the restoration of the people of Israel (generically referred to as Jews) to their land. The bare, dead wood of scattered Israel was replaced by fruit on new wood. It is likened to a people drawn back into their land and a nation that becomes a sign to the Gentiles. A remnant of these people becomes "the good, sweet crop." For decades the displaced Jewish remnant continued to return to their homeland, and their return continues today from all parts of the world. We have even seen Jerusalem recognized as Israel's capital in 2018, another "putting forth of leaves" for Israel and the fulfillment of biblical prophecy. "I am going to open your graves and bring you up from them; I will bring you back to the land of Israel...you will settle in your own land" (v. 13, 14). God's Word never returns empty, null, or void. He will always do as He says, no matter how long it may take. Ezekiel's prophecy and Jesus's prophecy in Matthew 24 confirm that we are now getting closer to the end of the age. As you can see, God can take anything that seems broken and completely restore it to life. "Truly I tell you, this generation will certainly not pass away until all these things have happened" (v. 34).

I once heard Pastor Charles Stanley say, "Our God is a personal potter," in one of his sermons. He never discards His vessels but tirelessly works to perfect them." In the eyes of a potter, the clay is never a throwaway. No matter how broken and useless the clay is, the potter always sees its potential. Do you desire God's best in life? Do you hope to become the person He created you to be? Able to accomplish all He has planned? Most likely, your answer is affirmative to both questions. But are you willing to let the Potter do whatever is necessary to bring about full submission in your life? This third question frequently does not receive a resounding "yes." Yet, to blossom into all we were designed to be, we must surrender and submit to His perfect will. We must submit to the Potter's wheel. Let me be the first to admit it is not an easy process. We all have desires and habits that we simply do not want to relinquish. John 12:20-26 teaches us that dying to ourselves is necessary before we can truly live for God. As you would expect, aspects of this submission are inevitably painful. It would be much easier if we could just choose to give up our stubborn and prideful wills. But according to scripture, when we become a follower of God, we retain unrighteous behavior patterns that can be deeply ingrained within our clay walls. God may permit enough difficulty to enter our lives so that our old "clay flesh" tendencies are broken. Only then can we yield our hearts to the Potter's wheel. Though it is hard to understand, our Creator allows times of pain in our lives because of His great love for creation. A good potter cannot and will not leave His work in a broken state. Just as a parent hates to see his child get hurt, God takes no pleasure in our difficulty. But He desires that we experience the fullness of life in Christ. We must have faith to surrender and submit to the Potter's wheel. Genuine faith is only possible when we submit to God's plan and stand on

God's promises. It is useless to pray for increased faith until we have fulfilled the conditions of faith. We cannot waste time mulling over regrets and past failures, which will only keep us from the Potter's wheel of sanctification. *See* God's plan for your life. Answer His call by submitting to His wheel without delay. With God, there is nothing impossible.

The Potter loves the clay substance so much that He paid a high price to maintain ownership. Out of desperation and brokenness, we must choose to submit to the Potter's wheel and undergo the shaping process. What kind of clay are you? Do you yield to the pressure of His hand, or do you harden your will and refuse to bend? His goal is to shape all of His creations into the image of His Son, vessels He can use to accomplish His plans in the world. But if you refuse to let Him complete the molding process, your heart will grow hard and resistant. The benefits of a heart submitted to God are worth any sacrifices He may require of us. Our plans will never be as good as the Lord wants to do in and through us. We will be transformed if we let Him have His way with our lives.

Submission has taken on a bad name with extremely negative interpretations. This word is looked down upon because many people have used submission for selfish and sinful purposes. The pride in our lives fights against the spirit of submission. When submission is filled with the spirit of love, all things work together for good. In James 4:7, we are called to submit to God because when we submit to Him, the devil must flee because of our commitment and trust in Him. God calls the wife to submit to her husband in marriage, just as a husband is called to love His wife and lay his life down for her well-being. We know that this doesn't mean that she is any less than her husband, but they are equals in Christ. Similarly, Jesus submitted Himself to His Father even though they are equally

God. There is a proper order and a heart of selflessness that God desires from us all. There are four key areas where God calls us to have a submissive heart in scripture: submission to the Holy Spirit, scripture, God's will, and the trials of life. [28]

Submission to the Holy Spirit

In Galatians 5:16-17, it says that if we walk by the Spirit, we'll have victory over sinful, fleshly habits and desires. Ephesians 3:14-16 also says those who yield to the Spirit's control gain inner strength. God wants us to submit to His all-knowing will for our lives, and that starts with a daily submission. Before we even take the first step out of bed, we must tell God we submit our lives to His loving hands. [30]

Submission to Scripture

1 Peter 1:22-23 says that obedience to God's Word purifies our souls so that we can sincerely love others. God calls us to submit to one another in love. John 14:21 tells us that keeping Christ's commandments increases our intimacy with Him. God's commands are never meant to stifle us but allow us to grow in freedom and reach our full potential. His commands are meant to bring us abundant life. [30]

Submission to God's Will

When we are willing to let go of our plans and accept God's purposes, we'll experience His good, acceptable, and perfect will (Rom. 12:1-2). The Lord wants to produce a joyful, prayerful, and thankful attitude (1 Thess. 5:16-18). [30]

Submission to the Lord during Trials of Life

Those who abide in God during times of adversity instead of always trying to escape hardships will develop endurance, proven character, and hope (Rom. 5:3-5). When we are distressed and broken, the Lord works to produce something more precious than gold—proven faith, which rejoices even in suffering. [30]

How do we become broken?

Our vessels become cracked and chipped through daily use and the intentional or unintentional falls of life. The vessel can also be broken in the fires of trial by not being able to withstand the "testing" experience. It can also crack from not having sufficient time to dry properly. This can mean that our faith is not strong enough to endure the trials in our personal lives. Either way, we are all broken vessels and need to be renovated by the Potter. This means dismantling the already present clay to rebuild the vessel into its true destiny. We can only mend ourselves for so long before hardness sets in, along with deeper cracks. The good news is that God has made a space for you in His workshop and this world. God creates a space, especially for the rough, broken, guilt-ridden, and neglected to thrive in His Kingdom. How do we know this? Just look at the people's lives He chose in the Old and New Testaments. Many of our Biblical heroes were broken vessels, including David and Peter. David identified himself as "broken pottery" in Psalm 31, and Peter "cracked" as He denied Jesus Christ. He even chose tax collectors, zealots, and prostitutes to "pick up their cross" to follow Him. It should not surprise us. After all, He said, "I have not come to call the righteous, but sinners to repentance" (Lk. 5:32). We may look at the seemingly beautiful vessels on

the shelves of the Potter's workshop, wishing it could be us. If only those vessels could testify to how they got to this pivotal moment in their relationship with the Potter. One might ask, *How are cracked vessels restored?* Cracked vessels in ancient times were repaired by applying blood from insects that clung to bulls and goats. The potter squeezes the insects, dropping the blood into the dried powder of the clay to make a paste. He then applies the paste to the cracked vessel. When you get cracked and broken, apply the blood of Jesus. His blood is the only remedy to mend His clay because He was cracked and broken for you. He loves to work with broken clay. He loves to make something beautiful out of brokenness.

All True Heroes are Broken

There is a verse giving us a glimpse into God's heart on what He desires for His vessels in Psalm 52:17, "The sacrifices of God are a broken spirit; a broken and contrite heart, O God, you will not despise." The people that God uses most to bring glory to Himself are those who are completely broken because the sacrifice that is acceptable to Him is "a broken and contrite heart." If we look back at the earlier life of Moses, it took years for his will to be *broken* as he shepherded over Jethro's flocks before being called to deliver the Israelites from bondage in Egypt. It wasn't until Jacob's natural strength was *broken* as he wrestled with God that He was able to fill Jacob with spiritual power. And it was not until Moses struck and *broke* the rock at Horeb that cool water came gushing out for the people to drink (See Ex. 17:6). It wasn't until Gideon's three hundred chosen soldiers "*broke* the clay jars that were in their hands" (See Judg. 7:19) that the hidden light of their torches blazed in the night sky. This obedient act brought terror to their enemies

and, ultimately, victory. By faith, there was once a poor widow who *broke* the seal of her last remaining jar of oil, and as she began to pour it out, God miraculously multiplied its contents to not only pay her debts, but supplied provision to the prophet Elijah (See 2 Kgs. 4:1-7). It was not until Esther risked her life and *broke* through the strict laws of the king's court that she obtained favor to rescue her people from death (See Est. 4:16). It wasn't until Jesus, who took "the five loaves...and *broke* them" (See Lk. 9:16), that the bread multiplied to feed the five thousand. An amazing miracle came forth through the very process of the loaves being *broken*. When Mary *broke* her "alabaster jar of priceless perfume" (See Matt. 26:7), the wonderful fragrance filled the house as a memorial before the Lord. And it was Jesus—the Passover lamb—who allowed His precious body to be *broken* and made subject to thorns, whips, and nails that His inner life was poured out like a spring of water for thirsty sinners to drink from and live. It is not until the seed falls into the ground, is broken, and dies that its inner heart sprouts, producing hundreds of other seeds. [7]

And so it has always been, down through the history of people, plants, and spiritual life, that God treasures broken things. Many of those the Holy Spirit has gripped have been broken in their self-will, ambitions, ideals, reputation, broken desires, and health. Yes, He uses the despised of the world and those who seem helpless to "carry off the plunder" (Isa. 33:23). With the truth of God's Word above, how can we follow Jesus' command in Matthew 5:48 to "Be perfect, therefore, as your heavenly Father is perfect." How can you and I be perfect yet broken at the same time? No one is perfect! We shouldn't get discouraged because He is faithful to help us get back up every time we fall. We are His workmanship. He knows that our efforts and good works will never bring us anywhere near

perfection. We must realize that every effort He is making to transform us is a work of perfection. It is a process of sanctification. Note the word "process." Every time we create something new, it results from a patient process. When I create a piece of art, I often find that the process is more fulfilling than the product. Why? Because each step of the process is teaching me something new. Each creative experiment is a step of faith that leads to greater hope and a deeper love for the Creator and His creation. No one in the whole world can prevent Him from perfecting us except you and me. God is not interested in creating a small vessel to live, but He desires to build a vessel as big as a palace. Why? Because He wants to live in and partner with us. He chooses to dwell within weak, earthen vessels to showcase His creative exploits in and through us. He desires to renovate us from the inside out!

Molding Moment

*A man with leprosy came to him and begged him on his knees,
"If you are willing, you can make me clean." Jesus was indignant.
He reached out his hand and touched the man. "I am willing,"
he said. "Be clean!" Immediately the leprosy left him
and he was cleansed.*

—Mark 1:40-42

If we look back to the garden with Adam and Eve, Satan tried to get them to doubt God's ability. He will try to do the same thing with us. Satan loves to go back into his old bag of tricks and use them repeatedly. He wants to question God's motives leading us to doubt, confusion, and rebellion. In Mark chapter 1, a man desperate for healing says to Jesus, "If you are willing, you can make me clean." Wow. Is God willing to heal the brokenness in your life? Is He willing to heal all your diseases? Yes! He died a terrible death to save, heal, and restore you. Jesus Himself is named *Jehovah Rapha*, "The Lord, The Healer" (Ex. 15). It translates into "I, the Lord, am your healer." Healing is His very nature. To deny this fact would deny Him to be the Savior. As mentioned earlier, the Greek word for Savior is *Sozo*. A savior saves, rescues, delivers, protects, preserves, and heals. He took on all the pain and suffering for you and me because "By His stripes, we are healed" (Isa. 53:5). He is more than willing to heal you of every disease, sickness, and addiction.

In my years of service as a deacon and a follower of Jesus, I have heard many people respond to people's needs in prayer

with the statement, "If it is God's will," when they pray for healing to descend in a person's life. But to pray in this way, when His will has been clearly revealed, is to pray in unbelief or with a wavering heart. Scripture tells us, "But when you ask, you must believe and not doubt, because the one who doubts is like a wave of the sea, blown and tossed by the wind. That person should not expect to receive anything from the Lord" (Jas. 1:6-7). We must move past the question, *What if He doesn't?* How can we expect to receive any healing from the Lord if we think this way? Do not doubt or be afraid of the unknown. The Potter is always willing to pick up the pieces and put His creation back together in perfect order. He specializes in turning chaos into order, and turmoil into peace. He is the God of wholeness, and His body was broken to make you whole. The Potter never rejects His clay. The Bible says, "The one who comes to me I will certainly not cast out" (Jn. 6:37). God will meet your every need. Be persistent. Continue to ask, seek, and knock because the door WILL BE OPENED in His time. Don't question God's motives any longer. Even though your life may be shrouded in miry darkness, the sun is still shining behind all the turmoil. Allow Him to speak "Peace" in your storm. You must ask yourself, *Am I truly willing to be healed, or have I somehow become accustomed to this lifestyle? Do I truly believe that I can be healed? Do I reap the benefits of others feeling sorry for me in this condition based on what I receive, whether it be monetary gifts, charity, or people feeling sorry for me?* If your answer is, *Yes,* any of the above questions may hinder you from receiving the free gift of healing. Come to the place of surrendering ALL on the Potter's wheel.

Learn this lesson: not to trust Christ because you repent, but trust Christ to make you repent; not to come to Christ because you have a broken heart, but to come to Him that He may give you a broken heart; not to come to Him because you are fit to come, but to come to Him because you are unfit to come. Your fitness is your unfitness. Your qualification is your lack of qualification.

—C.S. Spurgeon

Visual Journal & Creative Space

Expression #19

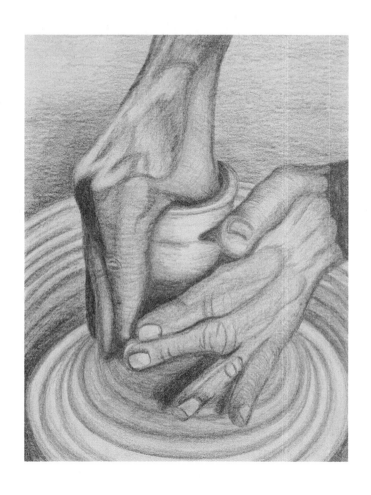

He lifted me out of the slimy pit, out of the mud and mire;
he set my feet on a rock and gave me a firm place to stand.

—Psalm 40:2

CHAPTER 17
MOLDING THE HEART OF CLAY

When we learn to trust in the hands of the Potter, we begin to feel as if we can exhale. Do you feel the same way? When we don't trust the Lord in any given difficulty, the entire weight of the burden falls upon us. As a result, our body becomes tense, and our lungs tighten. The entirety of our lives, hopes, dreams, aspirations, and talents begin to dry up, causing the hardness of the heart that only leads to broken fragments. But when we roll our heavy burden into the warm and loving hands of the Potter, we can finally exhale as our heart becomes soft and pliable. A life of faith is one of breathing deeply, being filled with the Holy Spirit's oxygen, and learning to relax in the Potter's hands. This is the place of a true blessing. One meaning of the word *blessed* means "happy." The Hebrew and the Greek term go far beyond human happiness, but a joyful spirit is an essential part of the meaning of this word. [4] Jeremiah learned the joy of trusting in the Creator, and he said, "But blessed is the one who trusts in the Lord, whose confidence is in him" (17:7). We need to take a deep breath and meditate on this truth. He is working all things together for our good.

When a potter takes a lump of clay, he knows what he wants to do with it. He knows if he wants to create a beautiful vase, bowl, or pitcher. He already knows what it is going to become. He takes the lump of clay, places it on the pottery wheel, and begins to shape it. However, the potter can only form this piece of clay into something beautiful by getting it to the center of the wheel. [29] The potter applies constant pressure to the clay

to shape it. It is an "upward & outward pressure." A similar pressure that God uses in our lives creates a higher fill capacity for His usefulness. God doesn't push us down or condemn us; instead, He wants to lift us upward in His mighty hands. His ultimate goal is to draw us to Himself, equip, and prepare us for His service, but it cannot be accomplished without pressure. The apostle Paul said, "I press on toward the goal for the prize of the upward call of God in Christ Jesus" (Phil. 3:14). When we are under His pressure, we need to keep our eyes on the eternal purposes God is creating within us. While the Potter is shaping the outside of the vessel, He is also shaping the inward parts. He pushes His fingers down into the vessel's center, known as the "heart," or the secret place unseen by others. If the Potter doesn't work on the vessel's heart, it will be unable to hold or contain any substance. The Potter continually crafts our whole being, equipping us for every good work. May our response be, *It is well with my soul.*

In the New Testament, the Greek word used for "equipping" or "preparing" is *katartismos.* Another form of this word is *katartizo,* which means "to create" or "form." The Potter is involved in preparing His people and forming the qualities necessary to carry out the mission He has called them to do. He wants to take each of us and form us into a vessel of honor.[8] Hebrews 13:20-21 says, "The God of peace...will equip you with everything good for doing his will." The equipping process aims to build into the lives of His people what is necessary to function as servants of God in the church and the world. We are called to be his disciples, and yes, we are a "work in progress." Paul says to Timothy, "That the man of God may be thoroughly equipped for every good work" (2 Tim. 3:17). This shaping begins with the water of His Word spoken over lives, as it leads to transformation. This process continues as

we are disciplined, serve others, and then share the overflow of what we have received from the goodness of His hands. Transformation is a process. I have heard that transformation is a journey, not a destination. [28] Just as the butterfly goes through the metamorphic transformation cycle, it is not an instantaneous result. It is a journey that begins deep within the heart and unveils its beauty gradually over time. You may feel unqualified, insufficient, and weak for God's tasks, but that's good news. You are exactly in the right place! We must understand that we do not possess the power, ingenuity, and creativity to pull this off in our strength. It is only through the transformative power of the Holy Spirit that can author this change. We can do nothing apart from His hands, but ALL things are possible with God!

In 2016 I created a painting entitled, *Driftwood*, which beautifully illustrates this concept of shaping and molding. I based it on a picture I had seen from Pebble Beach, on the California coast. The raging white surf continually roars, thundering and pounding against the rocks of the shoreline and any object caught up in its foamy waves. Sometimes God feels near to us, and other times far away. But the fury of His eternal love washes over us, creating a beautiful sculptural work, just like the seemingly lifeless piece of driftwood. These pieces of wood, glass, and stone (hard and rough-edged objects) get trapped in the arms of merciless waves. They are tossed and rolled against the sharp edges of the cliffs and the roughness of the ocean floor. Both day and night, this process of grinding continues relentlessly. What is the result? God uses the deep waters and crashing waves to refine, shape, and smooth areas of our lives, so we become a beautifully sculpted piece of His handiwork. The tumbled rock, sand, shells, and glass smooth the hard places of our lives, especially the hardest of hearts.

This period of rough waters makes us even more beautiful in the Creator's eyes. Sooner or later, He will command the series of refining waves to cease. Your mighty voice will declare, "Peace, be still" as His loving waves carry us back to the shore. The once dead roots of a tree become the focus of beauty as the viewer's marvel and rejoice in the Creator's handiwork. Since God knows what type of vessel He is creating and what purpose, let us trust Him to shape us into it. And since He knows what work we are to do, let us trust Him to mold us into His masterpiece.

Driftwood, 2016, Timothy Kosta

God has formed within each of us a certain set of gifts that must be discovered and utilized to enhance the culture. The equipper of these great gifts is also a repairer. He takes the brokenness of people's lives through past hardships and brings them into the right relationship with Himself. The equipper is also like a farmer who prepares the ground for a fruitful harvest; He sows, structures, molds, and forms all of the ingredients into the soil of our lives, so we can be released to fulfill all of God's

purposes. [7] It is similar to the cataract issue I spoke about at the beginning of this book. At first, our vision may be cloudy, unable to see the full picture of all we are meant to be. But that doesn't mean God isn't working actively behind the scenes preparing us for maximum impact. When God is preparing and molding the clay, we don't know what form He will shape us into, our exact purpose, or capacity. He may call us to impact a smaller remote area in our sphere of influence within our lives, or we may be formed into a large vessel to reach a multitude. Only when the preparation is complete will we be able to see clearly. Regardless, we must see through the eyes of supernatural faith. We must not lose our spiritual sight. We may not see clearly in the physical state we are in at this very moment, but we can be at peace knowing He is actively preparing us for all He desires to do in and through our lives. May our hearts never be satisfied until we are pliable in His hands while learning to trust Him. As we do so, "Then He will be able to make us perfect in every good work to do His will, working in us that which is pleasing in His sight, through Jesus Christ" (Heb. 13:21).

Tools the Creator Uses to Shape & Mold His Masterpiece

There are various materials and tools artists choose to create with in order to bring about a particular effect and expression in their artwork. Some artists may use mixed media, paint, clay, photography, interior design, and the list can go on and on. The artist has a vision of what the completed work will look like in their mind's eye and all it is meant to communicate to the viewer. The Creator uses various tools when working on one of His living masterpieces. When working on his marble sculpture, "The Pieta," Michelangelo's most effective tools to shape and mold the virgin Mary holding Jesus Christ were a

hammer and chisel. If we witnessed him working firsthand, we would never say he was butchering or maliciously destroying the marble. If we could observe his every move, we would not just see a mess but a work in progress. On the other hand, if someone never saw the artist's process and simply walked by this piece of stone, someone may suggest it is just a heap of broken rock. They would be partially correct because it is! Art starts as a mess and may not be pretty to look at initially. In the same way, a potter continues to smooth, mold, and remove anything from the clay that doesn't resemble the vessel he envisions. Various wire tools are used, but the most useful tool is his hands. All of us are in a broken state, yet it is a "work in progress."

Just as we see in pottery and sculpture, the Creator uses "tools" to bring about His desired result in our lives. Let's go back to the chisel and hammer. The chisel represents His Holy Word, the promises and truths found in the Bible. The Apostle Paul shares in the book of Hebrews chapter 4, "For the word of God is alive and active. Sharper than any double-edged sword, it penetrates even to dividing soul and spirit, joints and marrow; it judges the thoughts and attitudes of the heart" (v. 12). Hearing the truth can sometimes be painful as it penetrates through any facade, down to the true heart of the matter. He will use this tool to shape and mold His creation lovingly. He doesn't use it to violently cut, smash, bash, or condemn His creation. He uses it just as a doctor performs careful surgery with a scalpel to help bring healing and restoration to one of his patients. When the artist looks at a piece of marble or a lump of clay, he begins to chip away or smooth out anything that doesn't look like his envisioned work. The artist sees past the mess and sees the material's potential. He envisions the

fullness of what he intends to form and create. He sees a work of art with a beautiful purpose. [17]

The second tool the artist uses is the hammer of adversity. He uses adversity for an excellent purpose in our lives, yet many people view adversity as defeating. Adversity is an excellent tool to shape and mold His creation into a vessel of excellence and honor. God has designed adversity, regardless of its source, to be a vehicle that takes us to some of the biggest leaps forward in our faith and spiritual growth. The Potter utilizes the tool of adversity in our lives until it accomplishes the purpose in the creative process. Some may be rattled to the core when they face various trials, while others learn how to stand upon God's faithfulness. [28] As Psalm 119 shares, life's trials come no matter who you are or what you do. Suffering prepares and perfects us in various ways. Pressure from without increases pressure from within. We may feel it expressed as the darkness lingers, the pain intensifies, and the disappointment goes on and on. We do not have to give in to this mounting pressure in the spiritual realm. We can diffuse it by transferring it into the hands of the Potter and allowing Him to handle our hurts. The trials that go beyond our ability to control prove that we are not all-knowing, but God is. We become completely aware of our need for Him and His infinite wisdom to solve the problems we have no way to repair properly. We need a Savior. We need someone greater than our greatest fear who can meet ALL our needs. Only through His grace can we learn the truth behind our suffering. One truth that suffering can teach us is the intensity of God's immense love for us—His creation. Maybe you feel that the emotional or physical pain is too much even to bear. Maybe the amount of disappointment is much too weighty. Instead of becoming fearful, which is one of the greatest ploys of Satan to keep you from God, ask

the Lord to show you what He is up to in your life. Charles Spurgeon wrote, "God knows that soldiers are to be made only in battle; they are not to be grown in peaceful times. We may grow the stuff of which soldiers are made; but warriors are really educated by the smell of powder, in the midst of whizzing bullets and roaring cannonades...is He not developing in you the qualities of a soldier by throwing you into the heat of battle, and should you not use every application to come off conqueror?"[7]

Whether the potter or sculptor is working with clay or stone, brokenness is common in creating a sculptural masterpiece. Our lives should never be centered on how much we have accomplished or achieved for ourselves, others, or God. He never accepts us based on what we have done. Rather, He receives us because of what the Potter—Jesus Christ—has done for humanity on the cross (Eph. 2:8, 9). He instructs us to stop depending on what we can accomplish in our own strength and rely upon Him (Prov. 3:5, 6). This doesn't just apply to our salvation but to every aspect of our life. There is a remedy for healing through the power of faith, hope, and love. What is God trying to break from your life? What do you trust in more than God? God will break your dependence upon anything other than Himself, no matter how long it takes or how difficult the process may be. He is committed to bringing you to a place of wholeness and spiritual maturity, conforming you to the likeness of the Potter himself. He continues this work in a willing vessel to help bring wholeness and spiritual maturity in your own life and the lives of others through your personal testimony. The Apostle Paul faced a challenging time of brokenness, and he wrote, "I implored the Lord three times that it might leave me" (2 Cor. 12:8). Although God did not remove the "thorn" from him, He did help Paul to understand

that it was given to keep him from exalting himself from relying on anything other than Christ (2 Cor. 12:7-11). God also taught Paul that His grace was sufficient for all his weaknesses.

The same is true for you and me. Whenever we experience brokenness, God's grace can sustain and mature us in all aspects of our lives. He will show us how to let go of all our dependence on things of this world and teach us how to rest in His faith, hope, and love. In the same way, you will grow in the likeness of the Potter's image and be prepared for His service. The Apostle Peter wrote, "Beloved, do not be surprised at the fiery ordeal among you, which comes upon you for your testing, as though some strange thing were happening to you; but to the degree that you share the sufferings of Christ, keep on rejoicing, so that also at the revelation of His glory you may rejoice with exultation" (1 Pet. 4:12, 13). We also must remember that God uses brokenness to deepen our understanding. First, you can gain a new perspective of His mercy and provision while learning how to depend on Him more. Second, you develop a complete understanding of yourself. Third, your compassion and empathy for others' suffering continue to grow. You will truly become a ready and suitable vessel for the Potter's service. If you begin to trust in God and learn from Him through the adversity you face, He will undoubtedly reveal Himself to you and work through your vessel in supernatural ways. God has one goal in mind for your brokenness: a masterpiece.

Molding Moment

Do not conform to the pattern of this world but be transformed by the renewing of your mind. Then you will be able to test and approve what God's will is—his good, pleasing and perfect will.

—Romans 12:2

The key to becoming a completely transformed person is allowing our mind to be refashioned and shaped to the pattern of the Potter's thinking. When we look closely at the mind, it is similar to a factory open 24 hours a day. The mind is always at work, even when we are sleeping. There is a ton of activity going on at night worldwide, and by that, I mean spiritual activity. God and His forces are on the move, as well as the forces of darkness. Many of them could be vying for our attention even as we sleep. The thoughts we feed on during the day are the "raw material" that our mind continually processes. For example, if we go to bed with anxious thoughts of anxiety and fear, we will most likely wake up with a double sense of fear and anxiety. In contrast, if we go to sleep with thoughts of confidence, peace, and thoughts of the power of God working ALL things together for good, we will awaken with a deepened sense of security and confidence that He will meet ALL our needs. You must pray, quote scripture, and worship; think noble, positive, and truthful thoughts before drifting off to sleep. Give your mind holy material to process through before you fall asleep. When this is done, I have found there have been many nights where the Holy Spirit has come to my mind to deposit spiritual understanding, warnings, insight, and even healing words.

For each of us to become fully transformed, there must be a conversion in our conscious minds. This occurs when we come to Christ in repentance and decide we will follow Him. Truthfully, we will never be delivered from inner conflict and find joy in God's all for us. We cannot be fully healed until we give our minds completely over to Christ and allow Him to transform our thinking. This is where deliverance and joy can be found. We must renew our minds from all the pollution that tries to warp our thoughts and actions. Satan loves to attack our minds. He loves to attack our identity and make us THINK that God's Word is not true and that it will never come to pass. We are all born into sin; sinful thoughts, sinful choices, sinful lives. We can never say, *Well, this is just how my life is. These are my thoughts about my life, and I was just born this way.* Part of this is true; we are all born sinners. But that doesn't mean this is the way He wants us to remain. The Potter ordained every vessel to be "born again." The Potter wants to dismantle the old pot, the old way of thinking, and re-create our vessel. He wants to make us new. Like the caterpillar, He doesn't want us to remain in our state. He wants to transform and renew us so we can fulfill all we were destined to be. He wants us to be re-born spiritually! Jesus answered and said to him, "Truly, truly, I say to you, unless one is born again he cannot see the kingdom of God" (Jn. 3:3).

One of my favorite Biblical healing stories that I can relate to from an artist's perspective and someone who has dealt with blindness is found in Mark chapter 8:22-26. "They came to Bethsaida, and some people brought a blind man and begged Jesus to touch him. He took the blind man by the hand and led him outside the village. When he had spit on the man's eyes and put his hands on him, Jesus asked, 'Do you see anything?' He looked up and said, 'I see people; they look like

trees walking around.' Once more, Jesus put his hands on the man's eyes. Then his eyes were opened, his sight was restored, and he saw everything clearly. Jesus sent him home, saying, 'Don't even go into the village.'" If we look at the context of Mark chapter 8, we see Jesus talking about "seeing." He says, "Having eyes do you not see, and having ears do you not hear? And do you not remember? When I broke the five loaves for the five thousand, how many baskets full of broken pieces did you take up?' They said to him, 'Twelve. And the seven for the four thousand, how many baskets full of broken pieces did you take up?' And they said to him, 'Seven.' And he said to them, 'Do you not yet understand?'" (Mk. 8:18-21).

Here, Jesus is a perfect example of a potter redeeming his clay. He takes the dust of the earth and mixes it with a liquid (His saliva/the water of the Word) to create a moldable substance (clay). He then sculpts with this clay by applying it to the man's blind eyes. Here is a beautiful example of God using a created substance as the vehicle to deliver powerful healing. *Why such a strange healing? Why would Jesus spit in the blind man's eyes yet not completely heal him? Why would he still have poor sight? Why would Jesus have to touch him again?* I find it interesting how Jesus used a two-step healing process in this instance. Of course, He could have healed him instantaneously, but here Jesus wanted to demonstrate a situation where healing is a process. Some people may not like to hear this, but it is true. Remember, God is very interested in the internal condition of your heart and spirit. He will do anything to help shape and mold the depths of your being and your body physically.

Based on the context in Mark 8, I think it reminds us of the disciples and their lack of spiritual vision. They "see" and understand physically, but their spiritual understanding is feeble. They, too, will need a second touch from the hand of

the Potter. Notice what follows in this passage. Jesus asks His disciples, "Who do you say that I am?" Peter said, 'You are the Christ.'" Jesus is essentially asking the disciples, *Do you see? Do you understand?* The disciples respond, *Yes, we see you are the Christ.* Yet, they did not know the true meaning. They didn't see as clearly as they thought they did. The blind man saw "men, but they looked like trees" (Mk. 8:24). Later, this is proven true when Peter denies Jesus (Mk. 14:66-72). He truly did not "see" what it meant for Jesus to be the Christ. He, too, needed a second touch. [21]

Jesus is trying to teach us a profound parable through this healing method. Jesus asked, "Having eyes do you not see, and having ears do you not hear? And do you not remember?" (Mk. 8:18). It is as if the disciples could see, yet they couldn't see. This is an interesting paradox. Like the blind man, He had healed them, but their vision—their understanding—was still far from being complete. He would not fix their vision until later when they see Him again (Mk. 16:12-14). After Jesus' resurrection, He gave the disciples the correct understanding of who He was and the revelation they needed (Lk. 24:27, 44-47). After this two-step healing process, they could see with a renewed vision! This is what God may be doing in your life right now, healing you through a molding process one step at a time. Just because your healing hasn't manifested in the physical yet, doesn't mean you are not healed. God has already healed you the moment you prayed your prayer in faith. The moment you offer your prayer, the manifestation of healing makes its way from the heavenly Kingdom, through the material/earthly realm, and into your vessel. He is teaching you something fundamental on your journey of healing. It is something He is molding deep within your heart. Embrace the process with patience. The testimony He is developing within you is supernatural,

and it will transform the lives of many at the right moment in time. He is not only making you victorious but everyone else who takes the time to listen to your testimony with a heart of faith. In the process, your obedience and patience will grow others in their faith, as they trust in the One who paints the story of their lives.

When it comes to our position before God, we're perfect.
When He sees each of us, He sees one who has made perfect
through the One who is perfect—Jesus Christ.

—Max Lucado

Visual Journal & Creative Space

Expression #20

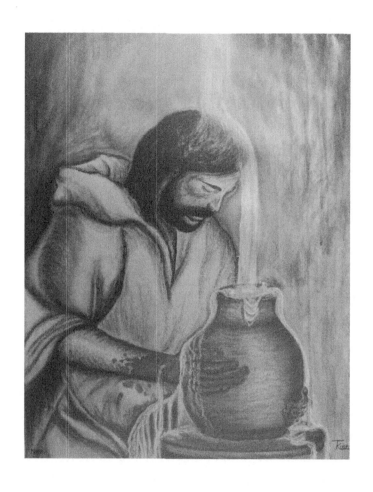

He saved us, not because of righteous things we had done, but because of his mercy. He saved us through the washing of rebirth and renewal by the Holy Spirit.

—Titus 3:5

CHAPTER 18
BAPTIZED BY WATER

When you willingly choose to obey the Potter and stay centered on the wheel of His perfect will, all the life within Him will flow in and through you. You need to have your life centered on Jesus in complete surrender. You must enter God's perfect will before He can fully form you into all He has called you to be. After this centering takes place, the clay becomes desperate for a good supply of water—the baptism of the Holy Spirit—the Living Word, to flow into the vessel so it can satisfy the depths of the soul. The living water of God's Word is necessary to sanctify and cleanse us thoroughly. Water from the living fountain mixes with the clay to soften its hardness, allowing it to become moldable in the warmth of the Potter's hands. This river flows from the Father, over His son, and into our lives through the Holy Spirit. God doesn't see an ordinary vessel to contain this water, but an extravagant container meant to be filled with an unlimited supply of provision. God looks with a keen eye on His children devoted to obedience, the one with a poor and contrite spirit who trembles at His Word (Isa. 68:2).

The Bible is clear, "Faith comes by hearing, and hearing the word of Christ" (Rom. 10:17). The Greek word *cometh* means to "increase." God wants our faith to increase, but it can only happen if we hear His voice. One of the important ways to listen to Him is by soaking in the water of His Word. The Bible is the most incredible health and healing manual of all time! Proverbs 3:8 says His words will, "Be healing to

your body and refreshment to your bones." God's words of life are meant to revive and refresh us. His words are sharper than any two-edged sword. After a sword is forged in the fire, you must sharpen it. As the sharpening process begins, a large quantity of water is necessary to help reduce the amount of friction exerted upon the blade. In the same way, our lives need the water of God's Word to reduce "the friction of worldly thinking" and to sharpen our lives spiritually and physically. [10]

The Creator desires to educate His children for the holy living. After He made our atonement with His blood, Jesus entered the Father's Kingdom. He did this to exchange His earthly presence for the precious Holy Spirit. A good father doesn't leave his children as orphans. As the Spirit of the Son, He breathes life, freedom, and liberty into our very existence. The Father, in His benevolence, imparted the most extraordinary gift to us—His spirit. You need to realize that you are a royal priesthood and a citizen of heaven because you are marked with His very own Spirit.

John 15:7 says, "If you abide in me, and my words abide in you, you can ask what you will, and it will be done for you." If we receive all we are asking for from God, Christ's Word must abide in us. We must study His Word and allow them to baptize or wash over our minds. We must study His Word and allow them to sink deep into our clay hearts by keeping them in our memory, obeying them constantly, and shaping and molding our daily lives. It is through His Word that Jesus imparts Himself to us. The words He speaks unto us, "They are spirit, and they are life" (Jn. 3:63). It is pointless to expect power in prayer unless we meditate upon the words of Christ; they must sink deep and find permanency in the depths of our hearts. Some even ask, *Why do I feel my prayers are so powerless?* The simple answer to this question is the neglect of the Word

of Jesus Christ. They have not hidden the Word in their heart, nor do they sit long enough to allow the water to fill their earthen vessel. His words do not abide in them. If the promises contained within His Word are exercised and spoken in faith, their prayers would be, *Yes, and amen!* It is only found in feeding upon His written voice in the Bible that these words can be implanted in our hearts. When His words fill us, we have the fuel for powerful prayers. The Word of God within His chosen instruments is the power through which the Holy Spirit flows. The person who wants to know the will of the Holy Spirit must fill up on the Word. The person who wants to pray in the Spirit must meditate on His Word so that the Spirit has something it can work through. If we take the fuel of God's Word and drench our prayers, there is no telling what impossible situations will become possible!

As we grow in our relationship with the Lord and abide in His Word, we begin to bear much fruit. The scriptures share that we will know who a true disciple of God is by the fruit produced within their lives. An orange tree will always yield a harvest of oranges. If the orange tree yielded a crop of bananas, we would know there is a major flaw with the tree. As in the beginning, the Potter desires that we bear much fruit and multiply. It is not a physical fruit that He is after; it's a spiritual fruit manifested through our lives—the *Fruits of the Spirit.* The byproduct of allowing the Holy Spirit to reign in our lives freely produces an abundance of fruit for all to enjoy. But it all starts with a good supply of living water—His Word. The Holy Spirit is constantly at work in the believer's life, ripening the fruits of *love, joy, peace, patience, kindness, goodness, faithfulness, gentleness, and self-control* (Gal. 5:22-23). The gardener constantly maintains the growth of the fruit by pruning branches that are not bearing fruit. In some instances,

He prunes branches that are producing fruit. This may seem counterproductive, but it is necessary to promote more fruit, which leads to multiplication and a greater harvest.

If you are uncomfortable in the place you are in right now in your life, the only thing that will satisfy you is to know God and receive the free gift of the Holy Spirit. I have heard it said this way: *A trustworthy person commands trust; not that this person orders someone around to trust them, but winning their trust by proving one trustworthy.* What the Potter says is true, "And if I be lifted up from the earth, will draw all men unto me" (Jn. 12:32). He desires to do the same in your life and mine. He wants to lift the walls of our clay vessel higher and higher. When you come to know Christ, you realize He is irresistible. You can no more help trusting Him than you can help to breathe. If every clay vessel allowed the washing of the Word to fill their lives, they too would fall at His feet in worship. First, God must reveal Himself to His creation for this to happen. Second, we must accept His revelation, believe what He reveals, and let that truth shape our vessels into all He has ordained us to be. He wants to weave irresistible trust into our lives leading to compelling faith. Allow the Holy Spirit to abide in you as you abide in Christ. He desires to fill you from the inside out.

Molding Moment

*Don't you realize that all of you together are the temple of God
and that the Spirit of God lives in you?*

—1 Corinthians 3:16

The above is another powerful scripture that proves that
God is more than willing to heal your vessel physically, spiri-
tually, emotionally, and socially. When you accept Jesus Christ
as your Savior, He takes up residence within you. You are the
temple that He lives within. Interestingly, the God of the
universe chose to live within broken vessels. Yes, you heard me
right. He lives within our broken vessels because that is the
only vessel that He can work through. So, we are imperfect,
and we do not have it all together. But we can allow the One
who knows how to put it all together into our lives. He loves
manifesting His power through weak, broken pots. The Potter
is very protective of His property as well. He goes to extreme
lengths to ensure His temple is clean from the devil's filth.
When Jesus came to the temple and saw that His house was
being used as a marketplace for profit, He had to cleanse it.
Why? Because what parent would let their child just lay over
their couch with muddy clothing? God wants to purify our
hearts. He came to cleanse and purify us. God is genuinely
concerned about the condition of His house, His dwelling
place—you and me. Just as He is concerned about our physical
health, our spiritual health is at the top of His list. Sometimes
He uses the physical manifestation of healing first to mold and
heal our inner spirit. Other times He will begin the creative

process of healing us on the inside, which naturally leads to physical healing. The Potter knows what method is best, just as a surgeon knows what instruments are necessary to bring about the right outcome during the surgery. He always sets His eyesight on the inside of our house because that is where He lives. As a result, He desires to heal us on the outside so others can see His excellent work.

The Potter wants to wash us clean from all selfishness. He wants to free us of pride, anger, resentment, bitterness, jealousy, and unforgiveness. Jesus said, "My house shall be called a house of prayer" (Matt. 21:13). We can maintain a healthy relationship with Him through prayer and worship. Prayer is fellowship, communion, and conversation with God. You can talk to Him just like you would talk to one of your closest friends. He wants you to express how you are feeling in all things and depend upon Him for supernatural help. Remember, God paid a high price for you—His house. Sickness and disease have no place in the house God purchased with His very own blood. After Jesus cleansed the temple, all the sick came to Him, and He healed them. God wants us to pray and commune with Him consistently. He urges us to "pray without ceasing" (1 Thess. 5:17). You are a house of prayer, so tell Him everything: "Cast all your cares upon Him because He cares for you" (1 Pet. 5:7).

Weave the fabric of God's Word through your heart and mind.
It will hold strong, even if the rest of life unravels.

—Gigi Graham Tchividjian

Visual Journal & Creative Space

Expression #21

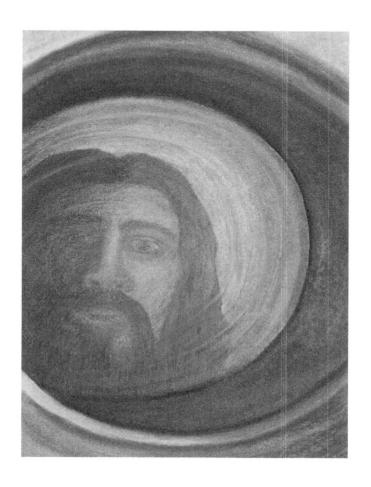

But we all, with unveiled face, beholding as in a mirror the glory of the Lord, are being transformed into the same image from glory to glory, just as from the Lord, the Spirit.

—2 Corinthians 3:18

CHAPTER 19
REFLECTION

Jesus once said, "I am the true vine, and my Father is the gardener. He cuts off every branch in me that bears no fruit, while every branch that does bear fruit he prunes so that it will be even more fruitful" (Jn. 15:1-2). The only way to be conformed to His image is by assimilating the Word of God into your character. What does it mean to abide in Christ—the Word of God? Jesus compared Himself to a vine and the disciples to the branches connected to the vine. Some branches remained unified to the vine, and the sap of life flowed freely into the branches; the buds, leaves, blossoms, and fruit were not theirs but belonged to the power of the vine itself. Other branches were utterly severed from the vine and could not receive that life-giving sap. Our lives must model after the branches that are connected to the vine. We must continually look to Christ for His thoughts to be manifested; His purposes, emotions, and affections to flow in and through us. When we do this, our prayers will align with His perfect will. God continues to form us until He sees the reflection of His Son within our vessel. We, in turn, should see the reflection of the Son as well. Our desires will not be our own, but Christ's; our prayers will not be our own, but Christ interceding. To abide in Christ, we must have received the atoning work of the Savior and renounce our self-life; every thought, purpose, desire, and affection that does not align with His while continually gazing upon the reflection of Christ. [33]

James 1:23-25 illustrates this concept of abiding and reflecting Christ by saying, "Anyone who listens to the word but does not do what it says is like someone who looks at his face in a mirror and, after looking at himself, goes away and immediately forgets what he looks like. But whoever looks intently into the perfect law that gives freedom, and continues in it—not forgetting what they have heard, but doing it—they will be blessed in what they do." If we are to receive all the Potter's blessings and provision to become all we are meant to be and do, His words must abide in us. The Word of God must fill our vessels to the brim. We must study His words and allow them to permeate the depths of our clay hearts. We must fix our eyes on the perfect reflection of His Word and promises by enabling them to sink into our memory. The words He speaks to us are spirit, and they are life (Jn. 6:63). I want to capitalize on what I mentioned in the previous chapter. We cannot have power in prayer unless we gaze and reflect on the Word of God. We cannot expect to be healed without knowing, meditating, and seeing God's Word formed within us to release the healing. His words must become a permanent image within our minds.

Why might your prayers seem powerless? It is the neglect to stare at the reflection of Christ—the Word of God. They have not hidden the Word in their hearts, nor do they abide in them. We gain power and strength by feeding on the Word of God and allowing the Holy Spirit to embed His truth deep within our hearts. When we begin to speak the Word of God, it stirs up the waters around us. [7] It is as if our words are like stones being thrown into a pond. The first stone that hits the water begins to create a ripple effect that cannot stop. God's Word is a powerful force that sets into motion a chain of events that brings life-changing results: "So is my word that goes out from my mouth: It will not return to me empty but will

accomplish what I desire and achieve the purpose for which I sent it" (Isa. 55:11).

I am reminded of the story of how Jesus turned the water in the clay cisterns into wine. The Potter always wants to partner with us, demanding our best, not our second best. When we have done all we know to do, that is when He gives us the extra we desperately need. It's as if He is actively waiting for us to exhaust all our resources. We must do our part before seeing the miracle unfold in our lives. That is exactly what happened during this event. The servants had to take the time to fill the clay cisterns to the brim with water. It took effort. It took faith and hope to hold on to the Word spoken by Jesus. It took their absolute best obedience. Like Peter, we must set sail after being out all night—without a catch—only to let our net down on the opposite side of the boat. We must bring the five loaves and the two fishes. The Potter transforms our best into His better. He changes water into wine. He takes a handful of mustard seeds and brings a harvest. Our ordinary lives become supernatural. Remember, the Lord keeps His best wine until the very end. Greater things are yet to come! "No eye has seen, no ear has heard, and no mind has imagined what God has prepared for those who love him" (1 Cor. 2:9 NLT).

He also requires our lives to become transparent, as He is transparent; where there is transparency in a relationship, an abundance of growth can be witnessed. As the window to our soul becomes unshaded to the Potter, we permit Him to offer light to our opinions, concerns, questions, and dreams. He is there to help balance and complete our thoughts while boosting them with visions of obtaining the impossible. He desires to share the keys of life, healing, encouragement, direction, and prevention, but it all begins with transparency. When we look at modern architecture, we see beautiful constructions

with more windows than walls. Similar to architecture, a life full of openness is a healthy one. The question is this: *Are we building more walls or opening more windows to let the fresh air of transparency into our lives?* Being honest with the Creator and coming to terms with our weaknesses is essential. All foolish pride must drown in the waters of His vivid reflection.

Molding Moment

The Potter wants you to see and trust Him for your healing spiritually, physically, and emotionally. You are already healed by faith. Allow your mind to be renewed so you can accept it through the eyes of faith. The key to renewing your mind is to focus your attention on the face of Christ—the living Word of God. When you continually set your eyes on His reflection, ALL things are possible to those who believe. His promises and truth become reflected in your own life. Water can be turned into wine in any situation! No longer should you see your face in the reflections of the past, but the face of the One who makes you completely new. God's purpose is completed by Him working in us, not our works. If you are currently having trouble seeing the image of the Potter fully reflected in you, fear not; the Maker is not finished yet. The painter has not finished painting the canvas of your life into the most beautiful portrait. The day will come when the work that began in Genesis will be completed in Revelation. All creation—including you and me—will be delivered entirely from bondage and corruption. As it says in Romans 8:22-23, "We know that the whole creation has been groaning as in the pains of childbirth right up to the present time. Not only so, but we ourselves, who have the first fruits of the Spirit, groan inwardly as we wait eagerly for our adoption to sonship, the redemption of our bodies." The Potter is coming back very soon. Can you not perceive it by what is happening around us and in our world currently? We need to watch, pray, and be

ready because the King of Kings is coming. Look up into the heavens because our redemption is drawing nigh!

It is the thoughts and the intents of the heart
that shape a person's life.

—John Eldredge

Visual Journal & Creative Space

Expression #22

Brothers and sisters, I do not consider myself yet to have taken hold of it. But one thing I do: Forgetting what is behind and straining toward what is ahead.

—Philippians 3:13

CHAPTER 20
PATIENTLY WAITING

Life has its mountain top experiences filled with triumphs and delights but is also marked by valleys of waiting for our prayers to be answered. I have discovered many truths about the valley experiences in times of waiting on God. In my valley of waiting for answered prayers, I have found that I have made the most significant strides in growing my faith while abiding by God's grace. After this waiting period is over, we can look back with thanksgiving for all the Potter has accomplished. In doing so, we can appreciate why He had us patiently wait. More importantly, the treasures we have learned during these waiting periods have further built our trust, appreciation, and love for the Potter's infinite wisdom. Looking back at my own experiences, I wouldn't trade the deeper trust and confidence I had experienced in the valley of waiting for a smooth, trouble-free life. *How can we ever grow if we don't wrestle against the opposing forces of the giants we face? How will we ever cultivate faith, hope, and love?* In those times, we truly learn about the beautiful attributes of our Potter. The creative tool of remembering our past experiences helps deepen our walk with the Lord. This is important because when the next valley occurs in our lives, our first reaction will be to thank and praise the Lord in advance for what He will bring out of the valley experience. I want my first reaction to be, *Lord, I know you didn't author this trying situation I am in right now, but you have allowed it and will use it as a part of working all things together for good. I trust you completely, Lord!* We must be

able to see and interpret the deeper meaning of our waiting experiences closely. In doing so, we must live fully in freedom amidst our current challenges. We can trust the Creator who has been faithful to us in the past, present, and future.

The number one desire of Christians is to live in God's will for their lives. And the number one question is, *How do I know His will?* First, God's general will for all Christians is found in the pages of scripture, which are the instructions on righteous living for God. For example, scripture tells us in Thessalonians 5:16-18, "Rejoice at all times. Pray without ceasing. Give thanks in every circumstance, for this is God's will for you in Christ Jesus." But then there is the specific will of God for one's personal life. Psalm 139:16 suggests that God has a plan for everyone's life, and the Bible is filled with examples proving just that. Jeremiah was told that God set him aside as a prophet; David was told he was to be Israel's king; the apostle Paul was commissioned to preach to the Gentiles; Moses was appointed to deliver the Hebrews from slavery; Samuel was called as a child to be a prophet; Barnabas was called to be a servant leader and encourager to others; Bezalel and Oholiab were filled with the Spirit of God in all artistic craftsmanship to fashion the Ark of the Covenant; Solomon was commissioned to build the temple and rule over Israel. All these callings share one thing in common: they came to fruition through the process of *time*. It is difficult to wait patiently for things to happen in this fast-paced culture. But regardless of what century we are in, God is not bound by time. He desires that we wait patiently for Him, just as a newly formed vessel needs the time to dry completely before it can advance to the next step in the process. True quality is marked by carefully implemented time. Do not doubt that God has a specific purpose for your life. Just be patient and prayerful as you begin

to see it unfold. God is working everything together for our good. And yes, He has a specific plan for you. [16]

Do you desire God's best for your life? Unfortunately, many people miss God's blessings because they are unwilling to wait for His timing. Scripture encourages believers to be patient. David was a good example of this virtue when he chose not to use violence against King Saul, even though he knew he would be the next king. King Saul became envious of the shepherd's ability, anointing, and the probable future royalty, so he planned to murder the young man. Twice, during this time of the pursuit, David had been in the arm's reach of Saul; he could have easily killed his pursuer in an instant. But in both instances, he chose to wait for God's timing. He was unwilling to take matters into his own hands, even though ending Saul's life would have provided much relief. Thankfully, David was patient. Notice the attributes that allowed him to wait for the Lord's timing. First, he had a strong faith and believed that God would gain victory in the right time and with the right method. Second, he had the correct values because killing a king would violate his conscience. Third, discernment helped him realize that assassination would mean stepping out of God's will. Fourth, strength played a role in this decision. How difficult it must have been to resist taking the action that would result in his freedom and royalty. [7] Patience is refined in trying times when you are frustrated with the waiting and tempted to act outside of God's will. Always seek His wisdom and follow the prescription you receive. Remember, "Those who wait on the Lord will gain new strength" (Isa. 40:31).

If you have ever broken a bone, you know that it takes weeks to heal even though the doctor has mended and set the bone back in its proper place. It takes time. Broken relationships take time to heal, recovering from sickness takes time to heal,

building relationships take time to develop, and creating art-work takes time to deliver the right message. It all takes time and patience. Developing patience is crucial to our work with the Potter. If we look closely at our everyday lives, we may encounter frustrating people and situations, such as a slow driver, a mischievous child, or an uncooperative co-worker. We may want to lash out, but God wants us to stay calm and be patient with everyone (1 Thess. 5:14). Why should we want to develop patience, you might ask? It is our calling. Though once alienated from the Lord, we have been made a part of His family through Jesus' work. As God's children, we are called to live a life worthy of Him, characterized by humility, gentleness, and patience (Eph. 4:1-3). We should develop patience because it is taught in God's love letter to us—the Bible. Scripture tells us to be tolerant of one another, bear each other's burdens, and respond with kindness. We want to develop patience because the Potter demonstrates patience with us, His clay. A good example of this was when the Lord demonstrated patience towards the Apostle Peter's reckless actions, the crowd's demands, and the leader's false accusations.

Developing patience is necessary to maintain healthy rela-tionships. If we lack this fruit of the Spirit, our impatience can hurt others and close off dialogue. Responding calmly gives the other person room to confess their wrongdoing, explain their attitude, and make changes. Most of all, developing our patience will gain God's approval. The apostle Paul wrote that we must be "Joyful in hope and patient in affliction" (Rom. 12:12). When we quietly endure our suffering, we find favor with the Lord. The Holy Spirit is conforming each of us to the Potter's image. As we cooperate with Him, He will develop in us the ability to persevere without becoming agitated when waiting or provoked. A calm demeanor in times of delay or

adversity can be a powerful witness to the transforming work of God.

One time Jesus told a parable about patience. The story is about a man who planted a fig tree in his garden. He checked the tree for fruit each year, but it never grew any figs. After three years, he said to his gardener, "I have been looking for fruit on this tree for three years, but I never found any. Cut it down! Why should it waste the ground?" But the gardener wanted to give the tree another chance (Lk. 13:6). Jesus told this story to help us understand how patient He is with people, just as a good painter is patient with his paint or a sculptor with his clay. He gives us many chances to live the life He wants us to live. The gardener in this story asked the master to give the fig tree another year to grow fruit. In the same way, the Potter is patient and waits for people to accept Him, even if it takes some time. He is full of mercy and grace.

Molding Moment

Now there is in Jerusalem by the Sheep Gate a pool, in Aramaic
called Bethesda, which has five roofed colonnades. In these lay a
multitude of invalids—blind, lame, and paralyzed. One man was
there who had been an invalid for thirty-eight years. When Jesus
saw him lying there and knew that he had already been there a
long time, he said to him, "Do you want to be healed?" The sick
man answered him, "Sir, I have no one to put me into the pool
when the water is stirred up, and while I am going another steps
down before me." Jesus said to him, "Get up, take up your bed,
and walk." And at once the man was healed,
and he took up his bed and walked.

—John 5:2-9 (ESV)

Wow! This man had been sick for 38 years. This is a long
time contending with an ailment, which must have been dis-
couraging. The scripture does not say exactly how old he is,
but this is a lengthy amount of time. Here, this man was with
others that were blind and crippled as well. As time passed,
a new culture in this particular community of Israel began to
form. Many may have become dependent on others to bring
them food, clothing, and common necessities. Some of them
may have come to the reality of accepting things just the way
they were. Is it possible that some people become so used to
being dependent on others that they may refuse their healing?
It is similar to someone who has been in jail for many years.
They may finally be granted parole but find themselves com-
mitting another crime just to go back to their normal lifestyles.

It sounds crazy, but fear and insecurity can hold us back from receiving God's healing for us. Often, people cannot imagine their lives without the ailment or addiction, so they may not have the desperation or the desire to be healed. Interestingly, Jesus says to the man, "Do you want to be healed?" (v. 6). This statement made by Jesus may give us some insight that deep down in His heart, something was keeping him from receiving his healing. It could have been excuses, lack of faith, or fear. Only God knows, but Jesus steps in and tells the man enough is enough, "Get up, take up your bed, and walk" (v. 8). Even though this man was discouraged, a glimmer of hope must have resided deep down within him. He did not give up; he still came seeking, hoping, and expecting. When Jesus showed up, something changed in this man's life. For the first time in his life, he had the faith to believe that it was not the pool water that could heal him; it was Jesus Himself.

We cannot let repeated disappointments keep us from the "divine appointment" that God has set for us to receive our healing. The enemy loves to use our disappointments to discourage us; he loves holding us back from our full potential by building resentment, anger, and bitterness. Satan's ultimate goal is to try and keep us from getting to the One who holds the life-giving water. It is only a matter of time before our healing will manifest. Sometimes healing can occur instantaneously through a miracle, while other times, healing is a process. Sometimes God desires to heal us through the hand of a skillful physician and medical treatments. God may choose either method, but He is your healer and your Deliverer. He is your Restorer. Scripture says that "The just shall live by faith" (Rom. 1:17). You are to live your life day by day by faith, faith in the One who knows the end from the beginning and the beginning to the end. Even though you have prayed for your

condition to be healed, you must continue to press in by faith. Are you going to give up on God, the Healer, just because you have not seen it happen yet? Keep your eyes fixed on Him and see yourself through the eyes of faith; healed, delivered, and restored all because of His Word. You are one step closer to victory. While waiting patiently, get close to the One who loves you unconditionally. We can be highly impatient and demand quick results to free us from our difficulties. [22] We want instant results in this fast-paced society. We can go from one solution to the next and one quick fix after another. We talk to one person, and if we do not like what they have to say, we are off to the next person to get advice. The question is, *Have you asked the Creator what His solution is? Have you paused to take the time to ask of your all-knowing, all-powerful God?* I am here to tell you that prayer works. Faith works. The Word of God is true, and it doesn't matter how long you have been in your current situation. Are you desperate for the Potter's touch?

God is in no hurry. Compared to works of mankind, He is extremely deliberate. God is not a slave to the human clock.

—Charles Swindoll

Visual Journal & Creative Space

Expression #23

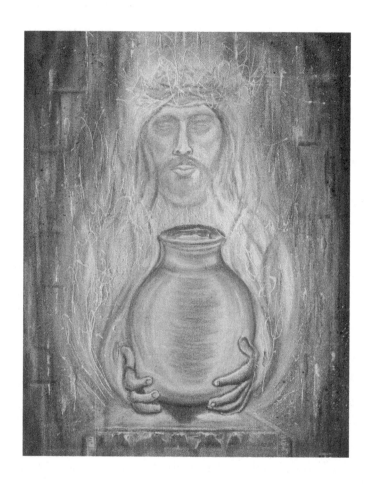

*Consider it pure joy, my brothers and sisters, whenever you face
trials of many kinds because you know that the testing of your faith
produces perseverance. Let perseverance finish its work so that you
may be mature and complete, not lacking anything.*

—James 1:2–4

CHAPTER 21
TESTED BY FIRE

Tests are the tools of spiritual formation that shape us into God's instrument. God tests each one of us through a series of fiery trials throughout our lives. We usually need to go through multiple tests before things become clear about what God is saying or trying to teach us personally. Testing times may vary depending on the results the Potter envisions for His clay. Testing is necessary to bring the clay to a transformed state—a state of purging for it to be refined like gold. He desires to bring us into a spiritual state of maturity. Fire makes the raw clay "stable," a state of peace in Christ. Jesus is our peace in the storm. We must willingly allow ourselves to be placed on the altar of testing as a sacrifice to the Lord. A quality of faith says, *Lord, I trust you in this fire.* As the intense heat strengthens the clay, the Potter's hands never leave the vessel's body. He may be positioned behind the clay and out of sight for the moment to test our faith even more, but believe me, He is Emmanuel—God with us! He, too, has endured the testing of His faith, obedience, and trust. Jesus passed through the flames of testing and came forth as precious gold. We can have the same victory as Christ did as we trust Him. The Potter allows us to go through many kinds of tests because He wants to see what is contained deep inside the heart of the clay. He will put us through various testing moments to test our faith, motivation, stewardship, credibility, submission, forgiveness, warfare, time, service, character, and authority. We must not let these tests discourage us from fulfilling God's plans for our

lives. Yes, we may lose some of the battles we face, but we must remember that we have not lost the war. We must get back up and keep on going. These tests will activate our deepest emotions, but we must pray, persevere, and celebrate before we see the manifestation of God's victory in the physical realm. [21]

The apostle Paul is an excellent example of how we can handle challenging circumstances. Even while confined to a prison cell—just as the clay is confined to a kiln—Paul placed his trust in the hands of the Savior. Despite being in chains, he celebrated the Lord's work in his life out of genuine praise and love for the Savior. The epistle he wrote from jail to the Philippians was filled with rejoicing and praise (1:18, 2:18, 3:1). Focusing on the Potter is neither a natural reaction nor an easy one, especially when we cannot see Him with our eyes. In these moments, we are forced to trust His hands, hold onto His heart with eyes of faith, and listen to His still, small voice. Our instinct is to dwell on the situation at hand. As a result, the fire may look scary and overwhelming; however, fear and defeat cannot live long within the heart of the one who trusts in the Lord. I am not saying you will forget what you are going through, but you can choose to dwell on His provision, care, deliverance, and healing instead. In the end, we must realize He is the *Deliverer* (2 Cor. 2:10), the *Healer* (Deut. 32:39), and our *Guide* (Prov. 3:6). The believer who claims divine promises discovers that God pushes back negative emotions, thoughts, and feelings; He replaces them with hope, confidence, contentment, and praise. You are not going to be happy with the difficult tests in life, but you can be satisfied that God is in control and up to something good—He is in the midst of the fire with you! The Lord's promises never change, no matter how difficult or painful the situation may be. Focus your attention on the promises spoken by the *Living Word* instead

of the circumstance itself. The good Potter will comfort the heart of His clay and bring you safely through the fires of life. Then you can answer Paul's call for us to "Rejoice in the Lord always" (Phil. 4:4).

In Daniel 3, Shadrach, Meshach, and Abednego were obedient to death by refusing to bow down and worship the golden statue set up by King Nebuchadnezzar. They trusted God had the power to save them from the fires of the furnace, yet they reasoned that even if God did not save them, they still would not bow down and worship the statue. This is the obedient response and radical trust God seeks in His vessels. This great faith in the Potter set into motion a miraculous display of His Glory for all to see. As they were thrown into the fiery furnace of testing, God gladly honored their obedience and showed up as the fourth man in the fire. Just as He redeemed these obedient men, He will deliver and redeem you! Regardless of the outcome of your trial, you are a child of God and have complete victory. Hold onto the hope found in Christ because He is never failing. May your heart take courage, and your soul be steadfast because triumph unfolds. Although this step in the process is dreaded by many, it is the catalyst stage for ultimate growth in all areas of our lives. Peter was restored to the Potter around a fire that Jesus built on the seashore (Jn. 21:5). The power of "fire and testing" transforms us into all we were meant to be—His choice vessel in the Potter's service.

Empowerment

As learned, God consists of the Father, the Son, and the Holy Spirit. Sometimes I feel humans can neglect God the Holy Spirit when He has been crucial to our victorious spiritual walk. The Holy Spirit helps us become more than we are.

He empowers us through the infilling of the Holy Spirit. The Spirit empowers every earthen vessel that has surrendered to the Potter's wheel. He empowers the clay to do more than it could ever do in its own strength. Those who received the Holy Spirit in Acts 2 began speaking with other tongues as the Spirit gave them utterance (v. 4). Peter, encouraged by the Holy Spirit, did the miraculous, baptized people, and helped add 3,000 people to the church. We can say that the Holy Spirit helped Peter beyond his natural ability. [8]

The Spirit's power fulfills Jesus' promise that those who believe in Him would do the same works He did, and even greater! Examples of God's power encourage us to believe for the supernatural to be made manifest in our lives. After the Holy Spirit fell, the disciples performed many miracles, such as healing the sick, casting out demons, and discipling thousands (Acts 2:38-39). Spirit-empowered discipleship means we understand that our relationship goes beyond belief or washing away our sins. It's not about doing more for God, performing at higher excellence levels, or experiencing miracles, signs, and wonders. Truly, it is all about knowing the Potter for who He is—knowing the Creator: "And this is eternal life, that they may know You, the only true God, and Jesus Christ whom You have sent" (Jn. 17:3). The apostle Paul understood this. To believers in Philippi, he made known that no power, prestige, or wealth could compete against the greatest adventure of knowing and pursuing God. Compared to the wonder and joy of his relationship with God, he explained that everything else is rubbish (Phil. 3:7-10). Every spiritual discipline and activity is meaningless without a growing relationship with Christ. [36] Eventually, a hollow, empty vessel will lead to frustration, disappointment, cracking, and shattering. Neglecting a growing relationship with God can only allow the dreaded

"air bubble" to expand within the clay walls. This air bubble is known as pride. When placed in the flames of testing—under extreme heat—the air bubbles within the clay walls will explode, resulting in hundreds of broken pieces. This will not only cause injury to yourself but to others around you.

When we are Spirit-empowered, everything we do is the byproduct of our relationship with Christ, as it reflects His artistry within us. In the Old Testament, the Israelites were commanded by God to make a house (temple) for Him—a dwelling place. As a result, He promised that His presence would fill the house made of stone and remain with them. The only issue was that they had access to Him from afar. The only one who had direct access was the high priest, only one day a year on Yom Kippur. God was untouchable during this time in history. It all changed when the Spirit came upon all flesh. God no longer occupies stone buildings; He now lives in houses of clay. Because of His desire to dwell within us, we too can dwell within Him. The result should create the desire to know and serve Him as we experience our full potential with our whole hearts. This is where transformation and empowerment begin. He wants to set you on fire from the inside out. Ultimately, God wants you to be filled with the baptism of the Holy Spirit. This is a free gift, just as salvation. Because you have a free will, you must ask Him for this gift. It just doesn't happen on its own. This empowerment is essential to the believer's spiritual walk. You cannot live a completely victorious life with Christ without it. If your best friend wants to give you a special gift, how many of us would reject it and say, "Thanks, but no, I don't want your gift right now." No one would give a response like that. Jesus, before He left to return to His Father in heaven, said it was good that He was going away because in doing so, He would send the Holy Spirit to

guide us in all truth and fill us with power (Jn. 16:7-10). To find out more about the baptism of the Holy Spirit and how to receive this free gift, please see the Appendix.

Molding Moment

While Jesus was still speaking, someone came from the house of Jairus, the synagogue leader. "Your daughter is dead," he said. "Don't bother the teacher anymore. Hearing this, Jesus said to Jairus, "Don't be afraid; just believe, and she will be healed."

—Luke 8:49-50

During the testing times in our lives, we must not give in to fear. Jesus continually tells us to "fear not" throughout the Bible. Fear is the absolute enemy of faith. Faith always strives to free us, whereas fear wants to bind and keep us grounded: "God has not given us a spirit of fear; but power, love, and a sound (disciplined) mind" (2 Tim. 1:7 emphasis added). Fear is a spirit that tries to unveil our insecurities, but we are to remain secure in the hands of the Potter's security. He is in the furnace of testing with us, and we have nothing to fear. We must realize that the testing of our faith will stretch us to new heights. This experience will only make us stronger and more confident in the Potter's ability to purify us for "greater works to come." Each test brings us closer to reaching our full potential while, at the same time, aligning our will to the will of the Potter. I have realized that the only way to have strong faith is to endure great trials. We gain strong faith by standing firm through the flames of testing. How true is this?! You must trust Him when all else fails. If you are enduring great trials at this very moment, you are at the precipice of your strongest faith. God will teach you during your darkest hours how to have the most powerful, closest bond to His throne

you could ever know. God's greatest gifts of faith can come through seasons of pain, but they are only for a season. Can we find anything of value in the spiritual and natural realm that has been made manifest without toil and tears? Has there ever been a great artwork, invention, creative endeavor, reform, discovery, or revival without blood, sweat, and tears? Great faith and strength cost us something. [31]

Place your hope in the fact that He already sees the finished work. Inquire of Him, and He will give you a vision of what you are meant to be. He will show you a picture in your heart, mind, and spirit if you ask. When you see the image by faith, write and sketch it out. If God loved us enough to send His Son to die in our place, how can we believe that His love for us will ever fail? Our greatest weakness can become our greatest strength. God loves us, and that love is eternal. That is why He desires for us to live forever in His presence. Jesus came to free us from the fear of death (Heb. 2:14-15). He not only sent His Son but His empowering Holy Spirit. We do not have to be insecure anymore but secure in the presence of almighty God. Nothing can separate us from the love of Christ: "Your faith will be like gold that has been tested in a fire. And these trials will prove that your faith is worth much more than gold that can be destroyed. They will show that you will be given praise and honor and glory when Jesus Christ returns" (1 Pet. 1:7). Wow! This is a scripture that builds a very vivid picture in our minds. Here is an example where Peter gives us insight into God's heart. He reveals that our faith is more important to Him than gold. God is more interested in seeing your spiritual life healed and your faith strong. Physical healing is a byproduct of your faith centered on the Healer Himself. He wants you healed spiritually, emotionally, and physically. His refining fire is meant to make you holy, and in

that process of holiness, He releases "wholeness" in our lives. Get closer and deeper in love with the One who made you. He has the keys to unlock the fullness of His glory and the overflow of healing. Do not despair: "Be still and know that I am God" (Ps. 46:10).

God's still, small voice is like a gentle rain shower that quenches the fiery flames. His words are like a shield against the extreme heat of affliction. The Potter's voice is the shield that quenches the fiery arrows of Satan. Sickness may try to intrude into our lives, but the cure is at hand. No matter what, God has chosen you. Do not be afraid, for the Lord is with you. His presence and creative voice are your comfort and safety through your trials. He will never leave or forsake you. Remain "seated" with Him in the heavenly realms with Christ Jesus. There is tremendous power in the stillness of waiting on the Lord, as you trust Him to fight your battles and deliver you from them all! God never puts new wine in old wineskins. The new wine and fire He pours into our lives supersedes the past to such a degree that the old container is no longer sufficient. Its rich complexity and warmth are much greater than the previous outpouring, resulting in the need to be placed into a newly formed container. May we always be willing to be a vessel of honor in our hearts.

In the midst of the pressure and the heat, I am confident His hand is on my life, developing my faith until I display His glory, transforming me into a vessel of honor that pleases Him.

—Anne Graham Lotz

New Wine

In the crushing
In the pressing
You are making new wine
In the soil
I now surrender
You are breaking new ground
So I yield to You into Your careful hand
When I trust You I don't need to understand
Make me Your vessel
Make me an offering
Make me whatever You want me to be
I came here with nothing
But all You have given me
Jesus bring new wine out of me
Cause where there is new wine
There is new power
There is new freedom
And the Kingdom is here
I lay down my old flames
To carry Your new fire today

Song lyrics by Brooke Gabrielle Fraser, Hillsong Publishing

Visual Journal & Creative Space

Expression #24

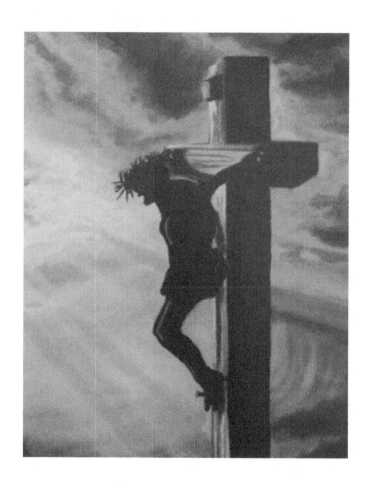

But God demonstrates his own love for us in this:
While we were still sinners, Christ died for us.

—Romans 5:8

CHAPTER 22
PRIMARY REDEMPTION

Though your sins be as scarlet, they shall be as white as snow;
though they be red like crimson, they shall be as wool.

—Isaiah 1:18

The above verse is rich with color, deep with meaning, and bold in action; it mentions scarlet, red, and crimson. For centuries, scarlet has been a color that signifies wealth, power, life, and love. While taking art history courses in college, I remember learning how the scarlet color comes from a particular insect. In antiquity, the finest scarlets came from a tiny male insect called *Kermes*, parasites among the oak trees throughout the Mediterranean. The male insects were tiny and could fly away, but the females had no wings. When collected, they were found to contain thousands of eggs, and their offspring were brilliant red. The insects were captured, dried, and ground into powder, which was used to form the scarlet dye. [16] Similarly, sin is a parasite on the human soul; it stains our lives and causes us to die physically. This is precisely what the devil wants—to stain us from the inside out. Only the scarlet blood of Jesus Christ can counteract the stain of sin, creating a reverse effect—making us white as snow. Thankfully through the blood of Jesus—the Lamb of God—there is no statute of limitation for confessing sin to receive God's forgiveness. If you sin and fail to confess it to God and then come under conviction about that sin ten years later, is it too late to confess it? Has God's grace period run out? Of course not! No such limitation exists. King David

waited almost a year before acknowledging his adultery and complicity in murder to God, and he only admitted then because he had been found out (2 Sam. 11-12). But God still forgave him. As a matter of fact, through David and the Davidic Covenant, the Messiah came to save humanity. The Creator works through dirty, muddy vessels because that is the only vessel He can work through. He who knew no sin makes us clean. He is willing and ready to forgive you regardless of what you have done because of one word—love.

As we walk through the fires of testing, we have someone who can sympathize with us in our sufferings. Scripture declares in Hebrews 4:15, "For we do not have a high priest who is unable to empathize with our weaknesses." The Potter knows how you feel right now. Long ago, He, too, walked through the fire. He has experienced the fire of pain, sorrow, loneliness, temptation, betrayal, and loss. We all belonged to the father of lies—the thief—Satan is his name. He lied to our forefathers and continues to this day. We all have fallen for his lies and have disobeyed the Potter's command—we have exchanged the truth for a lie. As a result, our earthen vessel will one day return to dust, yet our spirit will live for eternity. Our choices and willful disobedience would've sent us to a terrible place called Hell if it weren't for God's plan of salvation. Because of our sins, we were all marked with death. Thankfully, our good Creator didn't want to live without His prized creation and see us suffer the punishment for our lawbreaking for eternity (Rom. 3:23, Rom. 6:23, Dan. 12:2). Almighty God neither needs us but wants us out of sheer love. At the same time, He is a God of His word and a good judge. A good judge can't let a lawbreaker go unpunished. Our Potter is also a good craftsman who loves his work and never wants to see it destroyed—He is our redeemer. To *redeem* means to "rescue from loss." There

was only one way to satisfy God's judgment and, at the same time, make way for His mercy. He had to make a costly decision. The Potter chose to leave His Father in heaven and the paradise He created to stand in our place, as He willingly took upon Himself all of the world's punishment. He carried all of our wrongs and the wrongs of the entire world. He willingly chose to suffer, bleed, stretch out His arms and die for the entire world. He is Jesus—the son of the living God—our Potter. He bears the scars that demonstrate His love for us. By the stripes He bore upon His back, we are healed. He is the Lamb of God sacrificed on the altar, and it is only through His blood that we are cleansed from all our sins. Only by His handiwork is our relationship with the Father restored. This mutual restoration provides each believing individual with the promise of everlasting life. True love can get very messy, but it is a free gift that is ours for the taking.

To some, the cross of Jesus Christ presents a dilemma. If the heavenly Father is good and loving, why would He allow His son to endure the agony of crucifixion? From our human perspective, nothing is loving about this horrific scene. But when we look beyond the visible through the lens of faith, we'll see an awesome demonstration of love. To grasp what was going on at the cross, we must first understand that the Lord is righteous and just. He always does what is right and never acts contrary to His nature or His Word. On the other hand, humankind is sinful and deserving of eternal punishment. God couldn't simply decide to forgive us because He would cease to be just. Justice requires that a penalty be paid for sin. The Lord had to condemn us all to suffer His wrath. Or there had to be a plan before the world's creation to satisfy His justice yet allow Him to reveal His mercy. Praise God for the masterful plan He had in place before the world

began (Rev. 13:8). The sinless Son of God came to earth in human flesh to be our sin-bearer. The Father placed all our guilt, punishment, and brokenness upon Him to purchase our healing. He paid a very high price for our salvation. 1 Peter 1:18-19 says, "For you know that it was not with perishable things such as silver or gold that you were redeemed from the empty way of life handed down to you from your ancestors, but with the precious blood of Christ, a lamb without blemish or defect." Because the Savior's payment fully satisfied divine justice, a sinful man could now be declared righteous; justice punished sin while mercy rescued ALL sinners. Anyone who accepts Christ's payment can be saved and healed spiritually and physically. God proved His great love for us by the very act that looked cruel and hateful. This was the sole plan that could save us, and God's perfect Son was the only one qualified to be our substitute. The most beautiful truth of all is the fact that Jesus did it with a willing heart. [15]

When we look at the scene of the cross, it looks like a paradox. It demonstrates the power of God in what appears to be the weakest moment in His Son's life. With hands and feet nailed to a rugged piece of His very own creation, Jesus looked completely helpless. He remained on the cross while the crowd mocked Him: "If you are the Son of God come down from that cross" (Matt. 27:40). Strength is not always revealed in a dramatic display. Sometimes, it is simply demon-strated in determined endurance. What power held Jesus on that cross when He could have been free with one spoken word? Divine love kept Him there. With humanity's eternal destiny at stake, Christ hung on the cross until He attained our salvation. But the power didn't end when Jesus finished suffering, gave up His spirit, and died. His death opened wide the door of salvation and healing to ALL people. Those who

walk through this door by faith are forgiven for every sin and assured a place in heaven.

The Foundation of the New Covenant & the Great Mediator

Jesus is the mediator of the new covenant (Heb. 12:24), now and for all time. A mediator reconciles differences between two parties who are not in agreement with each other. Mediation can be difficult between two individuals in a disagreement in general, but can you imagine mediation between a sinless God and sinful humanity? Overcoming this enormous chasm physically and spiritually took more than a peaceful conversation to resolve. The resolution demanded a painful and messy sacrifice. Let's look back at Jesus's words during His last Passover meal. He said, "This cup is the new covenant in my blood, which is poured out for you" (Lk. 22:20). As was mentioned in previous chapters, under the Mosaic Covenant with Israel, the blood of a spotless animal was the price of one's sin offering. But this method of offering could not permanently bridge the gap between God and man. It served as a temporary bridge to satisfy the judgment, but it could not bring permanent obedience and relationship to both parties. The sin offering was a repeated, messy event, where the innocent and spotless animal was the substitutionary sacrifice by taking the punishment for sinful man. The animal could never be the "Great Mediator" to mend the broken relationship. Only the Son of God could stand in the gap, bridging healing and redemption once and for all. Jesus, our Creator, willingly came to earth to be that permanent sacrifice, not out of obligation, guilt, or responsibility. Jesus is the spotless and sinless lamb that willingly took our place of punishment to redeem the entire world. [8] Scripture states, "There is one God and one mediator between God and

men, the man Christ Jesus, who gave Himself as a ransom for all men" (1 Tim. 2:5). The next time you sit at the table of communion, listen closely to the voice of the mediator: "This [bread] is my body, which is broken for you...This cup is the new covenant in my blood" (1 Cor. 11:24-25). Our "Great Mediator" is not only our Creator, Potter, and friend—He is our great Redeemer!

After the work of salvation, Jesus calls out to us, "If anyone would come after me, he must deny himself and take up his cross and follow me" (Mk. 8:34). He calls out to us, not commanding us to go out and get rich, seek to have a comfortable life, acquire as many worldly possessions as possible, or seek power and prestige in our job. No. Jesus says we must deny ourselves, take up our cross (not comfortable) and follow Him. The cross that the Lord calls you and I to carry may take on various shapes and forms. You may have to be content with the mundane tasks in a limited-service area when you feel your abilities are suited for much greater work. You may be called to cultivate the same field year after year, even though it yields little or no harvest. God may ask you to sow in kind and loving thoughts about the very person who has wronged you; your calling may be to speak gently to them, take their side when others oppose them, and show sympathy and comfort to them. You may have to openly and boldly testify of the power of Jesus Christ's work on the cross before those individuals who necessarily may not want to be reminded of His claims. He may call you to walk through this world with a smiling face while having a broken heart deep within. Yes, there are many different shaped crosses, and each of them is heavy and painful. None of us would seek to carry one of these crosses. Yet, Jesus is never as near to you as when you lift your cross, lay it upon your shoulder in a spirit of submission, and welcome it with a

patient and uncomplaining spirit. He draws close to mature your wisdom, deepen your peace, increase your courage, and provide you with supernatural power from above. He does all of this so that the same painful and distressing experience can be helpful to others. Each one of Jesus' disciples knew this very well. Yet, they counted everything as a loss to follow Christ. From this pressing, the greatest anointing oil may flow into the vessels around you with the lingering aftertaste of, "Not by might, nor by power, but by my Spirit, says the Lord" (Zech. 4:6).

Even after salvation, many have answered Jesus' call to take up their cross to follow Him, as the power of the cross continues in the believer's lives. Millions of people have been transformed due to the Savior's victory over sin and death. He not only sets us free from sinful habits, addictions, sicknesses, and disease, but He empowers us to live victoriously in His righteousness. Have you let the cross do its work in your life? Jesus is the mediator who stretches out His arms, reaching to redeem you. Reach out and touch His nail-scarred hands to receive your redemption. He paid a high price for you and me. The Lord does not force His benefits on anyone. Rather, He offers them freely to all who will believe in Him and walk in His ways. With each step of faith taken, the mighty work of God in us will increase.

The Red Umbrella Vision

The Holy Spirit gave me a vivid vision in 2021. I was walking alone down a narrow pathway. In the distance, massive storm clouds filled the sky as lightning flashed from the east to the west. The winds began to pick up in speed and intensity as the atmosphere became increasingly ominous. Then, one by one, raindrops began to fall steadily. I anxiously searched

for a place to find shelter but could not do so. I then heard the steps of someone walking calmly in the distance. A man dressed in white began to walk beside me. It was Jesus! All I know is that He was radiant with peace and assurance. He told me that He would be my shelter from the storm. The rain began to fall heavier as we walked together, and I lost my balance due to the rough terrain. It became rockier and much more difficult as we journeyed further. Jesus took out a big red umbrella and opened it above our heads. As it popped open, a burst of tiny red droplets fell all around us in slow motion. After this moment, we were completely dry and safe as could be. It was as if He placed a shielding force field around us to keep us protected. As I continued to lose my footing, Jesus took His arm and lovingly placed it around my waist as He held me securely. I did the same in return. I felt a great intensity of faith, hope, and love surge into my body; His security, compassion, and assurance were indescribable. He held me tenderly like a husband would embrace his wife or a father, his child. His love was so great that I could not put it into words, but it kept me from stumbling. I walked down the path, now fully stable, even though the rocks were still underneath me. It was as if we were walking on air and hovering above it all. The darkness around us began to dissipate, and the pathway grew brighter and brighter with each step. I asked, *Where are we going?* While still holding the red umbrella and with great joy, Jesus replied, *I am taking you to meet the Father!* We came to a place of great beauty and light. The storm had ended, and we were now walking on smooth streets paved with gold. He still held the red umbrella even though the rain had stopped as we continued towards a greater light coming from a large structure. We entered through an outer courtyard, through the inner dwelling, and approached the Holy of Holies. I became

anxious as a million thoughts ran through my mind of all the wrongs I had done. Jesus replied with a smile on His face, *Fear not!*

There we were, now standing before the Father and His majestic presence. It was like a man introducing his father to the woman he had chosen to be his wife, seeking his approval and blessing for the marriage. Jesus, the Son, was full of joyful confidence as He introduced me with honor. We continued to stand under the big red umbrella. The Father called out to me and said, *Son, you are covered under my Son's own blood just as an umbrella shields you from the pouring rain. Because He has obediently and joyfully endured the cross, His blood covers all your sins—the past, present, and future. His blood makes you the righteousness of God through Christ and is your* **Umbrella Coverage***, erasing all your sin and debt. Because He took upon Himself all your punishment, you are now free from all destruction and have become whiter than snow. His blood covering can leave you with the assurance that you are forgiven, protected, and accepted. When I look upon you—my beautiful creation—I see a spotless bride that is pure and forgiven. I see the sacrificial work of my Son. He has presented you faultless before Me with glory and great joy. Enter into the presence of the Lord!*

There is no greater insurance policy with the ability to cover your entire life than the precious blood of Jesus! I share this revelation as a powerful reminder that we are fully secure in Christ. We now have the full assurance that we can come boldly before the throne of grace (Heb. 4:16). Jesus is the only redeemer, advocate, and insurer who guarantees our security now and forever. We now can approach the Father boldly and confidently! Through Christ, we have become sons and daughters of the Most-High God. You and I are called "Friends of God," as we will be in His presence soon. Thank you, Jesus, for

being my *Umbrella Coverage. Is your temple insured under the 'Red Umbrella Coverage' that the Father offers you?* A beautiful scripture that confirms this vision comes from Colossians 1:21-23, "Once you were alienated from God and were enemies in your minds because of your evil behavior. But now he has reconciled you by Christ's physical body through death to present you holy in his sight, without blemish and free from accusation—if you continue in your faith, established firm, and do not move from the hope held by the gospel. This is the gospel that you heard, and that has been proclaimed to every creature under heaven."

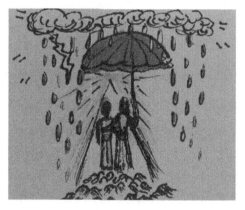

Umbrella Coverage, 2021 Visual Journal Sketch, by Timothy Kosta

Molding Moment

He himself bore our sins in his body on the cross,
so that we might die to sins and live for righteousness;
by his wounds you have been healed.

—1 Peter 2:24

Salvation is a free gift, as well as your healing. When Jesus Christ took the lashes on His back, He purchased that healing for you. But just as He paid the ultimate price, we also have a price to pay. His price is not money, our time, or our efforts. His price is our entire being. He wants all of us in a relationship. God even says, "You shall love the Lord your God with all your heart, and with all of your soul, and with all of your mind, and with all of your strength" (Mk. 12:30). We must be willing to give God our all. You can only receive your healing through faith. It is the faith in the work of Jesus' broken body that heals you. We must imagine our sickness, disease, pain, and addictions covered under the insurance of the broken body of Christ. God loves you and is more than willing to heal you. Our faith must continue to grow, and the only method for increasing that faith is through the Word of God. As scripture says, "Faith comes by hearing, and hearing the Word of God" (Rom. 10:17). The scriptures also declare that "Faith without works is dead" (Jas. 2:17). Faith must be expressed in some way to make it active. Galatians 5:6 gives us a clue to what those works entail, "Faith works through love." Wow! Faith is an action, and the work that must be present in our lives is love. Every miracle that Jesus performed during His time on earth was motivated by

love; His love for God the Father and His creation. Love is the power that stirs up faith and brings forth healing: "God is love" (1 Jn. 4:8). Faith is simply not enough. Love must be present for healing to take place. This love was expressed through the Father's only Son. God allowed the sacrifice of His beloved Son because of His love for you and me to save our souls from eternal separation in a place called hell.

What sickness, disease, or addiction can stand against the power of love? Express your love to Him today. Receive His love. Let the power of His love heal the innermost places of your life. [22] "One can recognize that Jesus demonstrated sacrificial love for us by dying for our sins, making possible our forgiveness and restoring us to fellowship with the Father. But Christ's love goes beyond the cross. Everything we do, don't do, face, and don't face is touched by His continuing love. Everything about us hinges on love because God, who is love, created us in His image (1 Jn. 4:8, 16). Because God loves us, He gives us blessings and lets us share them. When we pray and are told to wait, it is because He loves us and knows we need time to grow. When the overwhelming choices before us make it hard to know which way is up, our Lord and Savior shows us our need to depend on His guiding love. Jesus demonstrated this kind of amazing love to Mary and Martha upon Lazurus' death. Jesus knew Mary and Martha needed to grieve in order to grow. He allowed the sisters' pain because He loved them. Until we come to understand and believe at our deepest, innermost level that God is love, we will struggle with trusting Him, yielding to Him, obeying Him, and serving Him wholeheartedly. One of the keys to our spiritual growth as Christians is believing in God's love, even when we can not see it. While we are to live in faith and hope, our most important dwelling place is God's love. Without making His love our ultimate dwelling, we cannot fully live in faith and hope. We should refuse to

take a step or breath without remaining keenly sensitive to 'the greatest of these,' our Father's love [29] (p. 691). I encourage you to meditate on Hebrews 2:6-11:

"What is mankind that you are mindful of them, a son of man that you care for him? You made them a little lower than the angels; you crowned them with glory and honor and put everything under their feet. In putting everything under them, God left nothing that was not subject to them. Yet, at present, we do not see everything subject to them. But we do see Jesus, who was made lower than the angels for a little while, now crowned with glory and honor because he suffered death so that by the grace of God, he might taste death for everyone. In bringing many sons and daughters to glory, it was fitting that God, for whom and through whom everything exists, should make the pioneer of their salvation perfect through what he suffered. Both the one who makes people holy and those who are made holy are of the same family. So, Jesus is not ashamed to call them brothers and sisters."

To be a Christian means to forgive the inexcusable, because God has forgiven the inexcusable in you.

—C.S. Lewis

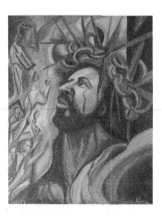

Redemption, 2009, Timothy J. Kosta

Visual Journal & Creative Space

Expression #25

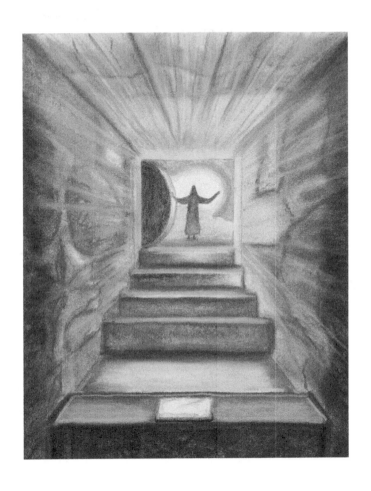

I am the resurrection and the life. The one who believes
in me will live, even though they die.

—John 11:25

CHAPTER 23
RESURRECTION

The story did not end with the death of Jesus Christ. Just as He raised others from the dead, the Spirit of God raised Christ back to life on the third day. No creation or clay vessel is too broken for Him to restore—He is our healer. Since He conquered all death, we also have the victory! His resurrection is the living proof that we, too, will live. His power is made perfect in our weakness because when we are weak, He is strong. When we trust Christ as our Savior, the Holy Spirit takes up residence within our vessel. The more we allow the Lord to fill us with the reality of His victory, the more powerful we become in facing the trials of life. We are not helpless, but victorious because of His death and resurrection. We have the power of Christ to be victorious in our ministry to one another in time of need; power over sickness, sin, and death with no weapon formed against us able to prosper. As a citizen of heaven, Satan no longer has any legal right to your spirit, soul, and body. You were bought with a price; the precious blood of Jesus Christ. After Jesus declared the power of faith over the government of evil, He said, "I will give you the keys of the kingdom of heaven; whatever you bind on earth will be bound in heaven, and whatever you loose on earth will be loosed in heaven" (Matt. 16:19). We have the power to bind Satan and loose people from their bonds of fear, doubt, unbelief, sicknesses, diseases, and demonic oppression. Many times, we find ourselves doing the opposite. We can easily bind people with our negative judgments, attitudes, and actions. In a sense, we are

giving Satan back the keys that Jesus laid His life down to take back from the enemy. What we say and how we act can hinder our prayers by stifling our growth. To counterattack this ploy by the enemy of the light, we are to claim our ministry of loosing people by helping set the captives free. We are to help bring freedom, liberty, and victory to our fellow vessels. This can be done by binding Satan in the name of Jesus Christ. The same power released through Jesus Christ is available to us, as He set people free while He walked this earth. God has given us the power of miracles, signs, and wonders to advance the kingdom of God and lead the captives to their liberator through the power of faith, hope, and love. We need to proclaim victory with the power and authority that comes from the life-giving blood of Jesus.

The ministry of loosing people includes listening, loving, and declaring the promises of God over people's lives with authority. In prayer, we should declare, *Christ, you are all-powerful. You are more powerful than evil, sickness, death, demonic oppression, generational curses, addiction, doubt, and discouragement. In Jesus' name, we bind Satan and loose this person. We ask you to loose the provision of heaven, miracles, signs, and wonders for the glory of your name.* [23] Calvary is the place of victory and ultimate transformation. We must constantly be reminded and remind the tempter of our soul; he is already defeated. Jesus is always victorious in our lives, and as we keep a right relationship with Him, the victory that He supplies within us can freely flow to all the vessels He brings to us along our journey. We have the power through Jesus Christ to redeem the present culture!

The Role of the Holy Spirit in the Resurrection of Jesus

As Jesus began His ministry, the Holy Spirit empowered every aspect of the redeeming work. Luke 4:14 says, "Jesus returned to Galilee in the power of the Spirit." As Jesus suffered mentally, emotionally, and physically in the garden of Gethsemane, an angel strengthened Him (Lk. 22:43). Knowing this, the Holy Spirit must have ministered to Jesus as He faced great torment that caused Him to sweat great drops of blood. Yet there was no greater manifestation of the Holy Spirit than in Christ's resurrection: "The Holy Spirit participated in the spectacular miracle of the resurrection of Jesus from the dead. Paul declared that Jesus, 'through the Spirit of holiness [Hebrew way of saying 'Holy Spirit'] was declared with power to be the Son of God by his resurrection from the dead' (Rom. 1:4) ...Had Jesus remained in the grave, His claims of deity would have been negated" (Palma 2001, p. 51). The powerful work of the Holy Spirit in the resurrection of Jesus is shared by the apostle Paul: "And if the Spirit of him who raised Jesus from the dead is living in you, he who raised Christ from the dead will also give life to your mortal bodies through his Spirit, who lives in you" (Rom. 8:11). Many focus their attention on this scripture when they need physical healing from God. But this verse will come to a complete fulfillment at the Rapture (see Appendix).

Just as the Holy Spirit raised Jesus from the dead, so will He one day raise us if we die before the Rapture. But the work of the Holy Spirit in this life is to prepare us for spending eternity with Jesus. Scripture says in John 17:3, "Now this is eternal life: that they know you, the only true God, and Jesus Christ, whom you have sent." What a life-changing scripture. If we look at this scripture in its context, it says that eternal

life is knowing God. If we receive and believe in the work He accomplished here on earth, and we are eternal beings seeking to love Him and have an intimate relationship with Him, then we have eternal life living within us! Start living out the Kingdom of God through His resurrection power right now, in real-time.

In one of his daily devotional entries entitled, "Between Passover and Pentecost," Charles Stanley writes about the significance of Christ's resurrection and our hope of a new day: [29]

"When Jesus spoke to the disciples about being raised from the dead in three days, it didn't make sense to them initially. They still may not have understood the full significance of what had occurred and what it really meant that the temple of His body had been raised. However, the feasts of the Lord help us to understand what happened. During the Passover feast, Jesus became our sacrificial lamb (1 Cor. 5:7). It's easy for us to see the spiritual significance of what occurred because we know His death and resurrection marked the beginning of a new covenant. Yet we often think the next feast the disciples celebrated was Pentecost—when the Holy Spirit empowered the church. Unfortunately, there's a feast we often miss. Pentecost—also known as the Feast of Weeks—refers to the fiftieth day of the Hebrew harvest; the harvest actually started on the third day after the Passover with the Feast of Firstfruits. Jesus rose from the dead on the Feast of Firstfruits—which makes sense because Jesus is the "firstborn over all creation" (Col. 1:15). In 1 Corinthians 15:20, Paul writes, "Christ is risen from the dead, and has become the *first fruits* of those who have fallen asleep."

During Firstfruits, people brought offerings of barley—the first crop of the year—to the temple. When God accepted it, He promised to provide for them with the rest of the harvest (Lev. 23:9-14; Prov. 3:9, 10). Likewise, Jesus' resurrection is given as a guarantee we will live forever. Now understand, when Jesus said, "Destroy this temple, and in three days I will raise it up" (Jn. 2:19), He wasn't only talking about His crucifixion and resurrection. He was saying that the way people worship and the way the church would function would completely change too. Remember, God said, "God is Spirit, and those who worship Him must worship in spirit and truth" (Jn. 4:24). No longer would people go to the temple to make offerings because Christ became our offering—and we ourselves became an offering as well (Rom. 12:1). On the Feast of Firstfruits, Jesus raised a new temple for us. We became God's temple. Paul writes, "Your body is the temple of the Holy Spirit who is in you, whom you have from God (1 Cor. 6:19). We are the new temple. When they tore Christ down, God raised us up. We are an acceptable offering to the Lord because Christ made us acceptable. The Romans destroyed the earthly temple—the one mentioned in John 2:20—in A.D. 70, and today what stands in its place is the Muslim Dome of the Rock and Al-Aqsa Mosque. However, we no longer look to a temple that can be destroyed. Rather, we are a temple that lasts forever—and grows in strength with each person who believes in Jesus Christ as his or her Savior (Eph. 2:20-22). What can we learn from this? What should we take away from the Feast of Firstfruits? In all things we must imitate Christ—the first of the harvest—and have the eternal perspective He had. Jesus came to give us everlasting life and change our focus from the temporary to the eternal. Is there something you are struggling with today—some temple being torn down in your life? Jesus is raising it up again, but

not necessarily the way you think. Jesus has a better eternal vision for your life than you can imagine, so trust Him. And be assured what He's building in you will last forever [29] (p. 601).

One of the major events recorded in scripture that supports Christ being the first fruits is that other "holy people" were raised back to life after Jesus's resurrection. On the day that Jesus died, scripture records that a massive earthquake occurred, splitting the temple curtain that separates the Holy of Holies from the inner court in two (Mk. 15:38, Lk 23: 44-45), as well as many graves of "holy people" being split open (Matt. 27:51-52). After Jesus' resurrection on the third day (Feast of Firstfruits), the NIV suggests that these deceased people were resurrected from the dead, came out of the split tombs, and returned to Jerusalem (the Holy City), where friends and family recognized them. Thomas Walvoord suggests this event was a "fulfillment of the Feast of the Firstfruits of harvest mentioned in Leviticus 23:10-14. On that occasion, as a token of the coming harvest, the people would bring a handful of grain to the priest. The resurrection of these saints, occurring after Jesus Himself was raised, is a token of the coming harvest when all the saints will be raised" (*Thy Kingdom Come*, p. 236).

1 John 5:4 tells us, "Everyone born of God overcomes the world. This victory has overcome the world, even our faith." Satan did everything in his power to try and rob Jesus and the entire world of the victory, but failed. Satan is far from retiring from his work of attempting to deceive and destroy the children of God. If you put into action victorious faith at the right moment of your seemingly defeated circumstances, you can snatch victory from the jaws of defeat. Jesus' defeat of the grave and death demonstrates how faith can change any situation, no matter how dark or difficult. Lifting your heart to God in a moment of genuine faith can quickly alter your

circumstances with resurrection power. God is mighty! He is more than able to deliver you; fear, death, sin, and sorrow have already been defeated through your faith in God and His conquering power. Even though the days may seem dark, have faith that the sun will shine. Even though there may be dark clouds today, you can have confidence that He has planned a bright future. Have faith in the one who has defeated death and has secured your inheritance. People of faith, your feet will soon sink into Heaven's golden shores.

Molding Moment

For it is by grace you have been saved, through faith and this is not from yourselves, it is the gift of God.

—Ephesians 2:8

The word "grace" has the meaning of unmerited favor and healing. Grace is a gift from God, and it cannot be bought or earned. Only by God's grace do we receive anything good in this life. By His grace, the plan of salvation existed from the beginning of time. In John chapter 1 it says, "The Word (God Himself) became flesh (Jesus) and dwelt among us, and we beheld His glory, glory as of the only begotten from the Father, full of grace and truth" [emphasis added]. Everything that Christ did on earth was an act of grace. Everything from raising the dead, healing the blind, cleansing the leper, and setting people free from demonic forces was all by His grace. It is a gift that must be received by faith. When you receive a gift at Christmas, you don't just marvel at the beautiful wrapping paper and leave the gift on the shelf unopened, simply speculating what it could be. Our first response is to want to open the gift to see what is on the inside. God wants us to receive and open the best gift He had to offer—His Son, Jesus Christ. He is the greatest treasure and the pearl of great price, but we must receive the gift inside our vessels. When God gives you His grace, He gives you something that you cannot produce on your own, nor something you deserve. It is by His grace that He made the crippled walk. It is by His grace that washes away your sins through His shed blood. Your sins have

been washed away only by His blood, and healing manifested in every part of your life. The gift of His grace allows you to be forgiven of your sins and provides you the opportunity to live forever in His presence. Place your trust and confidence in Him as you come under His hands of grace.

> *When a man comes under the blood of Christ, his whole capacity as a man is refashioned. His soul is saved, yes, but so are his mind and his body. True spirituality means the lordship of Christ over the total man.*

—Francis A. Schaeffer, "Art & the Bible"

Visual Journal & Creative Space

Expression #26

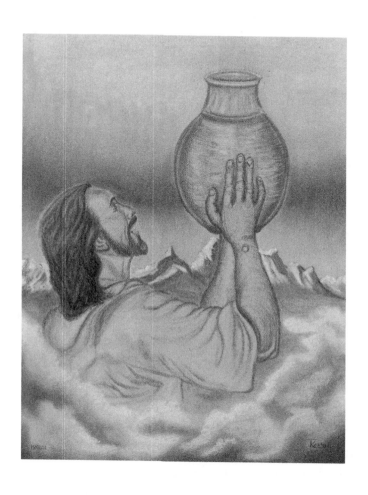

Therefore, if anyone is in Christ, the new creation has come:
The old has gone, the new is here!

—2 Corinthians 5:17

CHAPTER 24
REBORN TO INHERIT THE LAND

I remember learning about one of the earliest archaeological discoveries of God's covenant name—Yahweh—found on two silver amulets near Jerusalem. Amulets were small jewelry pieces thought to be protective of evil or harm. Inscribed on them was the "Aaronic blessing" found in Numbers 6:24-26, in which God's name Yahweh, "the Lord," occurs three times. This blessing is well known to churchgoers and Jewish people alike, as it is often used as a benediction: "The Lord bless you and keep you; the Lord make His face shine upon you and give you peace." It is one of the most beautiful benedictions known to the Jews and Christians. Paul gives a New Testament equivalent in 2 Corinthians 13:14. We can see why people want this amulet hanging around their neck. What harm can come to one who is cared for by Yahweh? We must realize that God is blessing you, making His face shine upon you at this moment, and giving you peace. The word *vessel* in this illustration is portrayed as an "offering" or a "lifting up." This is a vertical alignment of worship unto God the Father. God says in His Word, "To worship the Lord and serve him only" (Matt. 4:10). Here, the Potter is so full of joy and is delighting in His new creation. It has been born again! The vessel looks, acts, and serves a new purpose. The old ways of life are dead and buried, as the new life has come forth. Envision your very own face embraced by the Potter's loving hands. He is so proud of what you are becoming. He loves you because you are the work of His hands, and He says, *It is good…very good!*

Resurrection power has taken place, and the Potter elevates the vessel above the clouds and smoky haze of the furnace. He lifts the clay high above the mountain tops to offer praise and thanksgiving to the Father in heaven. Jesus sits at the right hand of God, the Father, making intercession on our behalf. As the Potter dedicates the vessel, a new flood of refreshing water refills the vessel to capacity. The Father places a rainbow in the sky to symbolize His everlasting covenant. He is faithful to His promises! The vessel is now radiantly filled with the Glory of the Lord, just as it was back in the garden. We now can see with renewed vision. The vessel is ready for service in the Potter's hands.

The Holy Spirit in the New Covenant

The new covenant is a spiritual relationship between the Creator and His creation. Still, frail humanity needs help keeping that relationship alive, healthy, and in divine fellowship. Looking back, we see that the Old Testament is a continuing story of the failures of God's chosen people. But God had a plan from the beginning that included a solution for this emptiness. The prophet Joel was given a tremendous prophetic word of promise from God: "I will pour out my Spirit on all people. Your sons and daughters will prophesy, your old men will dream dreams, your young men will see visions. Even on my servants, both men and women, I will pour out my Spirit in those days" (Joel 2:28-29).

Jesus, our Great Mediator, knew we needed help. Just before He left His disciples to return to the Father, Jesus promised that a Helper would come: "When the Counselor comes, whom I will send to you from the Father, the Spirit of truth who goes out from the Father, he will testify about me" (Jn.

15:26). Fifty days later, Joel's prophecy became a reality. On the day of Pentecost, the Holy Spirit descended with power, filling the 120 followers with His Spirit with the evidence of speaking in the tongues of foreign lands. The apostle Paul saw that the welcoming of the Holy Spirit by the Gentiles was part of the fulfillment of the promise of blessing that God gave to Abraham: "Christ redeemed us from the cures of the law by becoming a curse for us, for it is written: "Cursed is everyone who is hung on a tree." He redeemed us so that the blessing given to Abraham might come to the Gentiles (non-Jews) through Christ Jesus (Gal. 3:13-14).

When we trust in the covenant cut in, and through Jesus Christ, the Holy Spirit takes up residence within our vessels. This is the blessed result of coming under the new covenant. This is the moment of salvation when we become a new creation. Scripture declares, "For this reason Christ is the mediator of a new covenant, that those who are called may receive the promised eternal inheritance—now that he has died as a ransom to set them free from the sins committed under the first covenant" (Heb. 9:15). Yet until life in these earthly bodies ceases, there will continue to be a war between the old and new behavior patterns. The Lord may allow difficulty that brings about brokenness to lead us to victory. His purpose is to rid us of our old "flesh" to experience the fullness of life in Christ. It is a refinement where we may have to revisit the furnace of testing to strengthen the vessel further and deepen our faith in the Potter. There may be remaining areas of self-advancement, self-centeredness, self-will, self-dependency, and self-righteousness within the clay walls. Notice the keyword "self." To some extent, these motives exist in all of us, but our Father lovingly breaks them within His children over time. At salvation, God gives us a new nature, the evidence of which

is the fruit of the Spirit: "Love, joy, peace, patience, kindness, goodness, faithfulness, gentleness, and self-control" (Gal. 5:22). These qualities allow us to love and be loved; people will be attracted to Jesus when they sense these characteristics in us as believers. On the other hand, if these attributes are missing, we can never truly experience life as God intended. The process of brokenness and restoration is unpleasant at times. But the result is well worth the suffering that it requires. The good news is that we are continually being sanctified and conformed to His image. [36]

A wonderful future awaits the Spirit-filled believer. God says that, as believers, we will inherit the land. As we wait for the promise of His coming, "We have the first fruits of the Spirit...as we wait eagerly for...the redemption of your bodies" (Rom. 8:23). The fruit of the Spirit (Gal. 5:22-23) makes us more like the Potter with whom we will spend eternity. The gifts of the Spirit are just a taste of the exciting—new life—we will be living for eternity. We must remember that the old covenants in Scripture were not failures or lessons that needed to be learned. Of course, we can learn from people's choices, patterns, and mistakes. But these covenants were the creative, foundational layers for the progression of God's plan of redeeming the past and present cultures. Therefore, Israel is not forgotten, and God continues to have a special purpose for "the apple of His eye" in the imminent end-time events (see Appendix).

Inheriting the Land

There are countless scriptures in the Bible that declare that the righteous believers will "inherit the land." None of us are righteous in our strength, but because of our *Great*

Mediator—Jesus Christ's work—we have an inheritance waiting for us—the Kingdom of Heaven. Just as the promised covenants of God were given to Abraham, Moses, and David, every culture has had the opportunity to reap the benefits of God's inheritance. Because of the faith and obedience of our God-fearing ancestors, the promise that "all nations will be blessed because of you (Abraham)" was becoming a reality. Jesus is the fulfillment of the covenants. By purchasing our freedom with His blood, the Father freely gives access to His inheritance to everyone who believes in Him. After Jesus' resurrection, He gave one of the greatest prophecies, "You will receive power when the Holy Spirit comes upon you; and you will be my witnesses...to the ends of the earth" (Acts 1:8). This prophecy is still being fulfilled today when a believer receives the baptism in the Holy Spirit (see Appendix). Millions of people are coming to know Jesus because of the powerful witness of Spirit-filled believers, their faithfulness, and the authenticity of their lives.

Paul describes the Holy Spirit as a deposit with a guarantee for the future three times in two letters. The Spirit is "a deposit, guaranteeing what is to come" (2 Cor. 1:22; 5:5). Paul calls the Holy Spirit "a deposit guaranteeing our inheritance until the redemption of those who are God's possession" (Eph. 1:14). Horton [13] identifies the inheritance as coming at the Rapture: "The deposit...is a 'first installment,' an actual part of the inheritance that guarantees we will receive a larger measure later when we receive our full inheritance—that is when Jesus returns, and we receive our new bodies, changed into His likeness" (p. 156). The inheritance given to us by our parents or a family member is nothing compared to the inheritance we will receive when we meet our Lord. The Holy Spirit deposited in us is the guarantee of that inheritance.

Inheriting the Land: A personal experience

I have a very personal connection to the word "inheritance." When I was in elementary school, the Holy Spirit spoke to me and said, *You will inherit the land.* Since that time, the Holy Spirit has continued to bring illumination as to what those words truly mean. Naturally, I always thought it meant I would inherit the home I grew up in. But I am learning that those words mean so much more.

Our home had a rich history. My grandparents built the home in 1962. My mom was 11 years old when she moved into the house. After my mother and father got married, my grandparents kindly offered to have them live in the home as they started their new life together. As years passed, my parents continued to honor my grandparents, and as a result, they were invited to live in the home permanently. Two years later, I was born. I grew up being loved by my parents and grandparents in the same home. It was a wonderful childhood experience. In 2008 I married my wife Krissy, and we lived as newlyweds in an apartment for about three years. During that time, God's Word spoken over me from childhood continued to surface in my spirit, *You will inherit the land.* The following year my parents offered my wife and I the home I grew up in, just like my grandparents had done. Krissy was already pregnant with our first child, and we knew the time had come to move out of our small apartment. All of us knew God was opening a door of blessing. God gave me another prophetic word from Isaiah 54:2, "Enlarge your house; build an addition. Spread out your home and spare no expense!" We took God at His Word and stepped out in faith. My wife and I took out a mortgage to expand and renovate my childhood home. We knew God wanted to create a comfortable space for my parents and our

growing family. You see, God's Word came to pass because He already released His provision. We just had to take Him at His Word and receive the inheritance He had already given us. I had inherited the land just like God had promised. But it didn't stop there. I continued to hear those words echoing in my spirit. In the middle of building, expanding, and enlarging the borders, God spoke another word, *Will you continue to trust me if things don't go the way you planned? If things appear to get difficult?* Naturally, in our hearts, we trusted Him no matter what, even though the message was unsettling. While moving forward, the unthinkable had happened. My father, mother, and I had all lost our jobs simultaneously. We just took out a mortgage to expand the home, we were preparing to have our first baby, and now we had lost our jobs? How was God in all of this? Would we continue to move forward and trust in His promises?

Creativity, Art & Spiritual Warfare

As a teacher, it was difficult to find a job because many teachers were being excessed due to the economic recession in 2011. It was time to fight for the inheritance artistically and spiritually. During this time, God placed a series of specific artworks within my spirit. These works were meant to be created privately through spiritual warfare during prayer and worship. One was based upon Noah, and the spoken words, *Get in the ark. With faith comes favor.* The other was a picture of a fortress with *"A mighty fortress is our God. A strong tower in times of trouble"* written on the back. The Holy Spirit directed me to place pictures of my family (all those living on the inherited land) behind the artworks, as I continued to pray and fast for weeks. The visuals served as a great weapon in warfare,

as God allowed me to increase my faith and see His promise of victory. The morning I had come to collect my belongings from my classroom, I noticed it was extra quiet in the building. As I walked up to my classroom door and peered through the glass, I noticed something strange on the floor. It was a large ceiling tile that had fallen and smashed on the ground. As I slowly crept into the room, I peered up at a huge square hole in the ceiling. Naturally, I stopped, stared, and wondered how it could've happened. It isn't every day that ceiling tiles that snuggly fit into place come crashing to the floor. It was almost as if a shaking had occurred, like an earthquake. As soon as I said those words, I saw a ladder descend out of the gaping hole in the ceiling in the Spirit. I heard the Spirit say, *"I have heard your prayers, and I have made a way of escape for you. You will not be destroyed. I am going to 'translate' you. You will inherit the land."* Wow! All of that from a hole in the ceiling and a broken tile on the floor? Yes! A few months later, God did just that. He had a teacher resign from their art position at a new school district, which provided a new job for me. I will never forget the day I walked out of the administration building after signing the new contract. As I walked out of the building to get into my car, there in front of me was a large expanse of land; a brilliant green field. Another visual reminder of God's covenant with my family. Once again, I had "inherited the land"—a land He called me to cultivate.

These personal experiences were given to me to illustrate the future inheritance as "a deposit, guaranteeing what is to come" (2 Cor. 1:22; 5:5). The Holy Spirit said I would inherit the land. It goes way beyond inheriting just a house or a position. These are just the "Kingdom Deposits" tangible here on earth. The real inheritance is the Heavenly Kingdom to come, whether through the Rapture or natural death. The covenants

of the Old Testament, which served as "shadows" of what was to come in the New Covenant through Jesus Christ and the Holy Spirit, are a personal guarantee of the inheritance that will be given to me and any other believer. God revealed to me that the Holy Spirit living within my earthly vessel right now is the guarantee of the future inheritance. The home my wife, parents, son, and daughter live in currently (they are the 4th generation in this home) is my earthly inheritance. Still, it is a deposit or installment of God's promise that I have a greater inheritance in Heaven. The visual arts teaching position I received is one of many installments/guarantees of the priestly positions I will serve in the new Heaven and earth. Most of all, I will inherit a face-to-face relationship with the Father, Son, and Holy Spirit. God's presence and provision proved to be mighty, not only in my life, but also in my parents' life. After my parents lost their jobs, we had our first baby, Emma Grace. God removed my father and mother from their jobs to have the joy of caring for their granddaughter and later their grandson, Timothy John Jr. It was a win-win situation. The Lord provided for all of our needs. Emma and Timothy would now have the blessed experience of growing up with their grandparents' joy, love, and care.

In receiving an inheritance, only a living individual can obtain it. A dead person will not receive the inheritance but rather a son or daughter who is alive. The Holy Spirit says, *You will inherit the land.* I have recently been inquiring of the Lord, *What else do you have in store for me?* He softly says to my heart, *The Rapture. You, your whole family (mom & dad included), my bride (the church)—this generation—will walk into the kingdom I have prepared. You will receive my inheritance without experiencing death. I will translate you. I will transport you from where you are to where I Am in the twinkling of an eye;*

I will save you from the wrath and destruction. I will gather the elect from the four corners of the earth to walk where I walk, dance where I dance, and create where I create. Wow! I am hopefully looking forward to seeing this prophetic word unfold. Friend, this is a promise for you and me. Whether or not you received an inheritance when your parents left this earth doesn't matter. If you are a son or daughter of the Most-High God, you have a great inheritance waiting for you. God says, "Store up for yourself treasures in heaven" (Matt. 6:19-21). The Rapture of the church is closer today than ever before. The Rapture is imminent because of the Holy Spirit's work through the resurrection of Jesus Christ. Because He lives, you will live!

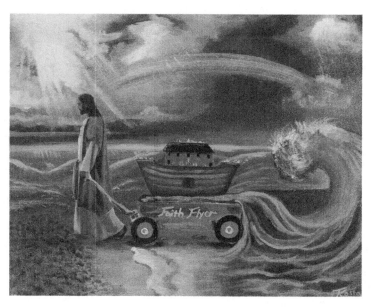

Faith & Favor—Inheriting the Land, 2011, Timothy J. Kosta

Molding Moment

Praise the LORD. How good it is to sing praises to our God, how pleasant and fitting to praise him! The LORD builds up Jerusalem; he gathers the exiles of Israel. He heals the brokenhearted and binds up their wounds.

—Psalm 47:1-3

One of the most important weapons in the believer's arsenal to defeat the lies of Satan and bring about healing is *praise*. Just as God has enabled creatures to heal themselves, we too have an earthen vessel capable of healing itself through God's grace. Yes, we need to have a positive attitude and positive thinking, but it goes well beyond this. A life filled with praise helps produce hope and faith in our lives. Praise and worship are more than the songs we sing, instruments we play, or paintings we create; it is our life song. A life filled with praise and love towards God will ultimately manifest in healing. As you meditate on God's Word, hope will fill your heart, causing your faith to soar on wings like eagles. How do you do this? As you concentrate the thoughts of your heart and mind on the greatness of God, His love, mercy, and compassion will begin to move in powerful ways. Allow yourself to be born again in spirit. God desires to not only make you a new creation. He wants you to live a supernatural life every day in the natural world. [16] Because Christ rose from the dead and defeated the grave, we too must be raised to life in the Spirit by trading in our old garments for new ones. We must be born again. Jesus answered the Pharisee Nicodemus, "Very truly I tell you, no

one can enter the kingdom of God unless they are born of water and the Spirit. Flesh gives birth to flesh, but the Spirit gives birth to spirit. You should not be surprised at my saying, 'You must be born again'" (Jn. 3:5-7). We cannot enter the Kingdom of God on our own terms. We must enter on God's terms through the remedy prescribed for us. This remedy is none other than walking on a narrow path and entering through One gate—Jesus Christ. As you seek Him, you will find that He will lead you into a life of healing, restoration, eternal life, and your true inheritance.

The righteous will inherit the land and dwell in it forever.

—Psalm 37:29

Visual Journal & Creative Space

Expression #27

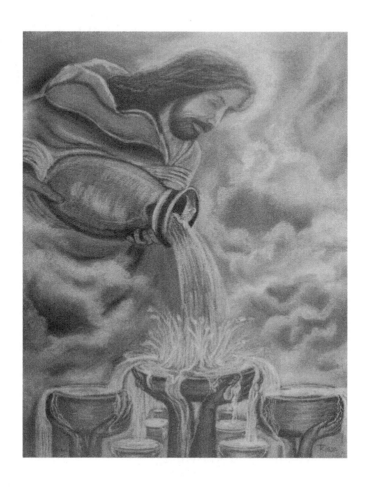

But you are God's chosen treasures…set apart as God's devoted ones. He called you out of darkness to experience his marvelous light, and now he claims you as his very own. He did this so that you would broadcast his glorious wonders throughout the world. For at one time you were not God's people, but now you are. At one time you knew nothing of God's mercy, because you hadn't received it yet, but now you are drenched with it!

—1 Peter 2:9–10 (TPT)

CHAPTER 25
GIVE THEM A DRINK

When we look back in Genesis, we see that the Lord gave Adam the creative job of naming all the animals. The Creator must have felt great excitement and joy as He waited to hear the names Adam created! While the details of this tremendous task are unknown, one thing is clear; the Creator wasn't interested in crafting mindless robots or enslaved people as a labor force to do His bidding. He desired children who would freely share in the "family business" of shaping and creating the culture of the world we inhabit. When you think about it, we are called to be fellow craftsmen and women at His side, "Created in Christ Jesus for good works" (Eph. 2:10). Since we are made in the likeness of God's image, we have the incredible privilege of reflecting His creativity in our work every day. The church itself is called to represent Him; "In whom are hidden all the treasures of wisdom and knowledge (Col. 2:3) by displaying the manifold nature of His creative genius" (Eph. 3:10). So, shouldn't those who hear His voice be among the world's most original thinkers, innovators, and problem-solvers? We often underestimate ourselves or don't feel positioned to shape history in this way, but when the Creator is present, all things are possible. What matters most is not our intellect, but our relationship with the One who makes the simple wise (Ps. 19:7). As we accept and build a relationship in prayer with Christ, something unique will begin to happen; we will gain supernatural insight we could have never conceived on our own. A creative idea may be birthed way ahead of schedule in

our mind, but it is something God has placed within us to be nurtured and imagined. This idea will manifest itself and come to pass, through faith, at a strategic moment in time. Solomon is a great example. After communicating with God, the King walked away with a great hidden treasure—wisdom. This gift was only hidden from the spirit's eye until he simply "asked" for the gift. The wisdom deposited surpassed administrative applications and overflowed into cutting-edge artistry. From the design of his home to the design of the temple, God's wisdom in him surpassed all others. It was so grand that even the Queen of Sheba was amazed! The most beautiful part of it all was that King Solomon didn't take credit for any of it. He gave all the praise and thanks to Yahweh (1 Kgs. 10:9).

The Bible is filled with people who were given impossible tasks and projects from God. Yet as they faced these challenges, God gave them great wisdom and supernatural strength to accomplish them all. Look at Noah. He was given detailed instructions for designing an ocean liner to accommodate every animal present (Gen. 6:14-16). Bezalel and Oholiab (Artisans) were filled with the Spirit to have an understanding of "all kinds of craftsmanship" for building the tabernacle (Ex. 31:3-5). It is one of the first mentions in the Bible of anyone being "filled with the Spirit." Interestingly, God chose to fill two artists: two people gifted with a creative spirit like their Creator. And Joseph was given great wisdom and creativity to ration Egypt's grain supply during the famine (Gen. 41:39-41). Think about your life and the assignments you have been given. Haven't you ever said to yourself, *How did I ever have the wisdom and ability to accomplish that?* It's by the grace and wisdom of God! These mighty acts were not just meant for the few but made available to everyone. Because of Christ's work on the cross, the same Spirit that rested on a few can

now indwell anyone who believes in Him. God has never been more willing to breathe upon your mind, inspire creativity, and display heaven's wisdom through you. God says He searches the earth, seeking to strengthen those whose hearts are fully committed to Him (2 Chron. 16:9). Have you chosen to commit your heart to Him?

Many influential people in our world have received great wisdom for great tasks. Renowned artist of the Renaissance, Michelangelo, was empowered by the Holy Spirit to paint the Sistine Chapel even though he hadn't fully realized it at the time. Later in his life, after losing the lost love of his life, he realized that his humanistic approach to art had been a "great mistake."[19] He had tried to "rise [to heaven] through the exaltation of beauty." He recanted:

> *My life's journey has finally arrived, after a stormy sea, in a fragile boat, at the common port, through which all must pass to render an account and explanation of their every act, evil and devout. So now I fully recognize how my fond imagination, which made art for me an idol and a tyrant, was laden with error...neither painting nor sculpting can any longer quieten my soul, turned now to that divine love which on the cross, to embrace us, opened wide its arms.* [25] From that moment forward, Michelangelo took the last 20 or so years of his life and devoted his creativity to honor God.

In my own life, I have had the privilege to portray the life, death, and resurrection of Jesus Christ in a musical theater production at my church entitled, *Risen*. Being given this role was an answer to prayer since I was a child. I have wonderful memories of watching the movie *Jesus of Nazareth* with my mother. This impactful film visually painted a beautiful picture

of what Jesus had done for me. Jesus' love-in-action affected me to the degree that I would act out the drama privately in my room in my personal time of worship. As time went on, I felt I was ready to reenact scenes from the movie in front of my parents and grandparents in our living room. It was beautiful. It was not only an intimate time of worship to my God, but preparation at a young age for what would come later—portraying Jesus' love to thousands of people. I have only been able to portray Christ's love story through His strength and inspiration from the Holy Spirit. In preparation for this role, I would daily take communion and intercede for wisdom, discernment, and understanding; to see people through the eyes of His love, compassion, and desire for His creation to come to the knowledge of the truth. You see, it is co-laboring with God that always prepares us for maximum impact. He is the God who "sees what is done in the secret place." Scripture tells us, "For there is nothing hidden that will not be disclosed, and nothing concealed that will not be known or brought out into the open" (Lk. 8:17). God always has the best ideas and methods of getting them across to His creation when we diligently seek His counsel.

Co-Laboring

This principle of co-laboring with God has echoed throughout the Bible in the lives of His followers, including my own. God has called us to "go into all the world and preach the gospel" (Mk. 16:15). Our whole life is worship unto the Lord along with everything we do. Worship doesn't stop on Sunday. It doesn't stop when we go to work or school. It is the very essence of who we are and what we do, as it is motivated by God's power source—love. Jesus said: "Love the Lord your God

with all your heart and with all your soul and with all your mind.' This is the first and greatest commandment. And the second is like it: 'Love your neighbor as yourself.' All the Law and the Prophets hang on these two commandments'" (Matt. 22:37). God has deposited gifts, talents, and abilities into each of us, great or small. He gave them to us for a purpose: to use them effectively through the power of His love to reach a lost and dying world. Think about it this way; no loving parent, accomplished painter, or sculptor would ever lack interest in their child's artwork. The parent's efforts to help the child improve their coloring skills in no way diminishes the joy and appreciation of the artwork. Rather, it fosters a beautiful memory between the two, as the parent takes the hand of the child in their own to demonstrate a technique. A wonderful mentor and friend in my life, Sal Nicosia, 92, who was my guidance counselor in high school, once told me to practice PLUCK. Pluck is an acronym that stands for patience, love, understanding, compassion, and kindness. These attributes must apply to every endeavor God calls us into; they must stand the test of time and prove to be lasting works of art.

This is exactly what God does with us as we turn to Him for wisdom in our labor. God calls us to get "understanding." As we sow our gifts and talents in love and adoration for the Creator, that same love will fuel our service to humanity. Our container is meant to be filled, but it doesn't stop there. We are called to be emptied so that a miracle can take place. A miracle is bound to happen as we allow ourselves to be poured out. The vessel will naturally overflow with life-giving water! He cares for our work, even those that may seem insignificant. Each assignment He leads us to is being used to prepare us for projects that lie ahead, whether later in life or in the life to come. This life on earth is all preparation for the "great

works" we have yet to accomplish in the "new heaven and the new earth." Jesus even told us, "No eye has seen, no ear has heard, and no mind has imagined what God has prepared for those who love him" (1 Cor. 2:9, NLT). No work is too menial for the Creator's input. His Holy Spirit can direct us in accomplishing the most difficult tasks, and He will send help along the way to make sure the task is complete. He will provide you with all the tools necessary to build the "Ark" He has asked you to build.

Years ago, as I created the images for the *Crafted by the Potter* series, I had no idea God had a plan for these works of art. I had no idea He would bring them to Africa to share the gospel message and inspire a series of children's books entitled, *The Adventures of Clay* and the book you are currently reading. It all started with worship. It led to the question asked by God, *Will you offer your life as a living sacrifice to me? Will you partner in this work with me?* Your answer to God's question is just the beginning of your adventure with God. Your resounding response should be, *Yes, Lord! Whatever it takes and whatever it costs, I will follow you.*

How do we receive the wisdom to move ahead with what God has asked us to do, you might ask? It is not about "what" you know as much as "who" you know. Remember, we are not alone in this adventure. He has called us alongside Himself. We are partnering with God in His work, and He is the one who says, "Call to me, and I will answer you, and I will tell you great and mighty things, which you do not know" (Jer. 33:3). The Creator calls us His friends. Friendship implies a bond of sharing in God's priorities that renders us trustworthy with His treasure. Friendship also implies conversation or desire for guidance, which assumes our intention to hear and obey. When this relationship becomes our lifestyle, we are positioned

for maximum impact in every endeavor. Scripture exhorts us, "If anyone lacks wisdom, let him ask of God, who gives to all generously and without reproach" (Jas. 1:5).

When I look at this image of the Potter gathering all of us—His clay vessels—I hear Him saying, *Clay, this is my command to you. Just as I have given you this living water, go now and freely pour it into every vessel I send to you. Love one another, as I have loved you. And know, I am with you always, even to the end.* The Potter is like a mighty mountain that everyone streams to. People from every tribe and nation come with their pots thirsty for living water, as He freely shares with us all. It reminds me of an old song called, *Spring up, oh well*, which comes from the scripture found in Numbers 21:17. It comes from a story in the Bible where children of Israel had been traveling over the desert's barren sands desperate for water, but there was none in sight. Then God spoke to Moses and told him to gather the people so He could give them water (v. 16). The people gathered together and began to dig deep into the ground, searching for the water as they began to sing, *Spring up, oh well! Sing about it.* As they watered the earth with their praise, physical water began to gush from the hot desert sand, filling the well and ground around it. They had tapped a stream hidden under the ground. God brought about provision through revelation. What an awesome picture of a river of blessing flowing through the lives of His vessels into others. If we respond with faith and praise, we will find our needs supplied in the driest of deserts while providing water to the thirstiest of souls. The Israelites found this river of blessing through faith and praise. Our praise will bring forth "water...in the wilderness and streams in the desert" (Isa. 35:6). The Potter is the source of all blessing and can meet every need according to His riches and glory (Phil. 4:9). What an amazing source! What an amazing supply from

whom all living water flows. When we trust the Lord, every cup overflows. Nothing is ever sparring with God but always springing forth in abundance. He always gives us His full measure of constant overflow.

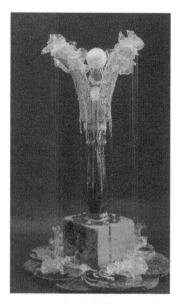

Spring Up O Well, Found Object Sculpture, 2018, Timothy J. Kosta

The amazing truth is that when we yield to Him, we are the ones in His hands co-laboring in the great harvest. We are right where we belong, in the hands and arms of our loving Savior. We are all on a journey with many parts still a "work in progress." The Potter calls it the "refining" process. Before the Potter went home to his eternal Kingdom, He told His creation to watch, pray and be ready. He said that He is coming back for us sooner than we think. That's a promise. How exciting! He is the greatest treasure, and we have found the pearl of great price, more precious than gold, rubies, or diamonds. We are His priceless treasure, and He must be ours. We are not meant to minister alone. God calls each of us to

accountability as a "priest" in service to the king. He even calls us a royal priesthood. We are not called just to be helpers in *The Great Commission*, but priests who are overflowing with love, forgiveness, kindness, and the Holy Spirit's power. The calling of each Christian includes *The Great Commission*. This is the mission and purpose of the church, along with every part of the body of Christ. We are to be cisterns of living water ready to worship through serving. Therefore, the Potter has fashioned unique gifts within all of us to serve the Lord and His people. God wants us to partner with others with similar creative talents to pour into the current and future generations. As we do so, the continuous cycle of sanctification and transformation will continue to wash over God's people bringing the barren places to life. We all must walk the wide and narrow road to discover this hidden truth. [15] The good news... we are all His treasures, regardless of what we have done or where we come from. Now, we can walk in the coolness of the day, awaiting his soon return, as we co-labor with Him to refresh those who are desperate for the Potter's touch. Just as He has led us on the journey home, we now need to guide others down the path to glory. Now I ask you. *Are you thirsty? Are you ready to receive the greatest treasure the world has ever known?* If so, your adventure has just begun!

"But you are God's chosen treasures...set apart as God's devoted ones. He called you out of darkness to experience his marvelous light, and now he claims you as his very own. He did this so that you would broadcast his glorious wonders throughout the world. For at one time you were not God's people, but now you are. At one time you knew nothing of God's mercy, because you hadn't received it yet, but now you are drenched with it!" (1 Pet. 2:9-10, TPT).

Molding Moment

This is why I speak to them in parables: "Though seeing, they do not see; though hearing, they do not hear or understand."

—Matthew 13:13

The Potter wants us to find, search, and get understanding. Sometimes we think we have a good grasp of what we see or hear when truthfully, we only see it in part. Understanding is part of the mind. It is the ability to put together facts, examine, organize, interpret, and reach rational conclusions. Just because you exercise your mind doesn't mean you will have a correct understanding. The crowd recognized Jesus as able to work in the people's lives in supernatural ways; He was a teacher, prophet, leader, and deliverer. But in the end, they thought he would be a powerful military leader freeing them from Roman rule. They were operating in their earthy reasoning. The disciples lacked knowledge on many occasions, and Jesus rebuked them at times for the lack thereof.

God wants each of us to have an open heart. He wants us to have an open heart to the words of the Holy Spirit regarding our present circumstances. Jesus said that His words were spiritual (Jn. 6:33), and spiritual words can only be perceived by those who are spiritual (1 Cor. 2:14). When your heart and mind are open to God's Spirit, His Word will fill you and others to abundant overflow. A closed heart will result in a closed mind, resulting in a lack of healing. Proverbs says, "Trust in the Lord with all your heart, and lean not on your own understanding (v. 6). Do not be wise in your own eyes;

fear the Lord and turn away from evil (v. 8). It will be healing to your body, and refreshment to your bones" (Prov. 3:5-8, NASB). Are you letting your mind and your "carnal understanding" regarding your circumstance get the better of you? Do you believe the doctor's report who says, *There is nothing else we can do for you*. Trust in the Lord with ALL your heart and lean not on your own understanding. Don't harden your heart because of this seemingly impossible task. Fear (honor) the Lord and not the report of the enemy. Hold on to the promises of God. Look at the life of Abraham and Sarah in the book of Genesis. Because of their age, they were told they would never have children, but God's Word to Abraham spoke louder than Abraham's voice. God's Word gave him a new perspective and new understanding. His Word and promises washed away all their doubt and unbelief. As a result, they were filled with a renewed faith, a faith to receive God's promise—a new son. Accepting God's understanding and perspective will "bring healing to your body, and refreshment to your bones." When Jesus was about to leave to sit at the right hand of God, He encouraged us by saying, "Blessed are those who have not seen and yet believed" (Jn. 20:29). Believe in the Lord Jesus Christ, and you will be saved.

We should learn to live in the presence of the living God.
He should be a well for us: delightful, comforting, unfailing,
springing up to eternal life (John 14:4) When we rely on other
people, their water supplies ultimately dry up. But the well
of the Creator never fails to nourish us.

—C.H. Spurgeon

Visual Journal & Creative Space

Expression #28

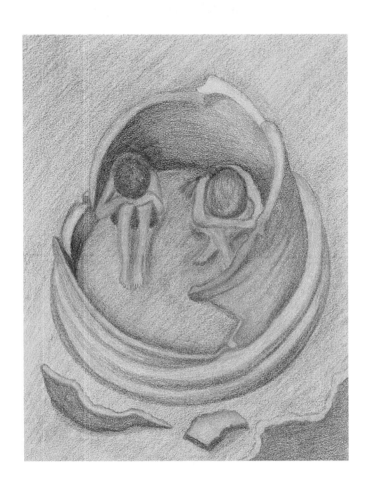

*Put your hope in the LORD, for with the LORD is unfailing love
and with him is full redemption.*

—Psalm 130:7

CHAPTER 26
REDEEMING A DISINTEGRATING CULTURE

In a world that is broken, messy, and disintegrating right before our very own eyes, what can you and I do to bring life and light to the vessels around us? Thankfully, Jesus gave us many clues on what to do and how to do it with confidence and empowerment. Colossians 3:1-4 says, "Since then, you have been raised with Christ, set your hearts on things above, where Christ is, seated at the right hand of God. Set your mind on things above, not on earthly things. For you died, and your life is now hidden with Christ in God. When Christ, who is your life, appears, then you also will appear with him in glory." Jesus is telling us that he is coming soon. He will return sooner than we think, as we see the escalation and convergence of events taking place all around us. His return is imminent.

Jesus said, "Now learn this lesson from the fig tree: As soon as its young shoots become tender and it puts out its leaves, you know that summer is near; so you, too, when you see all these things [taking place], know for certain that He is near, right at the door. I assure you and most solemnly say to you, this generation [the people living when these signs and events begin] will not pass away until all these things take place. Heaven and earth [as now known] will pass away, but My words will not pass away. But of that [exact] day and hour no one knows, not even the angels of heaven, nor the Son [in His humanity], but the Father alone" (Matt. 24:30-36, AMP). The world is in season. How do we know this? Because of all the prophesied events that have unfolded over the past 75 years.

We must keep our eyes on Israel because it will ultimately affect the entire world as prophetic events unfold. Jesus' words and prophecies are coming to pass right before our eyes. Our redemption is drawing near!

With this fact in the forefront of our minds, we need to live like there is no tomorrow for the glory of King Jesus. He is coming for vessels that are watching and waiting for His return (Matt. 24:42). With this knowledge, how do we function as we wait for him? The apostle Paul reveals that we can creatively redeem the culture by first setting our hearts and minds on things above—Heaven. God says we are citizens of Heaven. Look at this powerful verse, "But we are citizens of heaven, where the Lord Jesus Christ lives. And we are eagerly waiting for him to return as our Savior. He will take our weak mortal bodies and change them into glorious bodies like his own, using the same power with which he will bring everything under his control" (Phil. 3:20-21). Jesus tells us that we need to set our minds on Heaven, dwell on Heaven, and imagine Heaven. Heaven has already come to earth by making its home in our vessels. Every heart is a hosting place for the Spirit of God. And you can reach and touch each one with His miraculous glory. Direct your focus on "Seeking first the Kingdom of God and His righteousness" (Matt. 6:33), not on earthly things or earthly gains. Sure, we have responsibilities as citizens on this earth as husbands, fathers, and workers. But we are now at a point where we cannot set our hearts upon earthly riches and vain endeavors. Psalm 62:10 encourages us, "Do not trust in extortion or put vain hope in stolen goods; though your riches increase, do not set your heart on them."

Redeeming a disintegrating culture begins within our own mind and imagination. We need to be men and women of vision. Just as the Potter's hands form the clay vessel in the

wheel's center, we must center our heart, mind, and vision on things above in heavenly places. First, keep your mind and heart centered on the wheel of your identity found in Christ. So many people are struggling with their identity today, especially the youth. Because of the trauma of broken marriages, infidelity, physical and sexual abuse, neglect, etc., Satan is having a field day making people question who they are, where they came from, and where they are going. He is constantly engaging in "identity theft" by trying to desecrate God's temple because "He was a liar and a murderer from the beginning" (Jn. 8:44). Galatians 2:20 says exactly where our identity is to be centered by stating, "I have been crucified with Christ and I no longer live, but Christ lives in me. The life I now live in the body, I live by faith in the Son of God, who loved me and gave himself for me." He also wants us to be centered on the fact that, "We were therefore buried with him through baptism into death in order that, just as Christ was raised from the dead through the glory of the Father, we too may live a new life. For if we have been united with him in a death like his, we will certainly also be united with him in a resurrection like his" (Rom. 6:4-5). Our relationship with Christ isn't an old life but a new one. He is transforming us into vessels of honor resurrected in the newness of life in the Spirit. Because of Jesus' work, sin doesn't have reign over my life or yours anymore. Set your mind, creativity, and imagination on all the Potter has done to redeem you.

Second, keep your mind and heart centered on the wheel of your authority in Christ. Jesus sits at the right hand of the Father in full authority (Matt. 28:18, Mk. 16:19). Be encouraged that Jesus is in charge of everything in Heaven and on earth. He is the one who sits at the Potter's wheel and keeps His hands upon us. No wheel can spin too out of control

without Him knowing. No outside force or pressure can shape you without Him fixing. No fire can destroy you without Him perfecting and purifying you as gold. Be confident in His full authority. God has a perfect will for your life and knows the beginning and the end. He is the Alpha and the Omega. Even when we make the wrong choices and ignore God's "Plan A," we must come to realize that His "Plan B" can be even more amazing than "Plan A!"

Third, keep your mind and heart centered on the wheel of your security in Christ. The world is such an insecure place to be right now, but there is one person and one way to find ultimate security. When we die to the old way of life, our new life is hidden in Christ Jesus (Col. 3:3). That means you can have perfect peace and security knowing who you are in Christ and what He has done to save you; all of your past sin, pain, regret, and condemnation has been burned by the fire of Jesus' love at Calvary. The indwelling of the Holy Spirit within your life is God's security deposit within you that redeems your past, molds your present, and secures your future (resurrection & eternity). Romans 8:38-39 is one of my favorite security scriptures saying, "For I am sure that neither death nor life, nor angels nor rulers, nor things present nor things to come, nor powers, nor height nor depth, nor anything else in all creation, will be able to separate us from the love of God in Christ Jesus our Lord." Jude 24 declares how the Lord can keep you from stumbling. You are inscribed on the hands of God, and the Father holds you in his hands. What a secure and stable place to be! There is absolutely no persecution, problem, dilemma, or circumstance that can snatch you from His hands. God has the keeping power to sustain you. The only one who can remove you from the secure hands of God is yourself, by your own free will and through the choices you make. It is God's

loving Lordship that sustains you and me. It isn't the power of tyranny or control but the power of His eternal love. He allows us to make our own choices by keeping His grip upon our lives loose and flexible. His hand is always open, never gripping us to the point of squeezing our will or our choice out of us. He is always using His profound creativity to reach us, even when we have knowingly or unknowingly rejected His hands from sculpting something beautiful in our lives. Remember, He is the one who leaves the 99 sheep to find the one lost sheep. He is the one who shows up walking on water, as they are met with the turbulent storm. He alone is our security. Stay close to Him. Stay centered safely in-between the shadow of His hands.

Lastly, keep your mind and heart centered on the wheel of your destiny in Christ. You and I were destined to worship. We were destined to worship the Creator in spirit and truth. Out of worship flows the primary colors of faith, hope, and love, empowering our creativity to redeem the present culture. It not only creates the power for us to be redeemed, but allows us to co-labor with Him in redeeming others, just as our Creator has done for us. We were destined for miracles. The first miracle must occur within us, where He must fill us to overflowing. Once this happens, God works His miracle through us to outpour into the lives of others. It is a process. If someone has the vision to run a multi-million dollar company after working a short time at Wendy's and has never financed or handled millions of dollars, this new company would be destined to fail. Why? Because even though the vision and their ambition are commendable, it is not attainable at the present time. Is this a faithless statement? Absolutely not. It is harnessing this vision with wisdom. It's like a teenager driving a car for the first time who wants to go from 0 mph to 100 mph. It would

be a suicide mission leading to destruction. They run a high risk of killing themselves and others. Everything is a step-by-step process requiring time, patience, and experience. If you have a vision, you need to start with small steps in the field of interest by seeking out wise counsel from God in prayer and spending time with trusted individuals in that arena. When each foundational layer—no matter how insignificant or small it may seem at the moment—is scaffolded with daily faithfulness and perseverance, you can be assured that a grand vessel is being formed for the Master's service. There is a Biblical principle in Matthew 25:23 encouraging us to be faithful with the little we have been given, and in doing so, we will be entrusted with more. We live in a fast-paced, instant gratification culture. If we don't get what we want, when we want it, we either throw a tantrum like a two-year-old or give up on what we are seeking because it appears to be too much work to obtain it. You may not feel this way at all; you may simply feel completely inadequate to fulfill the vision He has called you to. But remember, when you feel weak, God says He will make you strong. All things are possible for those who love God and are called according to His purpose. He will give you the strength and ability to accomplish His will and the vision He has placed within you. [21]

As we freely have been given, we must freely give. When we are faithless, He remains faithful. When we are connected to Him, our cup of destiny remains full. How do we keep our destiny centered and full? First, it is by the priorities we set. We must seek first the Kingdom of God (Matt. 6:33). Second, we must invest in the Word of God. Sit on the Potter's wheel and allow Him to pour the refreshing water of His Word to teach, shape, and mold you into all He has called you to be. Lastly, invest your treasure (your creative gifts & talents) in

the Kingdom of Heaven. In the next chapter, you will learn how to live a life of worship by using your creative gifts and talents to redeem the present culture: "You will keep in perfect peace those whose minds are steadfast, because they trust in you" (Isa. 26:3).

Molding Moment

Whatever areas appear to be disintegrating right before your own eyes can be transformed, renewed, and brought back to life. Is it one of the areas mentioned above? Could it be a dream, vision, gift, or talent? Maybe it is your physical health or the health of a loved one? Is your marriage or a relationship falling apart with no help in sight? Perhaps it is the negative view of yourself? Whatever is hindering you right now, get your mind and heart centered on things that are above, seated in heavenly places. Jesus specializes in redeeming the crumbled and broken areas of our lives by turning them into masterpieces. We are all cracked and broken, but Jesus chose to work His creativity through our vessels anyway. Why? Because He loves His creation, and He loves you! He loves raising the dead areas in our lives back to life. He is the God of miracles, and you are His precious treasure. ALL things are possible with God to those who believe (Mk. 9:23).

In 2020, I had a vision where an angel came and spoke a profound word in a heavenly language. His voice trumpeted so loud that it was hard to understand his language. It was later that the Holy Spirit revealed the Word of the Lord to me. The angel said, *Come out of the flesh in these last days and come into the Spirit.* The doors of Heaven are open to you right now. These doors are filled with extraordinary revelations, but there are conditions to see the open door. We must know what it means to "come out of the flesh" and be "in the Spirit" (Rev. 1:10). We must be *pure in heart* (Matt. 5:8) and obedient in faith. We must be willing to come out of the flesh

by "counting everything a loss compared to the surpassing greatness of knowing Christ Jesus" (Phil. 3:8). Then, once God is everything to us, so that "in Him we live and move and have our being" (Acts 17:28), the door to heaven will stand open before us with great treasures of revelation. God wants to take your everyday creativity, gifts, and talents by making them supernaturally extraordinary! There is a world around us that needs to visually see, smell, taste, touch, and hear the manifest presence of God's love through you and me. Submit your creativity to the Potter every day, and watch Him as He takes the disintegrating places of your life and brings them into a state of wholeness.

As you and I lay up for ourselves living, lasting treasures in
Heaven, we come to the awesome conclusion
that we ourselves are His treasure!

—Ann Graham Lotz

Visual Journal & Creative Space

Expression #29

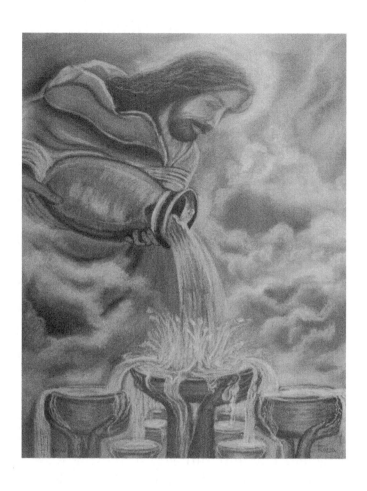

*Therefore, I urge you, brothers and sisters, in view of God's mercy,
to offer your bodies as a living sacrifice, holy and pleasing to
God—this is your true and proper worship.*

—Romans 12:1

CHAPTER 27
DESTINED TO WORSHIP

I believe that the Holy Spirit wants to bring a fresh perspective on a passage of scripture found in Ephesians chapter 4, as He desires to use every gift and talent He has placed within us for His glory. As God's creative individuals, He desires our everyday creativity (as simple as making breakfast, styling our hair, getting dressed, etc.), our activities, creations, songs hummed throughout the day, and artistry to emerge from a heart and life of worship. He wants us to have a clear vision of His heart and plan to advance His kingdom in these last days. We are at the precipice of a tremendous outpouring of the Holy Spirit like we have never seen before, where people will be reached with the gospel of Jesus Christ. The mantle of Esther is upon all of us. The body of Christ must fight against becoming stagnant, as the prince of this world uses every evil tactic to control and isolate the body of Christ. No persecution, isolation, or viruses will ever be able to stop Jesus' church from advancing. The only sure way of moving forward is to spend time, saturate in, and follow God's Word. This alone brings about the change in our understanding and initiates transformation in our strategies. We must take advantage of the opportunities that God is leading us to in the coming days. The days are growing short, and He will soon return. As a result, greater anointing, power, signs, and wonders will be demonstrated in and through His chosen vessels. As we have learned in previous chapters of this book, God is preparing his vessels for greater faith, hope, and love. He has destined

you and me to overflow with His power while partnering with Him to assist in equipping others.

A Living Sacrifice

Many people today—young and old—ask, *What is God's perfect will for my life?* This is a profound question answered by none other than the Holy Spirit in the inspired Word of God—the Bible. Here is the answer. God's perfect will for every person created in the world is, "To offer your bodies as a living sacrifice, holy and pleasing to God—this is your true and proper worship" (Rom. 12:1). As you commit yourself to fulfill God's overall will for your life—to be a living sacrifice—you will gain further revelation to understand God's specific will. But it all starts here—a commitment to being a living sacrifice.

Every person needs to find out God's specific will for their life. He has a pre-planned purpose for every vessel He makes. He created and designed you to fulfill that purpose. But He doesn't control you or force you into His perfect will because He gave you the freedom of choice. But to know His specific will, you need to do some work on your part; you need to seek, discover, and find out what that will is for your life. Not everything that happens to you in your life is God's perfect will. You may miss God's perfect will in your life, but He is a redeeming God and knows how to make "Plan B" even better. As you study God's Word, you must commit to having your thinking transformed. Remember, our ways are not God's ways, and we need transformation in our minds first. Romans 12:2 says, "Do not conform to the pattern of this world, but be transformed by the renewing of your mind. Then you will be able to test and approve what God's will is—his good, pleasing and perfect will." You can still miss God's specific will for your

life if you seek God's will without having your mind renewed and transformed. Most people don't know what they have in Jesus Christ. We are all made in His image, and God wants us to use what He has already given to us. It is already built into the walls of our clay vessels. This is why we need a living relationship with God through Jesus Christ. All the keys to unlock His purposes and promises (treasure) in your life are found in His Word.

The first step in this process is to say to the Creator, *God, here I am. I offer my life as a living sacrifice to you. I commit everything that I am and all that I have. Take all of my creativity, gifts, and talents. I willingly give it to you. Have your way within me and direct my paths into your specific will for my life.* The Creator longs for us to simply love Him. The scriptures declare, "Love the Lord your God with all your heart and with all your soul and with all your strength and with all your mind" (Lk. 10:27). Jesus said this was the greatest commandment in the Bible. The command says that God is the only true God, and we are to love Him in three ways: with all our heart, soul, and strength. When we love God with all our hearts, we act in ways that show commitment to Him. We spend time learning about God and offering praise to Him. When we love God with our souls, we give our lives completely to Him. We honor God with what we do with our body, mind, and spirit. We respect God in everything we do and are committed to Him. When we love God with our strength, we use what we have been given, such as our empowered creativity, gifts, and talents, in ways that honor God by serving others. God longs for all of our affections, and anything we do in His name must first generate from this sacred place—love for Him. If we do not worship from this central place of truth, everything is meaningless; all seemingly "good works" accomplished from a

heart of pride and selfish gain will burn up as chaff in the fire of testing. Only the overflow of worship from a selfless heart of faith, hope, and love will be purified as gold and counted as righteousness. God wants all our heart's pure affection! As scripture says, "The pure in heart will see God" (Matt. 5:8). Loving God is a joy because He first loved us with His whole heart, soul, and strength. It is true when scripture tells us, "We love because He first loved us" (1 Jn. 4:19).

Treasure in Heaven: Investing in the Kingdom

The Bible compares the union of Christ and the church as a marriage. This is the best image portrayed in the scriptures that teaches us how much God loves us. He loves us with an everlasting love. Jude expresses this relationship by saying, "Keep yourselves in God's love as you wait for the mercy of our Lord Jesus Christ to bring you eternal life" (v. 21). As the bride of Christ, this is how we should be preparing to be with Him. Knowing this, there is much more to do than just waiting for the blessed day of His appearing. Anyone preparing for a wedding knows there is much work to do; many preparations need to be made in anticipation of the big day. Christ (the groom) is not so much concerned with the outward appearance of the bride—our outward acts and deeds—but rather her inner life. Is the bride perfect? No, she is not. Does the bride wait to marry the groom until she is perfect? Absolutely not. If she did, the marriage would never happen. The bridegroom looks at his bride's heart and her affectionate love for him. As we wait for Christ to come, we need to prepare ourselves by being consistently purified. We are not perfect, but that doesn't mean we wait for God to use us until we are perfect by our standards. It is a process of sanctification that occurs as we

commit ourselves to be a living sacrifice for Jesus. Paul gave this advice to Titus about the process of sanctification by saying, "For the grace of God that brings salvation has appeared to all men. It teaches us to say 'No' to ungodliness and the worldly passions, and to live a self-controlled, upright and godly lives in this present age, while we wait for the Blessed Hope—the glorious appearing of our great God and Savior, Jesus Christ, who gave himself for us to redeem us from all wickedness and to purify for himself a people that are his very own, eager to do what is good" (Tit. 2:11-14). God teaches us that preparation includes learning to say, no, to worldly passions, and yes, to living upright and Godly lives. This scripture instructs us "to be eager to do good." This includes being eager to do good by investing our gifts and talents to bless others and lead them to the redemption of their Creator, Jesus Christ: "When he appears, we shall be like him, for we shall see him as he is. Everyone who has this hope in him purifies himself, just as he is pure" (1 Jn. 3:2-3).

The scriptures also teach us to be ready and alert. We know that staring up into the heavens is not what waiting for Christ's return looks like. After Jesus ascended after the resurrection, the disciples "were looking intently up into the sky as he was going" (Acts 1:10). As they watched this event occur, two angels appeared and assured them that just as Christ exited this earthly realm, He would also come back in the same way. We must be ready because He is coming for those watching and waiting for His return. With that being said, our thought lives must be sanctified. It says, "As a man thinks, so he is" (Prov. 23:7). I was once told we need to watch our thoughts because they become words. Watch your words because they become actions. Watch your actions because they become habits. Watch your habits because they become your character. Lastly,

your character becomes your eternal destiny. We must watch and guard our thoughts every day: "Finally, whatever is true, whatever is noble, whatever is right, whatever is pure, whatever is lovely, whatever is admirable—if anything is excellent or praiseworthy—think about such things" (Phil. 4:8). What we do in secret will one day be made known publicly. Too many are falling victim to the cancer of pornography and its destruction of the pure mind and heart. As mentioned earlier, creative people can fall victim to this attack because they are visually receptive. Remember, the eye is the body's guardian: "The eye is the lamp of the body. If your eyes are healthy, your whole body will be full of light. Therefore, "Flee from sexual immorality. All other sins a man commits are outside this body, but he who sins sexually sins against his own body. Do you not know that your body is the temple of the Holy Spirit, who is in you, whom you have received from God? You are not your own; you were bought with a price. Therefore, honor God with your body" (1 Cor. 6:18-20). Be the living sacrifice He has called you to be and renew your mind in Christ Jesus through the washing of the Word. God has called you to reach the masses through your unique talents. Surrender each one to the Potter's wheel, and allow Him to transform the culture one person at a time miraculously.

During this time of preparation, we must increase our intimacy with God in our creativity, worship, and communion. God is so Holy that He deserves all of our worship—the best sacrifice we can bring to Him. In an article titled, *A Bow and a Kiss*, the author writes that the "bow" before God represents our awe in the presence of One so much more majestic than we can ever comprehend. The "kiss" represents the personal love relationship we can have with our Creator. [37] We worship God, who is so much greater than we are, yet He wants us to

love Him as He loves us. The Potter constantly longs to have Spirit-filled communion with each of His vessels, just as we had seen back in the garden. The only way to do this is to prioritize giving Him our attention and time. As we do so, we can have the amazing opportunity to experience God's Glory revealed in and through our lives. God is omnipresent. Even though His Spirit is everywhere, He desires to physically manifest Himself in our lives and the lives of others in a powerful way! One of the ways I pray you are experiencing this intimacy is through the power of visual & written journaling.

Treasure in Heaven: Investing Our Creativity, Gifts & Talents

Overall, God is calling us to serve Him while we wait for His soon return. We will be investing treasure in Heaven through our unique gifts and talents as we do so. God wants us to labor in the Kingdom purposefully as we assist the Creator in redeeming the culture. Jesus' purpose in coming to earth solidifies what our primary purpose should be—*The Great Commission*. This should be our greatest passion and fulfillment because there is no greater calling than leading broken vessels to the wheel of the Potter's redemption. There is a lot of work to be done and the urgency of the hour is great. We have seen the beginning of God's plan for restoring fellowship and repairing the gaps between God and man. The plan will be completed very soon as biblical prophecy unfolds. But the church has an important role right here, right now. The plan calls for workers to go into the field white for harvest. We are Christ's witnesses "to the ends of the earth" (Acts 1:8). This means we must take our simplistic or complex visual art, music, dance, photography, weavings, graphic design, etc., and use it to assist in redeeming the culture. The only way for this to

happen is through the infilling of the Baptism of the Holy Spirit. This empowerment is desperately needed, as we live in these last days and see evil spreading on every side. Though one can be received during the Rapture without receiving this promised gift, God intends that every believer should receive the empowerment of the Holy Spirit. This empowerment effectively equips the believer for effective witnessing, sharing one's personal testimony, and expressing their creative abilities in a way that will draw people into a deeper faith, greater hope, and the redeeming love of God. If you haven't received the Baptism in the Holy Spirit, open your heart to receive this free gift (see Appendix). As we lovingly share the "Good News" through our God-given gifts and talents, the anointing of the Holy Spirit will move upon the hearts of His vessels. [8] We know the signs of the times are here. We are witnessing worldwide pandemics, vast enhancements in technology, drugs, talks of a one-world government, one-world currencies, global resets, lawlessness, rumors of wars, an increase in tornadoes, hurricanes, volcanic eruptions, famines, fires, and the list goes on and on. But children of God need not fear what is already here and what is coming. In fact, Jesus told His disciples, "Peace I leave with you; my peace I give you. I do not give to you as the world gives. Do not let your hearts be troubled and do not be afraid" (Jn. 14:27). This world is exhibiting many events that can cause fear. But placing ourselves in the hands of the Potter gives peace amid any storm (Mk. 4:39). The time for investing is now. You have nothing to lose and so much to gain.

Treasure in Heaven: Investing to Serve

Ephesians 4:11-12 tells us that the gift of ministries to the church (apostles, prophets, evangelists, pastors, and teachers)

is to be used to prepare God's people for the works of service so that the body of Christ might be built up. Not only this, but God desires to use all of the unique gifts and talents He has placed within us for worship, including the fine arts. If we look back in Exodus at the first artists God chose—Bezalel and Oholiab—God said, "See, I have chosen Bezalel son of Uri, the son of Hur, of the tribe of Judah, and I have filled him with the Spirit of God, with wisdom, with understanding, with knowledge and with all kinds of skills—to make artistic designs for work in gold, silver and bronze, to cut and set stones, to work in wood, and to engage in all kinds of crafts. Moreover, I have appointed Oholiab...to help him... also I have given the ability to all the skilled workers to make every-thing I have commanded you" (Ex. 31:2-6). We all have been given "all kinds of skills...to engage in all kinds of crafts." We all need to identify, acknowledge, and engage in those skills/crafts through the power of the Holy Spirit. We simply need to lay them on the altar by offering them a living sacrifice to God. As we do so, the Spirit of God will fill us with wisdom and knowledge on how to use the gift. He will take the most simplistic creative talents and work miracles through them. He takes whatever we offer Him, big or small, and can feed the thousands through it. Just as Jesus said, "Just as you have freely received, freely give" (Matt. 10:5.-8), our priority is to prepare God's people to be everything God has called them to be. Since the garden, God has always desired us to partner with Him in His Kingdom work. We must realize that every vessel within the body of Christ has a spiritual gift. God has called us ALL to minister unto one another. God has poured out His Spirit upon the whole church. He has prepared us to be a people of worship unto God first and foremost, then overflowing into others' lives through loving service. Just as the

Potter has come alongside to shape and mold us, we must come alongside others to partner in the redeeming work. The Potter has gifted each of His children so that we might serve Him. As Jesus called the twelve disciples, He trained, prepared, and then released them into ministry. We are the body of Christ, with each body part intended for a specific purpose. Everyone has something to contribute so that the body functions in unity. Every gift, talent, and ability must come to the surface and be exercised in a life filled with worship for this to occur. From the beginning, we were empowered to create and be the reflection of the Creator Himself. If we truly believe this with our hearts, humanity needs to brace itself for an impact that will send repercussions throughout the world. Just like the apostle Paul, we need to impart a passion for spreading the gospel of Jesus Christ through our unique giftedness. God has equipped us to reach individuals that no one else can in our specific spheres of influence. We were not meant to do this alone, but as a team and an army. I believe if we are going to see the Holy Spirit bring revival and renewal in supernatural ways, we must again "see" the Lord's way of advancing His church—through the eyes of purity coupled with creativity.

A beautiful story in the Bible that illustrates the sweet smell of love, worship, and service unto God and others is the life of Mary found in John, chapter 12. Jesus was at the home of Mary, Martha, and their brother Lazarus who was raised from the dead. The three siblings were giving a dinner to honor Jesus. Martha was serving while Lazarus was at the table with Jesus. Mary came toward Jesus with a small bottle of expensive perfume. She poured the perfume on Jesus' feet, then wiped His feet with her hair. The smell of the perfume filled the entire house with an elegant fragrance! One of Jesus' disciples was upset that Mary wasted such an expensive bottle

of perfume. Historians say that this one bottle of perfume had the value of one year's wages! It was Judas who was upset with Mary, who would later betray Jesus. Judas was not an honest man. He said that if Mary had sold the perfume, she could have given the money to the poor. But since Judas oversaw the money for Jesus' disciples, he wanted to keep some of the money for himself. Jesus knew what was in Judas's heart and told him to leave Mary alone. Jesus knew the contents of Mary's heart and the motivation for her actions. She seemed to have the spiritual understanding that Jesus would not be on the earth much longer. Jesus was about to give His life up for her and the entire world. Mary loved Jesus and wanted to express her love in a tangible and costly way. Nothing was too good or expensive for Jesus. His sacrifice was costly, like Mary's expensive perfume upon His feet. If you love Jesus and want to show it, live your life to please Him first and foremost. Offer your life as a living sacrifice to the Creator. In doing so, you will be like a sweet fragrance to those around you. The most important lesson to learn from this biblical account is to understand that God created you to enjoy a deep, intimate relationship with Himself. While works of service are important—a natural overflow from the heart unto others—they must never supersede the fellowship He wants to experience with each of us first and foremost. We know this by what is found in Ephesians 2:8-9, "For it is by grace you have been saved, through faith—and this is not from yourselves, it is the gift of God—**not by works**, so that no one can boast."

Treasure in Heaven: Equipping Clay Vessels

It all begins and ends with worship. Worship truly means to love and treasure God with everything within you. He must

be the most valuable possession in your life. If this is true, then your conduct, attitude, choices, and behavior will bear this fruit. God is a treasure, and He sees you and me as His. Therefore, we need to share that treasure with the world out of worship. When Jesus met the woman at the well, Jesus answered her, "If you knew the gift of God and who it is that asks you for a drink, you would have asked him and he would have given you living water" (Jn. 4:10). Jesus Christ is the gift from God, a gift that supplies all of creation with living water. When we acknowledge God and worship Him as the one true God, our lives will become fruitful; the hills will bloom with a fragrant life and multiplication. The devil tries to steal your identity by polluting the truth with lies because he knows your identity is destined for power and authority in Christ Jesus! This is why He fights for all your worship. Since the beginning of time, Satan has wanted to be worshiped. He pulled the same tactic in the garden, and he continues to fight for our worship to this day. He wants to steal all of your gifts and talents while manipulating their very nature into fleshly gain. He wants us to question our identity, significance, and purpose by making us believe that God is a tyrant. The opposite is true. When we are surrendered and rooted in Him, we are free to be all He has called you and me.

As Paul writes in Ephesians 4, equipping the church builds up the body to grow in Him and be unified in our faith and knowledge of Jesus Christ. He desires to lead us to maturity. God desires that we use what He is fashioning within us to help grow people up in Jesus. His will is that we would use the creative skills He has placed within us to help shape and mold our fellow clay vessels. It's not about big churches or big ministries. Our heart needs to be about the Father's business by helping others become everything God has ordained them

to be. People need to find their lives and purposes fulfilled in Jesus Christ. God has called us to love our neighbor as ourselves. In doing so, we are to serve one another, pray for each other, love one another, reach out to each other, and equip one another. We must also realize that each person in the church is essential, as they have something powerful to offer the body for it to function in perfect harmony.

For a long stretch of Christian history, including some of our finest moments as culture creators, an overwhelming majority of what was made served Christian purposes. God used His creative vessels to share the gospel in powerful visual methods. Throughout history, artists and creative individuals have envisioned and created cathedrals, frescoes, and illuminated manuscripts. These were all beautifully made and meant to express the truth of God's Word. As artists create, it mixes with play and pain, moments of joy and grief—just as in life. I think back on one of my favorite painters, Claude Monet, with his bright pastel-colored lilies and cathedrals. But Monet's work is less beautiful when you know his story. He loved Camille Doncieux, the subject of his painting who later became his wife, *The Woman in the Green Dress,* who died of tuberculosis. [2] Looking back in Biblical history, we see great heavyweights in God who experienced great testing and pain, one of which is Job. He was a work in progress—God's workmanship—who was remade into a vessel of honor. Of course, we cannot forget Jesus—the priceless vessel which was broken and painted red with His own blood to redeem humanity. The body of Christ is built up when the people of God have a place where they can exercise the gifts and talents that God has put in their lives. God wants His people to take a stand and help create areas within our churches for the gifts such as art, music, and dance to be expressed. As we come along beside our brothers

and sisters in Christ, we can assist in growing people in the Lord by helping them discover who they are and what they were made to do. Scripture says, "I can do everything through Him who gives me strength" (Phil. 4:13). In seeing this through the eyes of faith, people can believe that they have gifts and talents that God can use for His glory. In doing so, they then find fulfillment that empowers them to share the gift with others. The cycle of equipping, preparing, and discipleship continues once again. It's a beautiful cycle that continues to produce fruit and eventually a great harvest. [5]

Chosen to Redeem

The Potter has ordained us to be "Priestly Potters" by repairing broken clay vessels around us. We must love people, just as Christ loved us and gave up His own life on our behalf. Many people within our churches and spheres of influence need repair; people with hurt feelings, broken lives, and those who are physically and emotionally broken. A repairing process needs to take place within their lives. We need to love them enough to help them understand and discover God's calling on their lives. They need someone to wrap their hands around their clay vessel, to reach down deep into their hearts to help them identify their gifts and how they can use them for God's honor. God has called us to be instruments of healing, to help repair the damaged areas in people's lives that prevent them from being all God has called them to be. He desires to use us as a tool to help realign their vision and help them become centered on the Potter's wheel. God is raising leaders by placing a mantle of creativity on their shoulders, as we have never seen before. Even though it is a weighty mantle, we can place our full confidence in the strength of the Potter because He

is the one who declares, "My yoke is easy and my burden is light" (Matt. 11:28-30).

Running the Race of & Reaching the Finish Line

In Hebrews 12:1-2, the Apostle Paul tells us, "Therefore, since we are surrounded by such a great cloud of witnesses, let us throw off everything that hinders and the sin that so easily entangles. And let us run with perseverance the race marked out for us, fixing our eyes on Jesus, the author and finisher of our faith." We are all running a race in this life; the timing of when we reach the finish line (the end of life and the beginning of eternity) is different for each one of us. We are exhorted to throw off all the sins that easily entangle and weigh us down. But there is one finish line quickly approaching where anyone can cross the finish line of victory. The prequalification for this blessed opportunity is free and as simple as "fixing your eyes on Jesus, the author and finisher of our faith." We are living in the last days and nearing the end of the age. With all that the prophets have prophesied, and everything that we currently see happening around us throughout the world, the finish line is in sight! "There is a day approaching where not everyone will see death. Listen, I tell you a mystery: We will not all sleep, but we will all be changed—in a flash, in the twinkling of an eye, at the last trumpet. For the trumpet will sound, the dead will be raised imperishable, and we will be changed" (1 Cor. 15:51-52). This event recorded in scripture is known as the Rapture. This event, this finish line, will not be for everyone. Unfortunately, not all who call themselves a Christian will make it to this finish line. Jesus even said, "Not everyone who says to me, 'Lord, Lord,' will enter the kingdom of heaven, but only the one who does the will of my

Father who is in heaven" (Matt. 7:21). Some will have to keep running under the most terrible testing conditions the world has ever experienced in a time of history known as *The Great Tribulation* (see Appendix). This finish line—the Rapture of the church—is for those who are throwing off every sin that entangles and inhibits their progress. It is for the one who is running with endurance, watching, and praying with anticipation. It is for the one who sees their Father at the finish line and strives to be engulfed in His arms of faith, hope, and love. This finish line is for those who are "fixing their eyes on Jesus, the author and finisher of our faith" (Heb. 12:2). You already know if this describes you at this very moment. In the depths of your heart, you know whether or not you are ready to reach this "finish line" and meet the author and finisher of your faith—Jesus Christ, the Messiah (see Appendix for the Rapture of the church and how to be a part of it).

Scripture tells us that no one knows the day or the hour of Christ's return (Matt. 24:36-44, 1 Thess. 5:1-3, 2 Pet. 3:10), but Jesus did tell us we would know the season in which we should be looking for (Matt. 24: 3-14). Friends, we are living in this season right now! Prophecy is being fulfilled right before our very own eyes. World events are setting the stage for the church's race to be finished, while a difficult race will begin for those who are left behind. As we continue to press on towards the finish line, may we continue to fight the good fight of faith (1 Tim. 6:12), never growing weary in doing good because at the proper time, we will reap a harvest if we do not give up (Gal. 6:9).

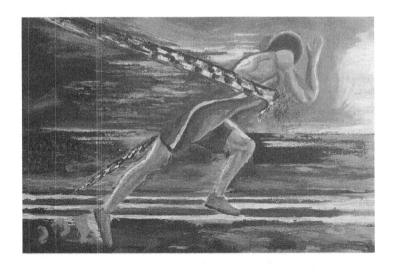

In 2017, I created this painting entitled, *The Race*. Below are the scriptures and the written description inspired by the Holy Spirit. We are now four years closer to the finish line!

"Did you know that in a race all the runners run, but only one gets the prize [few people, the rapture, emphasis added]? Run in such a way as to get the prize. Everyone who competes in the games goes into strict training. They do it to get a crown that will not last, but we do it to get a crown that will last forever (1 Cor. 9:24-25). Brothers and sisters, I do not consider myself yet to have taken hold of it. But one thing I do: forgetting what is behind and straining toward what is ahead. I press on toward the goal to win the prize for which God has called me heavenward in Christ Jesus (Phil. 3:13-14). As you run this race, a thousand may fall to your side, ten thousand at your right hand, but it will not come near you (Ps. 91:7). May our eyes look straight ahead; fix your gaze directly before you. Give careful thought to the paths of your feet and be steadfast in all your ways. Do not turn to the right

or to the left; keep your feet from evil (Prov. 4:25-27). Therefore, since we are surrounded by such a great cloud of witnesses, let us throw off everything that hinders and the sin that easily entangles. And let us run with perseverance the race marked out before us (Heb. 12:1). As we cross the finish line, we want to shout joyfully, "I have finished the race, I have kept the faith" (2 Tim. 4:7-8). Now there is in store for me a crown of righteousness, which the Lord, the righteous Judge, will award to me on that day and not only to me, but also to all who have longed for His appearing (Matt. 25:23). The Lord says, "Behold, I am coming quickly, and My reward is with Me, to render to every man according to what he has done" (Rev. 22:12). Breakthrough into Glory and victory is upon us. Fix your eyes on Jesus!

Running the Race Until He Appears

One of my favorite scripture passages comes from John 13:1-17. Here, Jesus beautifully models the heart of a servant for all mankind. Jesus is with His twelve disciples, even one who is about to betray Him. He demonstrated a beautiful love towards them. John says that "Having loved them, He loved them to the end." Jesus was committed to seeing them fulfill all their potential and specific gifts He had cultivated within their lives. As He was coming up to the final hours of His life, He was still training them on how to love and serve one another. He was teaching them how to worship well. As He washed the disciple's feet at the last supper, He said, "I have set an example that you also should wash one another's feet" (v. 15). He goes on to say, "Now that you know these things, you

will be blessed if you do them" (v. 17). God has commanded us to love one another as He has loved us—the church. Just as the Potter became messy on our behalf, He calls us to get messy on the behalf of others; not only to serve the ones we love, but the unlovable more so. In verse 4, Jesus wraps a towel around His waist before He starts to wash the disciple's feet. During ancient times, a servant was the one who wore the towel. Although a rabbi, Jesus removed His royal robe in exchange for a servant's garment. In doing so, He humbly wrapped Himself in the flesh to wash away the sins of the world. In this scene I envision Jesus putting on a potter's apron. As He sits down at the Potter's wheel, He willingly gets messy with us—His clay—while sculpting every area of our lives into all He envisions us to be. Just as He served us, He calls you and me to serve one another in love. Our Creator is an example of *Primary Redemption*. It is His faith, His hope, and His love that leads us to repentance. This heart quality—a heart of surrender—begins the creative process of true transformation. It is a process that not only leads you to redemption, but the cultures of the entire world. A process that transforms you from *Mess to Masterpiece*.

I pray that the Holy Spirit will strengthen, inspire, challenge, and awaken all the artists and creative individuals who have read this book. I pray it will empower you to daily take up your prophetic and priestly calling to love His church, all who are lost, dry and broken. May He use your unique talents to creatively spread His redeeming work to the present culture through faith, hope, and love. The call of Nehemiah is upon us. May we continue to rebuild our disintegrating culture with the message of the Creator's primary redemption while, at the same time, effectively wielding our weapons of warfare to tear down the principalities of darkness. May we watch, pray, and

keep our eyes heavenward as our redemption draws nigh! The King is coming sooner than you think. We will soon meet the author and finisher of our great faith, hope, and love—face to face—in the marvelous light of His glory and grace. Maranatha!

Molding Moment

You have given a banner to those who fear You, that it may be displayed because of the truth.

—Psalm 60:4

I want to end this book with a scripture stated in the beginning. God has given each of us a banner. God is called *Jehovah Nissi*, which means "banner." This banner could be visual art, song, dance, music, writing, poetry, gardening, cooking, photography, fashion, etc. This can be utilized as a focal point to place our eyes on the Potter—Jesus Christ—for a deeper faith in Him, hope, encouragement, and love of the Father. The Potter has uniquely molded your vessel with a creative inheritance of one, two, or more gifts. They are meant to be used for His glory and the benefit of others. In Exodus 17:5, Moses saw how God was a banner over him and the Israelites as they went into battle. God delivered them from all their enemies. I am here to tell you God is your *Jehovah Nissi*—your Banner. Everything you do needs to have His name spiritually infused upon it. He is your deliverer, no matter what the present circumstance appears to be. No situation is too big because He is the God who slays the giants. God inspired David's creativity to put a rock into a sling and release it by faith. What has the Creator put in your hand? Has He placed a paintbrush, clay, flag, camera, guitar, or pen in your grip? Whatever God has placed in your hands, use it by faith as a weapon to defeat your present enemy. You are empowered to redeem the present culture. The finished work is already in sight…now, run!

We do this by keeping our eyes on Jesus, the champion who initiates and perfects our faith.

—The Apostle Paul, Heb. 12:2 (NLT)

Visual Journal & Creative Space

Expression #30

*He has created us anew in Christ Jesus, so we can do the good
things he planned for us long ago.*

—Ephesians 2:10 (NLT)

CHAPTER 28
MESS TO MASTERPIECE

His Design

God created the entire world and the universe. We can see the evidence of his design by all the beauty surrounding us. It is impossible to ignore all the fascinating things He has made! Just look at the detailed designs of plants, animals, our own human body, or a brilliant sunset painted in the evening sky. The Bible tells us that God designed a world that worked perfectly, where everything and everyone were in a perfect relationship with each other. From the beginning, God designed us—His clay vessels—for a purpose. He created us "in His image," and with that came the free will to choose friendship with God. He freely shared His creative power by giving us an imagination with the ability to create just like Him. He allows us to make new things out of what He already created. His own nature is imprinted in each one of us. How incredible and loving! He created us to live for eternity and bring glory and honor to Him.

Read: Genesis 1:31, Psalm 19:1, Ephesians 2:10, Jeremiah 18.

Our Brokenness

If we look around and see what is happening in our world right now, it is easy to see that creation is not bringing glory to God. Instead, there is a brokenness in the world, and it all started in the garden with a wrong choice. Each one of us is a cracked and broken vessel. We see evidence of this in the evil

of violence, sickness, and disease, to name a few. Our sinful human nature and our choices are really to blame. We have not lived for God; we have not followed His rules, and instead, we have made our own. We have taken our relationship with God for granted, have run away from Him, and exchanged the truth for a lie by believing that we can "be God" and do things our own way. God calls this sin. In the Bible, it says that we all have sinned and fall short of God's standard. We are very good at covering up our messes and bandaging ourselves in creative ways. Most of us would even consider ourselves to be a good person. But even the good works we do for others can never earn God's forgiveness and truly repair our hearts. In the end, the problem remains, and we need a healer. We are still guilty of breaking God's laws, whether we choose to accept or ignore that fact. The Bible says that the consequence of our sin is death (physical and spiritual). Because of our sins, our relationship with God is broken, and unless it is repaired, the punishment for sin is physical and spiritual death. The truth is, we will be eternally separated from His presence and spend eternity in a place of torment called Hell. This is a place designed for lawbreakers, such as Satan and his fallen angels known as demons. This is a terrible reality and awful news. God doesn't want any of His creations destroyed. But there is hope. There is good news!

Read: Romans 1:25, Romans 3:23, Romans 6:23, Proverbs 14:12 & John 1:7-9

The Solution

Our brokenness helps us realize that we can't repair ourselves on our own. We need a remedy; we need a healer. Thank God, in His mercy and great love for His creation, He did not leave us in our brokenness. He sent His only Son, Jesus

(the Creator), to solve our sin problem. Jesus came to His broken world, lived the example of a perfect sin-free life, and willingly chose to die and become broken in our place to pay the penalty for our sin. He is called the *Lamb of God*, and it is only His sacrificial blood that repairs our broken vessels and makes us new. He rose back to life on the third day, proving His victory over death! Jesus did for us what we couldn't do for ourselves; He found us, He willingly took our place and died for us, and rose back to life to redeem us. Simply hearing this good news is not enough. We must do something about it. This is the remedy that heals each one of us from the inside out. We must receive and take it on the inside of our vessel. God's forgiveness and guarantee of eternal life is a free gift waiting for the taking! All he asks you to do is surrender your heart to Him by faith. You will receive forgiveness and the promise of eternal life when you do. He promises to shape you into the vessel He has destined you to become. How do you surrender to the Potter's wheel? **Repent** of your sins (confess your brokenness and your wrongs to God and turn from them). **Believe** in your heart (have faith) that Jesus not only died, but rose again. **Receive** him into your heart and life as your personal Lord, Savior, and friend.

Read: John 3:16, Colossians 2:14, Mark 1:15, Ephesians 2:8–9 & Isaiah 53:5

Isaiah 43:1-21

This portion of Isaiah sums up the message of this book beautifully:

"But now, this is what the Lord says—he who created you, Jacob, he who formed you, Israel: "Do not fear, for

I have redeemed you; I have summoned you by name; you are mine. When you pass through the waters, I will be with you; and when you pass through the rivers, they will not sweep over you. When you walk through the fire, you will not be burned; the flames will not set you ablaze. For I am the Lord your God, the Holy One of Israel, your Savior; I give Egypt for your ransom, Cush and Seba in your stead. Since you are precious and honored in my sight, and because I love you, I will give people in exchange for you, nations in exchange for your life. Do not be afraid, for I am with you; I will bring your children from the east and gather you from the west. I will say to the north, 'Give them up!' and to the south, 'Do not hold them back.' Bring my sons from afar and my daughters from the ends of the earth—everyone who is called by my name, whom I created for my glory, whom I formed and made." Lead out those who have eyes but are blind, who have ears but are deaf. All the nations gather together and the peoples assemble. Which of their gods foretold this and proclaimed to us the former things? Let them bring in their witnesses to prove they were right, so that others may hear and say, "It is true." "You are my witnesses," declares the Lord, "and my servant whom I have chosen, so that you may know and believe me and understand that I am he. Before me no god was formed, nor will there be one after me. I, even I, am the Lord, and apart from me there is no savior. I have revealed and saved and proclaimed—I, and not some foreign god among you. You are my witnesses," declares the Lord, "that I am God. Yes, and from ancient days I am he. No one can deliver out of my hand. When I act, who can reverse it?" This is what the Lord says—your Redeemer, the Holy One of

Israel: "For your sake I will send to Babylon and bring down as fugitives all the Babylonians, in the ships in which they took pride. I am the Lord, your Holy One, Israel's Creator, your King." This is what the Lord says—he who made a way through the sea, a path through the mighty waters, who drew out the chariots and horses, the army and reinforcements together, and they lay there, never to rise again, extinguished, snuffed out like a wick: "Forget the former things; do not dwell on the past. See, I am doing a new thing! Now it springs up; do you not perceive it? I am making a way in the wilderness and streams in the wasteland. The wild animals honor me, the jackals and the owls, because I provide water in the wilderness and streams in the wasteland, to give drink to my people, my chosen, the people I formed for myself that they may proclaim my praise."

Prayer of Salvation

Repent • Believe • Receive

Lord Jesus, I know I am a broken vessel and a sinner. I have disobeyed you and have done things my own way. You know everything I have done. I am sorry, and I know I cannot save myself. You are the only one who can fix me. I believe you are the Son of God who died on the cross for my sins and rose again on the third day. I believe you defeated death, and I receive your promise of everlasting life. Please come into my heart right now as my personal Lord and savior. Thank you for saving me and calling me your friend. Amen.

Do you have physical sickness in your body? Jesus Christ is not only the God of salvation but the Great Physician! Pray this prayer for healing:

Lord Jesus, I come before you in faith to receive my healing from _____ (say your sickness physically, emotionally, socially, etc.). Your word says you were pierced for my rebellion and crushed for my sins. You were beaten so I could be whole. You were whipped so I could be healed" (Isa. 53:5). I believe you already paid for my healing by taking my infirmity and carrying my sickness (Matt. 8:16-17) over 2,000 years ago at the cross. As a child of God, I believe that it is not only your will, but my inheritance to be healed from this sickness now and forever. I know there is nothing I need to do to earn my healing, only to simply believe and receive it by faith. I have already been formed into a new vessel by the work of your hands. I believe my healing was finished and paid for by your precious blood. I now walk by faith, believing I am healed in Jesus' name. Amen!

The way to receive health and provision today:

1. **Believe** that you have been made righteous by Jesus' finished work.

2. **Keep confessing,** "I am the righteousness of God in Christ." You will inherit all that God has for you!

3. **Keep hearing** the gospel of Christ. Because "faith comes from hearing, and hearing by the word of Christ" (Rom. 10:17 NASB).

Canvas & Clay

In my mother's womb

You formed me with Your hands

Known and loved by You

Before I took a breath

When I doubt it, Lord, remind me

I'm wonderfully made

You're an artist and a potter

I'm the canvas and the clay

You make all things work together

For my future and for my good

You make all things work together

For Your glory and for Your name

There's a healing light

Just beyond the clouds

Though I've walked through fire

I see clearly now

I know nothing has been wasted

No failure or mistake

You're an artist and a potter

I'm the canvas and the clay

Song Lyrics by Chris Tomlin/Pat Barrett/Ben Smith [3]

APPENDIX

QUESTIONS FOR THE CREATIVE & ARTISTIC INDIVIDUAL

How can the creative gifts, talents, and making of artwork be accomplished communally?

How might my creative gifts testify to the corporate character of the Christian faith? What are some simple creative tasks I can do every day to serve others and help redeem culture?

How can my creativity or art form speak to the wide range of people in my community and congregation? What can I do to enable worshipers to understand and experience this creativity more deeply?

What can I do so that my gift and talent is not merely admired, but is experienced as an act of prayer, worship, or proclamation?

What can I do for people to see through my creativity and artistic expression to perceive the beauty and glory of God daily?

What distorted notion of God's beauty and character can my creations and/or art resist? What neglected positive quality of God's beauty can my artwork or creativity highlight?

NEXT STEPS AS A DISCIPLE OF JESUS CHRIST

1. Be in His Word — The Bible

Now that you have decided to follow Jesus, your desire should be to want to become more like Him and know His heart and mind. He is the leader of your life now. You now need to understand how to live your new life with Him to be victorious in everything you do. The Bible is the Word of God, inspired by the Holy Spirit and written by His chosen vessels at strategic times. There are over 350 prophecies that were given to prophets in the Old Testament about the coming Messiah (Jesus) that have all come true. If we look at the news today, much of what is happening has already been prophesied (told) in the Bible, and we see it unfold every day. Every question on how to live your life for God is answered in the Bible. His Word is your food, the bread of life, and His Word is like water that satisfies your thirst. My suggestion is to start reading the Gospel of John. If you don't have a Bible, get one at your local church or order one today. There are many good understandable translations of the Bible. Get one that you are comfortable with. Get in the Word!

> "Jesus answered, 'It is written: Man shall not live on bread alone, but on every word that comes from the mouth of God.'" – Matthew 4:4

"For the word of God is alive and active. Sharper than any double-edged sword, it penetrates even to dividing soul and spirit, joints and marrow; it judges the thoughts and attitudes of the heart." – Hebrews 4:12

2. Be in Prayer & Worship

Prayer is having a conversation with God. You don't have to pray at one specific time for a set amount of time. God wants you to talk to Him all day long, and He wants to talk to *you* all day long. You should speak to Him just like you talk with your best friend. Don't worry about the right words; just be yourself and share what is in your heart. One might ask, *"If He knows everything, then why do I need to talk about it?"* Because He is a God of relationship. When you go through something difficult or fantastic, don't you want to tell someone? He is the first one you should tell. In prayer, you need to praise and thank Him. You need to honestly tell Him everything—your fears, mistakes, sins, failures, etc. We need to search our hearts and repent of any known sins we might make throughout the day. He is gracious to forgive us. A conversation is a two-way street. Stop to listen to what He speaks to your heart and mind. Have a Bible handy during prayer because He will speak to you through His Word. He may want you to pray or even sing some of the scriptures He leads you to. Slow yourself down and take time out to spend this time with God throughout your day. Jesus always made time to talk to His Father. It was part of His everyday life; make it yours. He also wants our worship! The Bible says, "He inhabits the praises of His people." You don't have to be a good singer or play an instrument. But if you are or do, use it to praise your God. Worship is not just the songs we sing but the life we lead. Everything that we do

is worship unto God. Our entire life is a painted masterpiece or a symphony sung unto the Lord. Whether at work, at home, at school, or just on vacation, everything we do is worship unto God. Use the creative gifts and talents He has molded into you to bring Glory to Him and lead others to Jesus!

"Rejoice always, pray continually, give thanks in all circumstances; for this is God's will for you in Christ Jesus." – 1 Thessalonians 5:16–18

"Do not be anxious about anything, but in every situation, by prayer and petition, with thanksgiving, present your requests to God. And the peace of God, which transcends all understanding, will guard your hearts and your minds in Christ Jesus." – Philippians 4:6–7

"Therefore, I urge you, brothers and sisters, in view of God's mercy, to offer your bodies as a living sacrifice, holy and pleasing to God—this is your true and proper worship." – Romans 12:1

3. Be Connected to the Body of Christ (meeting with fellow believers)

We, His believers, make up the church. It's not about buildings and programs. While they help in assisting His mission, Jesus loves us, the church. There is great unity when two or more gather as brothers and sisters in Christ, worshiping, praying, discipling, reading the Word, and serving the community locally and globally together with the love of Christ. The church is the powerful hands and feet of God, and Jesus laid down His life for her. There is great encouragement and

fellowship from joining a Bible-believing, Holy Spirit-filled church! Many thirsty souls can be satisfied when all the clay vessels are together getting filled with living water, many thirsty souls can be satisfied.

> "And let us consider how we may spur one another on toward love and good deeds, not giving up meeting together, as some are in the habit of doing, but encouraging one another—and all the more as you see the Day approaching." – Hebrews 10:24–25

> "For where two or three gather in my name, there am I with them." – Matthew 18:20

> "For just as each of us has one body with many members, and these members do not all have the same function, so in Christ we, though many, form one body, and each member belongs to all the others." – Romans 12:4–5

4. Be Baptized in Water

What is Baptism in Water? Do I Need to be Baptized?

Just as a clay pot needs water to be shaped and molded, we too need to be washed in the water of His Word and through baptism. After asking Jesus into our hearts, His Holy Spirit now lives within us and is with us always. The Holy Spirit dwells within your vessel to guide and lead you in your everyday life as a new believer. The presence of God lives within each of His surrendered clay vessels. How comforting! Now the Holy Spirit leads us to follow what Jesus taught while on earth.

Jesus was baptized as an example for us to follow. He also told the apostles to go and make disciples and baptize them in the name of the Father, Son, and Holy Spirit (Matt. 28:19). The Bible teaches that each one of us should make the personal decision to be baptized in water, whether we are young or old. Children can be baptized at an early age if they understand the meaning of baptism and express their desire to be baptized. They need to want to make their commitment to Christ known personally. I know children who have chosen to be baptized at five years old (my own children)! Baptism is different from being sprinkled with water as a baby. Parents choose for their children to be sprinkled and often believe that their children's salvation is secured for the rest of their lives. This is not so. The Bible does not say these things. Baptism doesn't secure your salvation, nor does it keep you from heaven if you are not baptized. Being baptized is an outward confession of your inward faith in Jesus Christ. It is not a testimony to God but to those who are witnesses (two or more). This is the believer's public declaration that their old way of life (past sinful living, thinking, choices, disobedience, etc.) is now dead and buried with the work of Jesus Christ, and the new you is raised to life because of His victory over death. It is an important covenant between you and God in front of witnesses. When a man and woman get married, they exchange vows. Baptism is a moment where you vow before witnesses that you have surrendered your life to God. You promise to love God in the good and bad times and follow Him all the days of your life. You promise to be joined to Him until He takes you home to heaven. You can be baptized anywhere—at church, at the beach, in your pool, or even in your bathtub. God always looks at your heart. Obey God's command and get baptized!

"And now what are you waiting for? Get up, be baptized and wash your sins away, calling on his name." – Acts 22:16

"Repent and be baptized, every one of you, in the name of Jesus Christ for the forgiveness of your sins. And you will receive the gift of the Holy Spirit." – Acts 2:38

5. Be Baptized in the Power of the Holy Spirit — Free Gift from God #2

After being baptized in water, God wants us to ask for another special gift that He makes readily available to us: *The Baptism of the Holy Spirit.* Just as asking Jesus into your heart is a free gift, so is the Baptism in the Holy Spirit. All you must do is desire and ask Him for the gift as you seek Him in prayer and personal worship. Jesus wants to baptize you in the Holy Spirit because it will fill your vessel with firepower, courage, and boldness to share the gospel with others and help you stand strong against Satan.

Baptism in the Holy Spirit will make you strong to handle the various tests and fiery trials you will face in life. These tests and difficult trials are not meant to destroy you but turn you into His masterpiece. As you ask God to empower you with the baptism of the Holy Spirit through a heart of faith, He will fill you with the outpouring. This can happen instantaneously or over a period of time as you continue to believe in the manifestation of His promise. Do not be discouraged! Continue to seek Him through intimate times of prayer and worship. He is faithful to provide for your every need. The evidence of you being filled with the Spirit will be the ability to speak in an unknown heavenly language. This language doesn't just come

over you without your personal will being engaged. You must open your mouth and begin to utter what He is prompting you in your heart. Don't be afraid or be worried about what is happening. Speaking in other "tongues" or a different language you don't understand is the outward evidence that you have been baptized in the Holy Spirit!

The Bible always tells us to use this new language. It is a powerful tool to help bring you comfort and battle against Satan because he doesn't understand it. It is a heavenly language given to you by God. I like to think of it as my "secret language." God says, "We fight not against flesh and blood" (Eph. 6:12). We are fighting an invisible spiritual battle, and we cannot see it, but it is more real than anything. In these dark days, we need God's power more than anything in these dark days. To get filled up with His power, ask, seek, knock, and receive it by faith. You will face victory every time. [8, 36]

> "Ask and it will be given to you; seek and you will find; knock and the door will be opened to you. For everyone who asks receives; the one who seeks finds; and to the one who knocks, the door will be opened." – Matthew 7:7–8

> "On hearing this, they were baptized in the name of the Lord Jesus. When Paul placed his hands on them, the Holy Spirit came on them, and they spoke in tongues and prophesied." – Acts 19:5–6

> "In the last days, God says, 'I will pour out my Spirit on all people. Your sons and daughters will prophesy, your young men will see visions, your old men will dream dreams.'" – Acts 2:17

6. Be the Clay Vessel He Has Called & Chosen You to Be — Give them a Drink

In the book of John, Chapter 4, Jesus was traveling on a long journey and became thirsty. He came to a well and waited for a Samaritan woman He knew would normally draw from the well at that time of day. He asked her for a drink of water, and it was not ordinary for a man to ask a Samaritan for anything. But Jesus then offers her a drink of water. This was not just any water like she thought He would give her; it was living water, which would quench her spiritual thirst and lead to eternal life. Jesus, a man of His word who lived as an example for us, said, "Go now and preach the Gospel and teach them everything I have commanded you."

Now, it is time to put God's words and the words in this story into action! You are His chosen vessel. He wants you to be the salt, the light, and the refreshment to a dark and thirsty world. Time is running short, and God wants us to preach the good news to the ends of the earth. It starts with your friends, family members, schoolmates, work companions, etc. The best tool you have been given to start this conversation is your story—your personal testimony of what Jesus has done for you. Your testimony is powerful because no one can argue with what you have seen or witnessed in your life personally. No one can argue with how God has touched your life and has "shown up" in personal and powerful ways. No one can argue with the facts of how you lived before Jesus Christ found you in the deserted wilderness and how your life has now been eternally transformed.

We must begin sharing the Good News because the news is too good not to share! Many people around us are spiritually asleep, and God has called you to be His mouth, His hands,

and His feet to lead others away from punishment and into the scarred hands of the one who purchased our freedom. You and I are not better than other believers or non-believers. God loves us all and wants no one to perish but come to the truth. We don't know which day will be our last on this earth before Jesus calls us home to His Kingdom. Begin sharing the Good News with at least one person today! Remember, it is not our job to make them believe in Jesus Christ. Our job is to share and testify to what He has done in our lives. We are all His "works in progress."

"For I will pour water on the thirsty land, and streams on the dry ground; I will pour out my Spirit on your offspring, and my blessing on your descendants." – Isaiah 44:3

"Blessed are those who hunger and thirst for righteousness, for they shall be satisfied." – Matthew 5:6

"The Spirit and the bride say, 'Come.' And let the one who hears say, 'Come.' And let the one who is thirsty come; let the one who wishes take the water of life without cost." – Revelation 22:17

"If your enemy is hungry, give him food to eat; if he is thirsty, give him water to drink." – Proverbs 25:21

"Each of you should use whatever gift you have received to serve others, as faithful stewards of God's grace in its various forms." – 1 Peter 4:10

7. Be Continually Sanctified

Since we are all works in progress, none of us has arrived at our destination, and we will never truly arrive until we are home with our Savior. Even then, it will take an eternity to understand the creativity, power, and mystery of our triune God! Sanctification means to be "set apart" from all else. This means that when we surrender ourselves to the Potter's wheel and begin the remaking process, we become set apart from other vessels that also have been created (some vessels for honor and dishonor). We have been separated from the ways of this "earthly world" unto God alone for His glory and honor. Because of the work of Jesus Christ's death and resurrection, we are now justified—being "made right" in God's eyes. Because of this, we can now be continually sanctified day by day.

God wants to mold us and shape us into His image continually. We must often go through the dismantling of our vessel for the Potter to make us bigger to hold more for a season. Other times, He may have to make us as small as a clay oil lamp for us to be a bright light in a dark place. Then comes drying on the shelf and waiting patiently. Next, we go through the fires of testing to make us stronger than ever before. Other times, we find ourselves in the "cocoon of fire" to be purged and refined. And so, the cycle of transformation continues. Our lives can truly be patterned off the beautiful butterfly as it goes through its transformation process. It is filled with hope that it will once again fly to new heights. Read Romans, Chapter 6.

"Therefore, if anyone cleanses himself from what is dishonorable, he will be a vessel for honorable use, set apart as holy, useful to the master of the house, ready for every good work." – 2 Timothy 2:21 ESV

"Therefore, if anyone is in Christ, the new creation has come: The old has gone, the new is here!" – 2 Corinthians 5:17

"You were taught, with regard to your former way of life, to put off your old self, which is being corrupted by its deceitful desires; to be made new in the attitude of your minds; and to put on the new self, created to be like God in true righteousness and holiness." – Ephesians 4:22–24

THE RAPTURE: ARE YOU READY TO RECEIVE YOUR FULL INHERITANCE?

What is the Rapture?

If you look up the word *rapture,* it is taken from the Latin "rapio" for the two words "caught up" used in 1 Thess. 4:17. The *Rapture* is the event that will occur when Jesus calls His followers (both gentile and Jewish believers) to heaven. With the sound of a trumpet blast, in the "twinkling of an eye," believers all around the world who have been expectantly praying, watching, and waiting for Jesus' return will be instantaneously caught up in the air to meet Him. After this reunion, He will escort His bride (the church) to His heavenly kingdom where they will participate in the Judgment Seat of Christ (award ceremony for our faithful service unto Him while on earth) and the "Marriage Supper of the Lamb." The Rapture is an event that will not be hidden. [1]

Biblical Foundation for the Rapture

"Take notice, I am telling you a secret. We shall not all die but we shall all be changed, in a moment, in the twinkling of an eye, at the last trumpet call. For the trumpet will sound and the dead will be raised imperishable, and we shall all be changed" (1 Cor. 15:51-52).

"For with a shout, with the voice of the archangel and the trumpet of God, the Lord Himself will descend from Heaven,

and those who died in Christ will rise first. Afterward, we the living who remain, will be caught up along with them in the clouds to meet the Lord in the air. And so we shall forever be with the Lord" (1 Thess. 4:16-17).

"For I am going away to prepare a place for you. And when I have gone and have prepared a place for you, I will come again and take you to Myself so that where I am, you also will be" (Jn. 14:2-3).

Events and Circumstances Before the Rapture

If we look around us, our world is in a constant downward spiral. All of this change is being accomplished through the work of Satan, as he cannot tolerate anything that originated from God's creation. Originally, the Bible tells us that when God created the world, He declared that it was "good." That means that it was perfect and no changes were necessary. Included in His creation were standards to live by that He gave to Adam and Eve. These standards covered everything from how to live in our private lives, proper domestic relationships, and principles for governing a community. Satan seeks to change everything that God has created and established, thus he has used his power and influence to make subtle deviations from God's original plan. Satan's goal is to establish a world order headed by his chosen world dictator, known in the Bible as the Beast and Antichrist. His goal will be to spend his time and effort changing everything to oppose God's will as expressed in the Bible. This is predicted in the Bible in the book of Daniel, "And he will intend to make alterations in times and in law" (Dan. 7:25).

Political Climate

In today's political environment, there is no effective leadership globally. Every nation lacks strong and competent leaders able to deal with the problems at home and abroad. The United States, which has been the world leader for the last 50 years, has steadily lost its influence among other nations because of political leaders in the United States. They have no moral center to direct their decision-making process. However, this distrust and dislike of government and government leaders is not just an American phenomenon but is a common theme in Europe, South America, Asia, and the entire world. Because of this leadership vacuum in the world, there is now an opportunity for a man to arise who is very charismatic, strong, and attractive to peoples of all nations. Based on the prophecies in the Bible, such a man will arise, and he will be successful in uniting the various nations to rule as a dictator.

The move to unite the world under one government has been active since the early 1950's. This has become more of a reality in recent years as many nations have given up their sovereignty to the United Nations during armed conflicts (ex. Kuwait, Somalia, Bosnia). In these conflicts, the nations of the world contributed manpower and machinery to be used under the flag of the United Nations. The United States of America surrendered its sovereignty in these situations to much weaker nations by allowing its military to be controlled by these nations. In addition to these military actions, the nations of the world also agreed to control trade and labor practices with international treaties such as NAFTA and GATT. There is no dominant nation to provide leadership to the world, thus the stage is set for a man to arise out of the masses to unite the world as a dictator.

Social Climate

The foundational building block of society, that element which has always been responsible for social order and peace—the family—has been virtually destroyed. The family is to be a man, his wife, and their children. The man provides for the wife and children, the wife nurtures and educates the children, and the children obey their parents. In a community of families, adults hold the other adults and children accountable for their actions. The family is based on marriage. Marriage is an institution of God and therefore hated by Satan. The devil has worked very hard, primarily through communications media such as TV, movies, news journalists, and entertainment, to convince women that marriage is detrimental to their freedom and fulfillment. Satan has deceived women into believing that they have the same sexual desire as men and that all differences result from culture. Satan has worked hard to divide men and women and has them at war with one another, and because of this, the violence between men and women has dramatically increased.

Civil war has been a constant theme of this age. Unrest will continue into the end times: man vs. women, black vs. white, Muslim vs. Jew, Catholic vs. Protestant, Muslim vs. Christian, one Muslim faction vs. another Muslim faction, one black African tribe vs. another black African tribe, nation vs. nation, people vs. people. Satan uses whatever divides people into different groups to inspire hate, strife, and violence.

Homosexuality and all sorts of perverse behavior are accepted as normal. The world dictator (Antichrist) himself will not have the normal sexual attraction to women. Many theologians believe that he may be openly homosexual or so consumed with his evil mission, that he will have no interest in earthly relationships as indicated in the book of Daniel 11:37: "And he will show no regard for the gods of his fathers

or for the desire of women." And therefore, after the Rapture, marriage will likely be discouraged or illegal, and homosexual and lesbian relationships will be highly encouraged.

Economic Climate

On the economic scene, the trend is toward poverty for the masses, with wealth concentrated in the hands of very few people. These controllers of the wealth will be the kings of commerce and banking and be the power behind the world's politics. Small businesses are merged into larger companies, and the larger companies merge with themselves to increase profits. The result is huge multi-national companies with no allegiance to any community, state, nation, or people, whose only devotion is to increased profits for management and shareholders. The result is workers who are little more than peasants and presidents of companies who are more and more like kings. These "kings" will usher in the world dictator to protect their wealth and power. Expect all commerce—buying and selling—to be controlled by a mark on the right hand or forehead of every person who wants to participate in the economy.

Only those people with the mark will be able to buy and sell, but the consequences of taking the mark is eternal damnation (Rev. 14:9-11).

Geophysical Climate

In the gospel of Matthew, chapter 24, Jesus spoke to his disciples and indicated to them that one of the signs of the time of the end of the world would be, "As it were in the days of Noah, so will the coming of the son of man be." We read in Genesis that in the days of Noah, "the earth was filled with violence." This speaks not only of the violence men inflict on

one another: war, civil wars, rape, brutality, murder, abortion, and other indiscriminate, random acts of violence, but the earth itself is also filled with violence. We see increasing pestilences, earthquakes, volcanoes, hurricanes, tornadoes, floods, drought, lightning storms, and unusual atmospheric phenomena. While all of these have existed in the past, over the last 50 years, the number and intensity of these conditions and the property damage associated with these natural catastrophes have increased. As the level of violence increases, so has the violent reaction of the earth increased.

Signs of the Times

When Jesus' disciples asked Him about the signs that would be a precursor to His coming and the end of the age, His response, recorded in Matthew 24, was:

- Wars and rumors of wars (Currently, the stage is being set for the Russia/China/Middle East Coalition for the prophesied Ezekiel 38—Gog & Magog War with Israel).
- Nation will rise against nation. It is fascinating that the Greek word translated as nation is "ethnos," which deals with ethnic background and race. Most of the wars and conflicts are wars among ethnic groups and tribes.
- Kingdom will rise against kingdom
- Famines
- Earthquakes are like the early pangs of childbirth. As the time grows nearer and nearer to His coming, the frequency and intensity of these five signs will increase.
- The followers of Jesus will be handed over to be persecuted and killed. This is happening more frequently in

the Muslim-controlled nations in the Middle East and Africa, where Black Muslims enslave Black Christians.

- All nations will hate Christians on account of His name. In many parts of the world, Christians are jailed and killed for their beliefs; in the United States, Christians are hated by the media and liberals and are known by the code words "religious right."
- Many will fall away...that is, many who claimed to be Christians will recant their faith, betray, and hate Christians.
- Many false prophets will arise and deceive many.
- Due to excessive lawlessness, the love of many will grow cold.

Primed & Ready

The Rapture concept has already been known to the masses. The world's media will treat it with ridicule, contempt, and mockery, but God will see to it that it will be highly publicized before it occurs just so that those left behind might still come to their senses. It will occur in the open, and everybody left behind will know someone who was raptured.

As the Bible says, it will happen suddenly, unexpectedly, and lightning-fast, "in the twinkling of an eye," as the Bible says. And there will be evidence all over the world that this event occurred. Some national leaders will disappear, celebrities in entertainment and professional sports will disappear, entire families will disappear, disbelieving spouses will see their mates vanish, and children will disappear. Bank accounts, homes, cars, businesses, and relationships will be left behind. The problem for the world's leaders will be trying to convince people that it didn't happen. Because if the world's leaders admit that it did

happen, then, logically, everything Christians preached about Jesus Christ being the Son of God, the Savior, the Messiah, the Prince of Peace, the Lord of Lords and King of Kings, and everything that Jesus preached and taught must be true. And if all of this is true, then the only logical response would be to fall on one's knees before God in repentance and absolute submission to every word of God revealed in the Bible. But all of this is opposed to the world's way, which preaches freedom from the constraints of God's Word, perverse sex, materialism, and the devaluation of human life. So, although the Rapture will shock everybody and be covered in the media and everybody left will be aware of someone who is gone, the world leaders will begin their great deception, trying to convince the population left behind that there was no Rapture.

How is this going to be accomplished? Well, pretty quickly because most of the people left behind are already in a state of deception. They have been deceived into believing that Jesus is not the Messiah; they have been deceived into believing that the Word of God is not true; they have been deceived into living a lifestyle that only brings constant pain and suffering instead of freedom and paradise that God offers. The world's leaders will declare that there was no Rapture, that a mass hysteria took place, and the news media will follow the party line. Many will even say that extraterrestrial beings abducted humans. Have you noticed the build-up of UFO sightings in the news based on facts supposedly revealed by the U.S. military? The Rapture cover-up is already in the works. Then to make things easier, shortly after the Rapture, one-fourth of the world's population will be decimated due to wars, famine, and plague. Those who were raptured may be counted among the dead. The stage is being set as it is primed and ready for a leader who can bring a so-called "peace and order" to the world's chaos. [1]

POST-RAPTURE REDEMPTION: HOPE FOR A SECOND CHANCE

If there has been a mass disappearance of family members, friends, or coworkers and you are reading this book, then unfortunately, you have been left behind. The days ahead are not going to be easy. Truthfully, they will be the worst and most costly days of your life on Earth. That is just the reality, but I am here to tell you there is hope for a second chance of gaining eternal life in heaven. Read below to find out what will happen on earth going forward and how you can secure your eternal inheritance.

The False Prophet and the One World Religion

After the Rapture, a religious leader will arise. The Bible refers to him as the *False Prophet* because while he claims to be from God, he is inspired by Satan. He will team with Satan and the Antichrist to form an unholy trinity. Satan imitates the Father, The Antichrist imitates the Son, and the False Prophet imitates the Holy Spirit. And just as the Holy Spirit draws people to Jesus, the False Prophet draws people to the Antichrist. This is how the Bible says he will accomplish that:

He Will Appear to be Peaceful

"Then I saw another beast coming up out of the earth, and he had two horns like a lamb and spoke like a dragon" (Rev. 13:11).

The False Prophet will appear to be a man of peace and unity. That's why Revelation 13:11 says he has horns like a lamb. But he will speak like a dragon. His message will be against the Bible and Christians.

He Will be the Head of a One World Religion

"And he exercises all the authority of the first beast [the Antichrist] in his presence, and causes the earth and those who dwell in it to worship the first beast, whose deadly wound was healed" (Rev. 13:12). The False Prophet will unite the world's religions. While the idea of all religions coming together as one sounds wonderful, all religions do not teach the same thing. Truth is not relative; it is absolute. One teaching is right. The others are wrong. Jesus said that He is the Way, the Truth, and the Life and that no man can go to heaven and be with God except through Him (Jn. 14:6). One road leads to God; the rest leads away from Him. Those who follow this one-world religion are the enemies of God and will be separated from Him in hell forever (Matt. 7:13-14).

He Will Perform Signs & Wonders

"He performs great signs, so that he even makes fire come down from heaven on the earth in the sight of men" (Rev. 13:13). To gain a greater following, the False Prophet will perform many miracles and the world will be amazed. But don't be deceived. Satan comes disguised as an angel of light (2 Cor. 11:14-15), and so do his followers. Heed the warning of Matthew 7:15, "Watch out for false prophets. They come to you in sheep's clothing, but inwardly they are ferocious wolves."

He Will Force the World to Worship the Antichrist

"And he deceives those who dwell on the earth by those signs which he was granted to do in the sight of the beast, telling those who dwell on the earth to make an image to the beast who was wounded by the sword and lived." (Rev. 13:14) He starts peacefully like a lamb, unites the world's religions, and performs miraculous feats. Once he has gained the world's trust, the False Prophet will command that an image of the Antichrist be made. He will then show his true colors.

He will Kill those Who Do Not Worship the Antichrist

"He was granted power to give breath to the image of the beast [Antichrist], that the image of the beast should both speak and cause as many as would not worship the image of the beast to be killed" (Rev. 13:15). After performing another miracle—making the image of the beast speak—he will kill those who refuse to worship the image. But be encouraged. Jesus told us not to fear those who can kill the body, but rather fear those who can kill the body and cast the soul into hell" (Matt. 10:28). For those who follow Christ, death is not to be feared because to be absent from the body is to be present with the Lord (2 Cor. 5:8).

The Mark of the Beast

One of the most important things that you have to understand during this time is the *Mark of the Beast*. First, let's look at all of the references in the book of Revelation concerning this mark.

"And he caused all, both small and great, rich and poor, free and bond, to receive a mark in their right hand, or their foreheads: And that no man might buy or sell, save he that had the mark, or the name of the beast, or the number of his name. Here is wisdom. Let him that hath understanding count the number of the beast: for it is the number of a man; and his number is Six hundred threescore and six" (Rev. 13:16-18).

"And the third angel followed them, saying with a loud voice, If any man worship the beast and his image, and receive his mark in his forehead, or in his hand, The same shall drink of the wine of the wrath of God, which is poured out without mixture into the cup of his indignation; and he shall be tormented with fire and brimstone in the presence of the holy angels, and in the presence of the Lamb: And the smoke of their torment ascended up forever and ever: and they have no rest day nor night, who worship the beast and his image, and whosoever received the mark of his name" (Rev. 14:9-11).

"And I saw as it were a sea of glass mingled with fire: and them that had gotten the victory over the beast, and over his image, and over his mark, and over the number of his name, stand on the sea of glass, having the harps of God" (Rev. 15:2).

"And the first went, and poured out his vial upon the earth; and there fell a noisome and grievous sore upon the men which had the mark of the beast, and upon them which worshiped his image" (Rev. 16:2).

"And the beast was taken, and with him the false prophet that wrought miracles before him, with which he deceived them that had received the mark of the beast, and them that worshiped his image. These both were cast alive into a lake of fire burning with brimstone" (Rev. 19:20).

"And I saw thrones, and they sat upon them, and judgment was given unto them: and I saw the souls of them that were beheaded for the witness of Jesus, and for the word of God, and which had not worshiped the beast, neither his image, neither had received his mark upon their foreheads, or in their hands; and they lived and reigned with Christ a thousand years" (Rev. 20:4).

What is Known About the Mark of the Beast:

- During the Antichrist's rule, he will institute a system whereby nobody can buy or sell anything. This will be a very trying time for the Christians on the earth. You will not be able to buy food, medicine, clothes, etc. Likewise, you will not be able to sell anything. Money will likely be obsolete, and any funds you may have in the bank (or stocks, etc.) is worthless unless you take this mark. Living day to day will become difficult without the ability to buy or sell anything.
- Anyone who receives this mark will have painful sores on their body when the angel pours out God's wrath upon the earth. These sores will not be a slight nuisance, and they will be terribly painful.
- Anyone who receives this mark will be pledging their allegiance to the Antichrist regime, resulting in

spending eternity in Hell (the lake of fire) and being tormented forever. This is the most important thing to remember about this mark. Even though it means that you might starve to death or be killed for refusing this mark, remember that you are an eternal creature. Life doesn't stop when you die on this earth. You will spend eternity with God in paradise or the Lake of Fire. Many Christians before you have died as martyrs and kept their faith through trials and tribulations. Let me assure you that your reward in heaven is incomprehensibly better than any temporary safety you may garner from accepting this mark.

- The Antichrist will persecute anyone who refuses to accept the mark. Most people will accept this mark and seal their fate forever. The Christians, who will most likely be the majority of those refusing to take this mark, will bear the brunt of this persecution. There could be a price on anyone's head for refusing to take this mark. Your friends and family may turn you in, possibly your own spouse or children. The Antichrist will probably portray the people refusing the mark as the evil ones. No matter what anybody says, no matter what violence you are threatened with—do not take this mark.

Things Currently Unknown

- We don't know what the mark will actually be. Many people think that it will be some sort of implantable microchip. This makes sense because the ability to track purchases electronically is commonplace. It could be that the microchip will be tied into a huge

database that verifies the person's bank accounts and automatically deducts the funds. Also, the Antichrist may pitch different selling points of the mark, like the ability to track lost children, the ability to catch criminals very fast, and the ability to safeguard your money. However, I believe the main point of the mark will be to show that you worship the Antichrist. The mark could also be a tattoo. When the Antichrist makes this system mandatory worldwide, you will know what it is.

- We don't know what the number of the beast actually is. I mention this because in Revelation 13:18, it mentions the beast's number (the Antichrist) in reference to the mark. Many people have tried to figure out which world leader is the Antichrist by adding up the numerical values of their names. Many prophecy scholars think that the number 666 is a reference to the Antichrist mimicking the Holy trinity.

- We don't know when the mark will be instituted. Most prophecy scholars think that the mark of the beast will be instituted at the midpoint during the tribulation (after the Antichrist comes back to life from a fatal wound, Rev. 13:3). Be prepared at any time for the mark to be instituted.

What You Can Do to Prepare for the Mark of the Beast

1. Pray to God for guidance.

2. Get out of the cities and towns and into the countryside. Get in contact with other Christians and work with them on contingency plans.

3. Store food and medicine in a safe place. If possible, store these items in two or more secure locations if you have to leave suddenly or one of your stashes is found.

4. Learn as much as you can about survival skills. What things in the woods you can eat, how to make a quick shelter in the wilderness, etc. This may come in handy if you have to be on the run.

Post Rapture Events

Shortly after the Rapture, a seven-year period known in the Bible as the *Great Tribulation* will take place. It will begin with the signing of a peace agreement between Israel and her enemies, and it will end with the physical return of Jesus Christ to set up His kingdom on earth. In between will be seven years of terror for those on earth. The following events and trends will occur in those seven years:

- Violence will increase in all parts of the world, both nation against nation (ethnic wars) and domestically. Men will indiscriminately slay one another as peace will be removed from the earth (Rev. 6:3-4).

- There will be extreme inflation, poverty, and lack of food as one day's wages will buy enough food for one day for one person (Rev. 6:5-6).

- In a very short period of time, one-quarter of the earth's population will be killed due to wars, famine, pestilence, and wild beasts. These wild beasts could be viruses, bacteria, and other microbes. In late 1995, Time magazine ran a cover story on the rise of new infections and called microbes "malevolent little beasts" (Rev. 6:7-8).

- Many people will experience a religious conversion and become followers of Jesus Christ, and most of these people will be hunted down and killed (Dan. 7:21).
- There will be a great earthquake, the sun will be blackened, the moon will turn red, and all mountains and islands (underwater mountains) will be moved (Joel 2:30-32).
- There will be a brief period of calm on the earth following this great earthquake, giving those who survive a false sense of security (Rev. 8).
- One-third of the earth, one-third of all trees, and all the green grass will be burned up due to a comet or meteor that hits the earth (Rev. 8:7).
- A meteor will hit the earth, causing the sea to become like blood, killing one-third of all sea creatures and destroying one-third of all shipping (Rev. 8:8-9).
- A "star" named *Wormwood* will fall from the sky and poison one-third of all freshwater, killing many people (Rev. 8:10-11).
- The sun, moon, and stars will be darkened by one-third. The day and night will be reduced by one-third. There is speculation that this means the earth's rotation will be changed so that a day lasts only 16 hours instead of 24 hours (Rev. 8:12).
- Fearsome locust-like beings will be released underground and only attack people who are not followers of Jesus Christ. These attacks will be excruciating but last only five months (Rev. 9:1-11).
- An army of 200 million horse-like creatures will kill one-third of humanity (Rev. 9:13-19).

- Two men (known as witnesses) of Jewish origin will preach the Gospel of Jesus Christ for 3 1/2 years and be killed at the midpoint of the 7-year tribulation. These two will be responsible for a 3 1/2 year world-wide drought and will be killed by the Antichrist.

- People will be required to receive a mark on their right hand or forehead to buy and sell. Those who receive this mark will quickly develop a loathsome and malignant sore on their bodies (Rev. 13:13-18).

- The oceans will chemically change and become like the blood of a dead man, and everything in the sea will die (Rev. 16:3).

- The fresh waters will become like blood (Rev. 16:4-7).

- The sun will scorch the people on earth with fierce heat (Rev. 16:8-9).

- The throne of the Anti-Christ and his kingdom will become darkened (Rev. 16:10-11).

- The Euphrates river will dry up, allowing the east kings to march westward (Rev. 16:12).

- The world's kings will gather their armies to battle God at Armageddon. There will be an earthquake so great that all the mountains and islands will disappear. There will be hailstones weighing close to 100 pounds that will crush the gathered armies (Rev. 16:17-22).

- Shortly after this great earthquake, Jesus Christ will return with His army (angels and the raptured church) to claim the earth as His possession (Zech. 14:3-5).

The Two Witnesses (Rev. 11)

Because God doesn't want any of His creation to perish, two men will be sent as a gift to the people of the earth who refused to submit to the lordship of Jesus Christ before the rapture. Many will recognize their error in life and seek God. These two men will proclaim the gospel and provide faith, hope, and love for those left behind. Their message is for the salvation of the soul. They will have no message about how you can avoid the hell that life on earth has become because there is no way to avoid that tribulation. If you are left on earth, your destiny is to go through the fires of testing and more than likely have to lay down your life for Christ. But you still have the hope of salvation. Listen to what these two men are preaching and turn to God.

The Bible does not say who these two men are. Many speculate that they are Elijah and Enoch, two ancient prophets of God who never died. Regardless, they will be responsible for many of the natural catastrophes that will wreak havoc on the property and economy of the earth. They will have the power to prevent rain, and there will be a three-and-a-half-year drought until they die. They will turn water into blood, cause all kinds of plagues on earth and, in general, make life miserable for those living on earth. Also, they will be invincible, as many will try to kill them only to be killed by their own hands. Those who attempt to destroy them will destroy themselves. Only the world dictator will be able to kill them, and only when God allows it.

The purpose of all the misery that these two witnesses inflict on the earth dwellers is to turn people back to God in repentance. The misery will be so great that when the world dictator finally kills these two, the world will rejoice in a

Christmas-like celebration, giving gifts to one another. Three and one-half days after their death, they will be resurrected and, in full view of the world's entire population, ascend to heaven at the command of God when He calls them to "Come up here." Shortly after killing the two witnesses, the world dictator declares himself to be God. He is the Antichrist.

The 144,000 Jewish Witnesses

Shortly after the Rapture, God will call His army of 144,000 Jewish believers into service to provide a voice of hope for Jews throughout the world. The best friends and most staunch supporters of Jews have always been true, believing Christians. This element of the world's population provided help and support for Israel and the Jewish people. The Rapture removed the Christian people from the earth and awakened the 144,000 to their purpose. These 144,000 preach to Jews worldwide that Jesus is the Messiah. These 144,000 will be spread out worldwide and more than likely go about in pairs, two by two, as Jesus instructed His disciples to do. It will be these 144,000 who will oppose Israel signing a peace treaty for protection; it will be the 144,000 who will identify the Anti-Christ for who he is; it will be the 144,000 who will warn Israel of the treachery of the Antichrist, and it will be the 144,000 who will lead the Jews worldwide to the hiding place prepared for them by God in the Judean desert. These 144,000 Jews are going to be strange people by normal standards: they will be celibate, very bold, fearless, spiritually strong, and probably very much like John the Baptist. You can read more about the 144,000 witnesses in Revelation 14.

Hard money currency will become obsolete. This is no surprise, as banks and governments have been working to

eliminate currency, coin money, and paper transactions for decades. Currency is expensive to produce, readily available to drug trafficking, and is easily counterfeited with high-tech equipment. Banks desire to eliminate the teller position as an expense item, and with the elimination of paper checks and currency, all financial transactions can be handled with a computer. The debit card will become the tool for all personal financial transactions. However, at some point after the rapture, probably right after the two witnesses are killed, everyone will be required to get a mark on their right hand or forehead to buy and sell. DO NOT under any circumstances participate by receiving this mark. All those who receive this mark, known as *The Mark of the Beast,* are doomed for eternity. By taking this mark, you are swearing allegiance to the Antichrist. You may as well attempt to enjoy life as best you can because eternity for you will be hell. At this point, God will have separated His followers from Satan's followers. Those who have taken the mark will persecute those without the mark. God will render judgment on those with the mark by inflicting them with a disgusting-looking and very painful ulcer covering their bodies.

So how can a person without the mark survive and still buy and sell? Again, this will almost be impossible, but there will be people who are part of the Antichrist's regime who don't believe in the Antichrist; they are just "survivors" who pick the "winner" and seek to profit from that relationship. Therefore, save up gold; gold has always had value as money and always will, even in a cashless society. Find a new believer in Christ and seek to purchase food and supplies from him. However, don't ever disclose how much gold you have and where it is. You will have a price on your head for not taking the mark. Obviously, you won't be living an open life, as you will be hiding somewhere in a remote location or the forest on the outskirts

of a large city. Your only goal will be to eat to live and hope to escape the militia hunting for you and those like you. Should you get caught, your fate will be either death or slavery.

Safety Concerns

This era will be the most violent of times in the history of the world. Death, brutality, and destruction will be part of everyday life. One of the defining characteristics of the last days following the Rapture will be a lack of peace. There will be civil wars throughout the world: people will kill one another indiscriminately. Random acts of violence will fill people with fear: Car-jacking, home invasions, drive-by shootings, and bombings will all increase with an intensity that will leave people with absolutely no sense of security. In order to survive this time, you will need to remove yourself from society and live in a remote area that is difficult to access. Getting together with a group of like-minded believers in Jesus Christ would provide additional support and safety.

As mentioned earlier, stock up on food, medicines, living supplies, weaponry, and gold. You will need enough for seven years. Don't plan on being able to supplement your food with hunting and fishing because the stocks of wild animals and fish will have been depleted and destroyed by the three-and-a-half-year worldwide drought. There will also be three successive meteor-like or comet-like objects that strike the earth sometime after the rapture. The two witnesses bring on the three-and-a-half-year drought. The first object from outer space to strike the earth will destroy 1/3 of all trees and all the green grass on earth. More like a meteor, the second object strikes the sea and destroys 1/3 of all sea creatures and 1/3 of all shipping. The third object turns 1/3 of all fresh water poisonous and kills

many people. This will also seriously deplete the food supplies for the world's population, causing food prices to skyrocket. Those people in the world who have never before missed a meal or worried about food will become very familiar with hunger pangs and the feeling of going without food for long periods of time. This will be one of the causes of the increased violence as people become more self-centered, short-tempered, and competitive with the food sources in short supply. As Jesus spoke to His disciples about these days, He said, "People will betray one another and hate one another…the love of many will grow cold" (Matt. 24:12).

Health Concerns

Prior to the Rapture, the world experienced an increase in health-related catastrophes, new infectious diseases, and the return of diseases thought to have been eradicated or brought under control. The past few decades have brought on AIDS, EBOLA virus, flesh-eating bacteria, the return of tuberculosis, incurable gonorrhea, herpes, many other virtually incurable sexually transmitted diseases, and the most recent worldwide COVID-19 pandemic. After the Rapture, things do not get better, as one-quarter of the world's population will die due to wars, famine, and plague. Sometime after the two witnesses are murdered and after people are required to take the mark on the right hand or forehead, there will be a terrible plague causing a loathsome and malignant ulcer on the bodies of those who have taken the mark. This will be a very ugly and very painful sore that will make life miserable for those who have it.

In addition to all this, because of the poor economic situation worldwide and the three-and-a-half drought that depletes the world's water supply, sanitation practices will deteriorate

even in what were advanced nations in Europe and North America. With the short supply of water, there won't be sufficient water for flushing toilets, taking baths, washing clothes, and transporting wastewater to treatment facilities. This will increase typhus, cholera, salmonella, and E. coli infections. Therefore, since you have decided to reject Christ's offer to join in the Rapture, your concern is how to maintain good health in the post-Rapture era. You must build a supply of multiple vitamins with particular emphasis on anti-oxidants such as C, E, and minerals. It will also be necessary to have a collection of disinfectants, particularly one that can be added to water to make it potable.

Above all, do not accept the beast's mark on your right hand or forehead. If you do take the mark, your destiny will be secured for eternity, and nothing can be done for you. You will suffer the malignant ulcer making the rest of your life almost unbearable. Did you ever have a canker sore in your mouth? If so, you know how painful that one little canker sore was. Now think of having canker sores all over your body, on your genitalia, in your mouth. Think how painful and unbearable your life will be. Then follow that misery with eternity in hell. DON'T TAKE THE MARK. Your ETERNITY depends on it! You must be strong and courageous as you place your faith, hope, and Love in none other than Jesus Christ.

In summary, if you haven't accepted Jesus as your personal Savior yet, that is without a doubt the most critical decision you have to make at this very minute. If you don't take the Mark of the Beast, but still haven't accepted Christ as your Savior before you die, your eternal destination will be separation from your Creator in hell. There will be no second chance for salvation. To be very clear, your chances of surviving until the end of the tribulation period are improbable. But there is

the promise of redemption and restoration in your newfound faith, hope, and love! I want to encourage you with this verse:

And God shall wipe away all tears from their eyes; and there shall be no more death, neither sorrow, nor crying, neither shall there be any more pain: for the former things are passed away.

—Revelation 21:4

The above information about the end times is cited from the Bible (NIV) unless otherwise noted & www.raptureready.com [18]

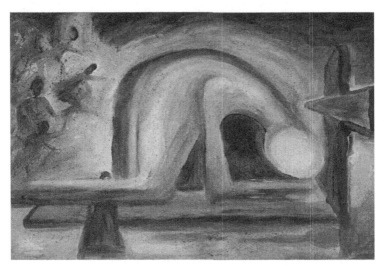

Repentance, 2010, Timothy J. Kosta

BE PREPARED & READY

Prayer of Salvation

Lord Jesus, I know I am a broken vessel and a sinner. I have disobeyed you and have done things my own way. You know everything I have done. I am sorry, and I know I cannot save myself. You are the only one who can fix me. I believe you are the Son of God who died on the cross for my sins and rose again on the third day. I believe you defeated death, and I receive your promise of everlasting life. Please come into my heart right now as my personal Lord and savior. Thank you for saving me and calling me your friend. Amen.

Do you have physical sickness in your body? Jesus Christ is not only the God of salvation but the great physician and healer! Pray this prayer for healing:

Lord Jesus, I come before you in faith to receive my healing from _____ (say your sickness physically, emotionally, socially, etc.). Your word says you were pierced for my rebellion and crushed for my sins. You were beaten so I could be whole. You were whipped so I could be healed" (Isa. 53:5). I believe you already paid for my healing by taking my infirmity and carrying my sickness (Matt. 8:16–17) over 2,000 years ago at the cross. As a child of God, I believe that it is not only your will, but my inheritance to be healed from this sickness now and forever. I know there is nothing I need to do to earn my healing, only to simply believe and receive it by faith. I have already been formed into a new vessel by the work of your hands. I believe my healing was finished and paid for by

your precious blood. I now walk by faith, believing I am healed in Jesus' name. Amen!

Additional Resources on the Rapture & Global End-Time Events:

- *Amir Tsarfati:* www.beholdisrael.org
- *Jan Markel:* www.olivetreeviews.org
- *Dr. David Jeremiah:* www.davidjeremiah.org
- *Perry Stone:* www.perrystone.org
- *Jimmy Evans:* www.endtimes.substack.com

REFERENCES

1. Bicket, Zenas. 2015. *Eschatology: A Study of Things to Come.* Springfield, MO: Gospel Publishing House.
2. Brown, Clint. Artist to Artist. Eugene Delacroix quoted, 182.
3. "Believe." *Merriam-Webster.com.* 2011. https://www. merriam-webster.com (8 May 2011).
4. "Blessed." Blue Letter Bible.com 2022 https://www. blueletterbible.org/search/search.cfm?Criteria=Blessed& t=KJV#s=s_lexiconc (17 April 2022).
5. *Canvas And Clay.* Song lyrics by Chris Tomlin/ Pat Barrett/ Ben Smith © S.d.g. Publishing, Capitol Cmg Paragon, Capitol Cmg Genesis, Vamos Publishing, Housefires Sounds
6. Chaffey, Tim, 2012. *Theophanies in the Old Testament.* https:// answersingenesis.org/jesus/incarnation/theophanies-in-the-old-testament/ Retrieved 5, May, 2022.
7. Cowman, L.B. 1997. *Streams in the Desert.* Zondervan, Grand Rapids, MI. 20, 24, 27, 31, 49, 332-33, 422, 448
8. Garrison, Alton. 2017. *A Spirit-Empowered Church: An Acts 2 Ministry Model.* Springfield, MO. Gospel Publishing House. 37, 43-44, 51, 53-54, 113-19, 140-47, 165-70
9. Gilles Neret, *Michelangelo* (Koln, Germany: Taschen, 2005), 83.
10. Graham, Ron. 2001. https://www.simplybible.com/f180-three-the-arrows-of-god.htm. retrieved May 7, 2021
11. "Hamartia" Blue Letter Bible.com 2022 https://www. blueletterbible.org/lexicon/g266/kjv/tr/0-1/ (17 April 2022).
12. Hayford, Jack. *A Treasury of Wisdom,* "Building Monuments Against Forgetfulness." Barbour Publishing, Inc. OH. July 9. 186-87.

13. Horton, Stanley M. 1996. *Our Destiny: Biblical Teachings on the Last Things.* Springfield, MO: Logion Press.

14. Hurst, Randy. 2010 (Third Edition). *The Local Church in Evangelism.* Springfield, MO. Gospel Publishing House. 55-56

15. Iwasko, Ronald A. and Teague, Willard. 2010 (Second Edition). *Introduction to Assemblies of God Missions.* Springfield, MO. Gospel Publishing House. 125, 126, 135-38

16. Jeremiah, David. *Looking for God.* Turning Points Magazine & Devotional, Vol. 22, No. 9, September 2020. 9-15, 18-23, 30-43

17. Kendall, R. T., *A Treasury of Wisdom*, "Artist At Work." Barbour Publishing, Inc. OH. January 29. 34

18. Kosta, Timothy J., 2022. *The Adventures of Clay, The Hidden Treasure.* Timothy J. Kosta

19. Michelangelo, quoted in C. Ryan, *The Poetry of Michelangelo: An Introduction* (Madison, NJ: Fairleigh Dickinson University Press, 1998), 208.

20. McElroy, Scott J. 2008. *Finding Divine Inspiration.* Shippensburg, PA. Destiny Image Publishers. 28-29, 41-42, 52, 76, 86, 173-74

21. McManus, Ron. 2010 (Second Edition). *Effective Leadership.* Springfield, MO. Gospel Publishing House. 47-48, 51-53, 68-71, 75-80

22. Miller, Bob. 2003. *The Bible Prescription for Healing,* NY. Available on Amazon.com. 11, 13-14, 16, 28, 53

23. Ogilvie, Lloyd J. *A Treasury of Wisdom*, "Focus on Christ-Claim Christ's Victory." March 5. 67-68 LOOSING

24. Prince, Joseph. 2006. *Health And Wholeness Through the Holy Communion.* Joseph Prince, USA. 62-65

25. Ryan, C. The Poetry of Michelangelo: An Introduction. Madison, NJ: Fairleigh Dickinson University Press, 1998, 208.

26. Schaeffer, Edith. *A Treasury of Wisdom*, "God's Creation." Barbour Publishing, Inc. OH. July 15. 194-95.

27. Seland, Kurt. 2019. https://www.raptureready.com/2016/07/19/the-post-rapture-survival-guide/Retrieved March 2022

28. Stanley, Charles F. & Anderson, Fil. 2016. *Work in Progress*. In Touch Magazine, Vol. 2, No. 3, May/June 2016. 24-26, 42-45

29. Stanley, Charles F. 2011. *The Charles F. Stanley Life Principles Bible*, NASB. Charles F. Stanley. 395, 601, 691, 1013, 1,548

30. Stanley, Charles. 2011. *In Touch Magazine: What Only God Can Do*. "The Value of Submission." Vol. 34, No. 8. 13

31. Taylor, David W.O. 2010. *For the Beauty of the Church: Casting Vision for the Arts*. Grand Rapids, MI. Baker Books. 31-42, 66-67, 106-107, 110, 113

32. Taylor, Justin. 2020. https://www.thegospelcoalition.org/blogs/justin-taylor/using-a-diagram-to-illustrate-trinitarian-relationships/Retrieved May 3, 2021.

33. Torrey, R.A. *A Treasury of Wisdom*, "Abiding in Christ." Barbour Publishing, Inc. OH. September 2. 242

34. Tozer, A.W., *A Treasury of Wisdom*, "God Never Violates our Freedom of Choice." Barbour Publishing, Inc. OH. July 6th

35. Weckeman, A.W. Feb. 1999. *Spirit, Soul & Body*. (Revised April 2020).

36. Wood, George O. 2010 (Third Edition). *Acts: The Holy Spirit at Work in Believers*. Springfield, MO. Gospel Publishing House.

37. Yancy, Philip. 1980. *Christianity Today*. "A Bow and a Kiss," Vol. 49, No. 5, May 2005.

ABOUT THE AUTHOR & ILLUSTRATOR

 Timothy Kosta, author and illustrator, grew up and lives on Long Island in New York. He is a visual arts educator serving in the public school system for over 17 years and a professional artist and illustrator. Timothy has had many pieces of work exhibited in galleries across Long Island and has written/ illustrated several children's books entitled, *The Adventures of Clay*. He has also written several articles for *Arts & Activities Magazine*. Timothy serves his local community through leadership, ministry, and artistic projects at his church and nonprofit organizations. He serves as a prophetic artist and visual arts ministry leader. He also enjoys using his creativity as an actor and set design painter. He has portrayed the life, death, and resurrection of Jesus Christ in a musical theater production entitled "Risen" for several years. Timothy loves getting his inspiration by spending time in the great outdoors with his Creator, wife, and two children.

To contact the author/artist, purchase original artwork & art prints, guest speaking engagements, request prayer, or share personal testimonies of how this book has impacted your life, visit: *www.TimothyKosta.com*. You can also connect on *Facebook* to receive news and updates at *Primary Redemption: Mess to Masterpiece* and *The Adventures of Clay* for the children and youth companion books.

OTHER BOOKS BY AUTHOR & ILLUSTRATOR

TIMOTHY J. KOSTA

Go on a Family Adventure Today!

Take the whole family on an action-packed adventure in search of the world's richest treasure! *The Adventures of Clay, The Hidden Treasure* is a series of family-orientated companion books based on the principles found *in Primary Redemption, Mess to Masterpiece.* Get your family companion books today!

The Adventures of Clay, The Hidden Treasure
Chapter Book (Ages 9 & Up)

Come on a fun, action-packed adventure with Clay as he encounters danger while searching for the world's richest treasure. This book promotes strong personal and group character building, wise decision making, forgiving yourself and others, positive self-esteem, empathy, and spiritual development. Each chapter's *Molding Moments* and *Fun Facts* creates a beautiful opportunity for personal reflection and family discussion. You can bring the adventure to life by visiting the *Treasure Chest* at the back of the book. Includes art lesson plans & activities! Available on *Amazon.com*

The Adventures of Clay Jr., The Hidden Treasure
Ages Birth–8

With the same captivating storyline and vivid illustrations found in *The Adventures of Clay, The Hidden Treasure*, the Jr. Edition contains simplified text for tiny adventurers. Whether taking a picture walk or reading its profound truths, this book teaches young children about the priceless treasures of faith, hope, and love. Available on *Amazon.com*

The Adventures of Clay Coloring & Activity Book
All Ages

In *The Adventures of Clay Coloring & Activity Book,* the priceless treasures of faith, hope, and love come to life, creating hours of fun for children of all ages! The book includes over 30 coloring pages of your favorite illustrations from *The Adventures of Clay, The Hidden Treasure.* It also includes a word search, crossword puzzle, maze, picture hunt, sketching space, and more. Enjoy the coloring and activity adventure! Available on ***Amazon.com***

The Adventures of Clay, The Hidden Treasure Curriculum Guide
All Ages

A curriculum guide for parents, schools, educators, churches, Sunday school programs & camps. Includes guided questions & reflection for each chapter, lesson plans, art projects, activities & much more! Check resource availability for download at ***teacherspayteachers.com***

Made in the USA
Middletown, DE
19 September 2022

10173824R00232